IMAGINING ROME

IMAGINING ROME

British Artists and Rome
in the Nineteenth Century

EDITED BY
MICHAEL LIVERSIDGE
AND CATHARINE EDWARDS

MERRELL HOLBERTON
PUBLISHERS LONDON

The catalogue accompanies the exhibition held at the
Bristol City Museum and Art Gallery 3 May – 23 June 1996

First published in 1996 by
Merrell Holberton Publishers Ltd
Axe and Bottle Court
70 Newcomen Street
London SE1 1YT

ISBN 1 85894 029 X (hardback)
ISBN 1 85894 030 3 (paperback)

Produced by Merrell Holberton Publishers
Designed by Roger Davies
Typeset by SX Composing DTP
Printed and bound in Italy by Grafiche Milani

Front jacket/cover illustration: Edward John Poynter, *Diadumenè*, 1884 (cat. 56)

Back jacket/cover illustration: Edward Lear, *Campagna di Roma: via Prenestina* (cat. 42)

Halftitle illustration: After J.M.W. Turner, *Rome. The Forum*,
engraved by Edward Goodall, from Samuel Rogers, *Italy. A Poem,* 1830

Frontispiece: Edward John Poynter, *The Ides of March* (cat. 55; detail)

Acknowledgements

University of Bristol

Paul Mellon Centre for Studies in British Art, London

Bristol Auction Rooms

Many people have helped to make this exhibition and its catalogue possible. The organizers and editors are grateful to them all, especially to the private owners and public collections separately acknowledged in the list of lenders. Special thanks are also due to those whose names follow:

Bathsheba Abse (Keats-Shelley Memorial House, Rome), Brian Allen (Paul Mellon Centre for Studies in British Art, London), Michael Allen, David Alston (National Museums and Art Gallery of Wales, Cardiff), David Blayney Brown (Tate Gallery), Michael Campbell (Campbell Fine Art, Tunbridge Wells), Mungo Campbell (National Gallery of Scotland, Edinburgh), Peter Cannon-Brookes, Margie Christian (Christie's, London), Michael Clarke (National Gallery of Scotland, Edinburgh), Viscount Dalmeny, Linda Fairlie (Dick Institute, Kilmarnock), Carlotta Gelmetti (Tate Publishing, London), Melanie Gardner, Richard Gray (Manchester City Art Gallery), Julian Hartnoll (Julian Hartnoll Gallery, London), Sandra Martin (Manchester City Art Gallery), Edward Morris (National Museums and Galleries on Merseyside, Walker Art Gallery, Liverpool), Anthea Paice (History of Art Department, University of Bristol), Elizabeth Powis (Paul Mellon Centre for Studies in British Art, London), Susan Steer (History of Art Department, University of Bristol), Simon Taylor (Sotheby's, London), Suzy van den Berg (Sotheby's, London), Valerie Westcott (Sotheby's, New York), Sarah Wimbush (Courtauld Institute of Art, Photographic Survey), Andrew Wyld (Agnew's, London).

Contents

Lenders

Stanley J. Allen, Esq.

The Earl of Rosebery

The Provost and Fellows of Eton College

Anonymous Private Collectors

The Trustees of the Cecil Higgins Art Gallery, Bedford

Birmingham City Museums and Art Gallery

Bristol City Museum and Art Gallery

The National Museum and Gallery of Wales, Cardiff

National Galleries of Scotland, Edinburgh

The Royal Albert Memorial Museum, Exeter

Art Gallery and Museum, Kelvingrove, Glasgow

The Dick Institute, Kilmarnock

The Trustees of the National Museums and Galleries on Merseyside:
Walker Art Gallery, Liverpool

Guildhall Art Gallery, Corporation of London

Leighton House, London

The Trustees of the Tate Gallery, London

The Trustees of the Victoria and Albert Museum, London

Manchester City Art Gallery

Laing Art Gallery, Newcastle upon Tyne (Tyne and Wear Museums)

Northampton Art Gallery

The Visitors of the Ashmolean Museum, Oxford

The Trustees of the National Museums and Galleries on Merseyside:
Lady Lever Art Gallery, Port Sunlight

Wolverhampton Art Gallery

Foreword

'Rome' conjures up a multiplicity of ideas and associations. Over the centuries it has been perhaps the most enduring of the influences which have formed the modern world. Yet in some ways Rome's history is so multifarious that it eludes definition. In antiquity Rome stood for a vast empire and for the common culture of Latin-speaking, toga-wearing and pagan religious practices that bound the empire together. Within a few centuries Rome had acquired a new identity as the Christian capital from which the Roman Catholic Church has continued to exercise vast intellectual and cultural, as well as spiritual influence over most of Europe. In the latter part of the nineteenth century, Rome became a symbol of the new Italy, a fledgling nation united for the first time since the collapse of the Roman empire. The idea of Rome has been used to justify continuities, revivals and even revolutions in a wide variety of contexts – literary, artistic, educational, legal, political.

British responses to Rome are, of course, part of a broader western tradition. Indeed, Protestant Britain might seem marginal to some aspects of Rome's legacy. Yet Rome, in its various manifestations, is still inextricably entwined in Britons' perceptions of their own history. Rome, after all, invaded Britain under Julius Caesar and conquered much of the island a century later, constructing enduring symbols of occupation such as Hadrian's Wall. From a very different Rome Augustine embarked to convert the British to Christianity. British attitudes to Catholic Rome shifted with the Protestant Reformation. Rome's pagan empire, however, could still serve as model and justification for Britain's own imperial ambitions in the eighteenth and nineteenth centuries (though accompanied by a moral – the abuse of wealth and power could lead to disaster). In the present post-imperial age, another of Rome's manifestations promises to reshape the identity of Britain and other nations – the Treaty of Rome, with its symbolic appeal to ancient authority, validates a new European order.

This exhibition explores one aspect of Britain's perception of Rome: how nineteenth-century British artists from Turner to Alma-Tadema responded to the inspiration of Roman antiquity, and how their paintings – ranging from picturesque and romantic representations of the city and its classical remains to imaginary reconstructions of Roman life and history – reflected and expressed various strands of the period's cultural engagement with a subject that excited an especially vivid reaction. Roman antiquity represented both republican virtue and imperial decadence. Its ruins symbolized both the transience of all human achievements and also the durability of their remains. Rome was a sign both of the triumph of Christianity and of the continuing authority of classical, pagan culture in the western tradition.

The idea for *Imagining Rome* originated with the inauguration of a research project, 'Receptions of Rome in the Nineteenth and Twentieth Centuries', in the Department of Classics & Ancient History at the University of Bristol, sustained over three years (1993–96) by a grant from the Leverhulme Trust. A series of six conferences (organized by Catharine Edwards), exploring in depth different aspects of Rome's reception over the past two centuries, has formed the core of the project. The initial suggestion for the exhibition came from Charles Martindale, Professor of Latin and Director of the Receptions of Rome project: his interest in the exhibition and the ideas he has contributed towards developing its theme have played a major part in shaping the final outcome. An equal debt of gratitude is owed to Francis Greenacre, Curator of Fine Art at Bristol City Museum and Art Gallery, who has undertaken the enormous task of arranging loans and co-ordinating the exhibition. Without his efforts, ably supported by Sheena Stoddard, Assistant Curator of Fine Art, and their professional colleagues there could not have been an exhibition.

Nor would the exhibition and accompanying catalogue have been possible without the generous support of sponsors. We are grateful to Bristol Auction Rooms for a substantial donation. The Paul Mellon Centre for Studies in British Art made a generous grant towards the catalogue illustrations. From the University of Bristol Faculty of Arts Research Fund and the Vice-Chancellor's Fund we received major contributions towards research and publication costs. The successful completion of the project is also due to the interest of an anonymous private benefactor who has supported it financially and lent from his collection. Bristol City Council, through its Leisure Services Committee, has enabled this collaboration between the University and the City Museum and Art Gallery to take shape and come to fruition. To all our lenders we express our sincere thanks for permitting us to borrow their pictures. Finally we should wish to thank our publishers, Hugh Merrell and Paul Holberton, for their painstaking work on the production of this book.

Michael Liversidge, Catharine Edwards

The Roads to Rome

CATHARINE EDWARDS

Roman antiquity is part of the common past of all European countries, even of those never included in the Roman empire. Yet different nations have used and responded to the ancient Roman past in quite different ways. In the early nineteenth century, the French under Napoleon sought to turn Paris into a new Rome, with copies of some of the most famous Roman monuments; their imperial ambitions were justified by appeal to Roman precedent. German scholars, on the other hand, wrote of the noble struggles of their barbarian forefathers against the Roman oppressor. The literature of ancient Rome had long played a central role in the education of the British upper classes (though ancient Greek was also becoming increasingly popular by the early years of the nineteenth century). Boys in particular spent many years learning to write in Latin and to read classic works of Latin literature, principally, in the early nineteenth century, those of Cicero, Livy, Virgil and Horace. Their stories of men devoted to public duty in the forum and on the battlefield were thought especially suitable for young men who were to play a leading role in their own country's social and political life. The time and money spent on acquiring this difficult dead language made it a most effective marker of social status. By the time they left school, boys would have read as part of their formal education a great deal more Latin than English literature; in 1840, for instance, between three quarters and four fifths of the lesson-time at public schools was spent on classics.[1] Ancient Rome was in some ways a familiar world for Britain's ruling classes.

In the nineteenth century, as in earlier periods, the young men of Britain's élite came to Rome first through ancient literature. But this was often followed by more direct experience of the city. Many young men had traditionally extended their classical education by travelling on a Grand Tour through France and Italy. Rome was generally the culmination of such a tour. An essential part of the Grand Tourist's experience of Rome was the thrill of treading on the ground where Cicero or Caesar had once stood (though the actual remains generally dated from the Imperial period of Roman history). The Rev. J.C. Eustace's *A Classical Tour through Italy* (London 1812) and Joseph Forsyth's *Remarks on Antiquities, Arts etc. in Italy* (1813), both often reprinted guides aimed at the educated traveller,

right Fig. 1 William Bell Scott, *Building a Roman wall*, mural from a programme devised in 1856, Wallington Hall
The National Trust, Wallington, Northumberland (photographic copyright, National Trust Photographic Library/Derrick E. Witty)

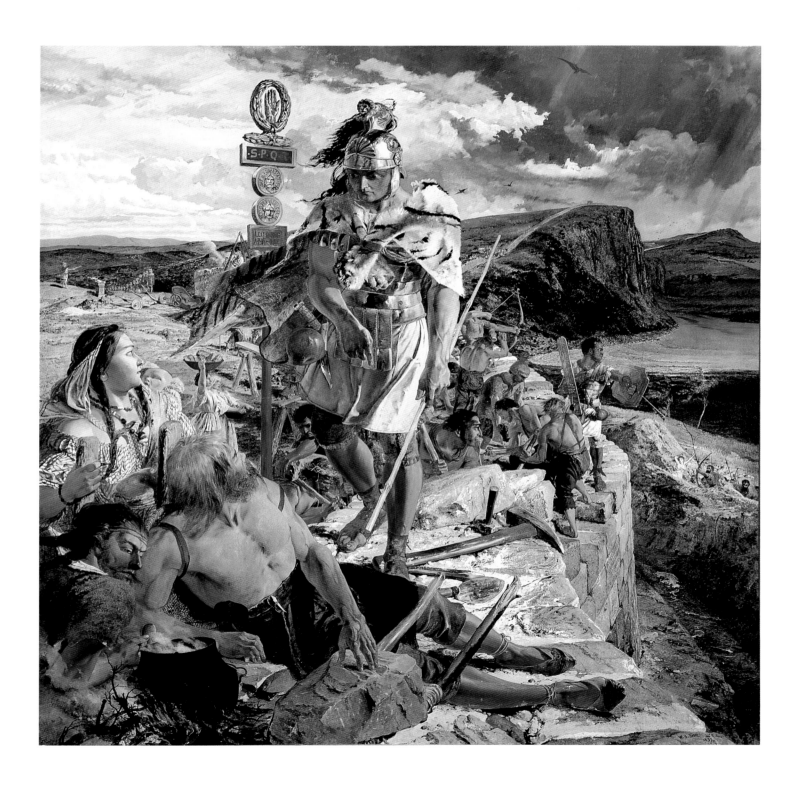

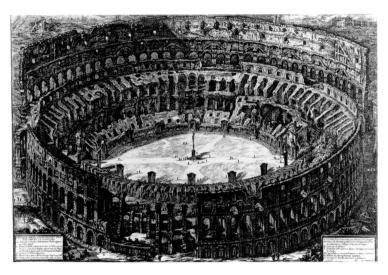

Fig. 2 Giovanni Battista Piranesi, *The Colosseum*, 1776
Etching, 19¼ × 27¾ ins (49 × 71 cm), from the *Vedute di Roma* series

gave pride of place among the sights of Italy to the remains of antiquity.

The 'classical tour' was a complement to the classical education, without which the visitor could not hope to make sense of the crumbling ruins of Roman civilization. Eustace writes in his guidebook:"Our early studies … allow us to sympathize in the feelings of a Roman; and one might almost say of every school-boy not insensible of the sweets of his first studies, that he becomes in feeling and sentiments, perhaps even in language, a Roman".[2] Grand Tourists were approaching the city of Rome after, in some cases, decades of preparation (though not all seem to have been wholly concerned with antiquities – educationalists worried about the temptations to vice which might lie in wait for young men in foreign countries). The Roman past was, in Eustace's view, a country by no means foreign to the properly educated young Briton. Those with the right education (and, of course, the means to finance an extended period of travel) should feel a special affinity with the remains of ancient Rome.[3]

Such visitors had long constituted a good market for pictures of classical remains, as well as for more portable antiquities. These would in later years decorate their owners' great houses, serving as tangible signs of their classical travels – and their membership of the cultural élite. The pictures Grand Tourists acquired were, like the guidebooks they took with them, preoccupied with the classical past. The classical scenes painted in oils by Giovanni Paninni in the mid-eighteenth century, for instance, were much sought after, while Giovanni Battista Piranesi's dramatic engravings of Roman antiquities, produced around the same time, acquired immense popularity [see fig. 2]. A number of the views of ruins in this exhibition and catalogue will have fulfilled a similar purpose for visitors to Rome in the early years of the nineteenth century.

The sight of Rome's ruins prompted in visitors the recollection not of the millions who had once thronged the city's streets but rather of a handful of 'great' Romans, known to them through literature. For visitors with a traditional classical education, it was almost as if Cicero, Horace and the characters from Livy's history were the only people to have lived in Rome. But the ruins were also a reminder of the great distance which separated the modern visitor from these heroes of antiquity.

This sense of the intangibility of the past can be found in some earlier responses to Rome's ruins but it becomes particularly evident in the poems of Byron. In his work Rome is a scene of desolation and absence.[4] Byron's evocation of Rome in the Fourth Canto of *Childe Harold's Pilgrimage* emphasizes the impossibility of tracing Rome's history in its ruins (80):

> Chaos of ruins! who shall trace the void,
> O'er the dim fragments cast a lunar light,
> And say, 'here was, or is', where all is doubly night?

For Byron it is this which makes Rome such a potent experience. What can survive of Rome is only "Tully's [Cicero's] voice, and Virgil's Lay/ And Livy's pictured page" (82) – literary traces which cannot be neatly connected with the fragmentary material remains of the city.

There was perhaps a particular poignancy in the absence of a past so familiar from literature. This sense of poignant distance is evident, too, in paintings of the first few decades of the nineteenth century. In so far as there are figures in Turner's images of antiquity recreated they are distant and indistinct. His picture *Regulus* of 1828 places the hero in a corner of the composition (indeed the figure has often been overlooked by critics). In

Cicero at his villa (1839), the great orator is shown as a small figure with his back to the viewer [fig. 3].

The Romans associated with this kind of classical landscape are heroes rather than real people. Charlotte Eaton (whose three-volume *Rome in the Nineteenth Century* was published in 1820) was full of questions about the ancient city. She longed, she wrote, to put them to an ancient Roman. She would not, however, dare ask Cicero himself to be her cicerone – a man of his heroic standing seemed unapproachable – though she could more comfortably imagine herself putting prosaic questions to the less awesome Pliny (a Roman magistrate whose letters, written in the time of the emperor Trajan, provide detailed, if idealized, accounts of high society and the administration of the provinces).[5]

Indeed Cicero himself would have been little help as a guide to many of the ancient remains visible to the nineteenth-century visitor, since they mostly dated from periods considerably later than the time of his death. Many visitors brought up on a strict diet of classical literature were disappointed not to see buildings directly connected with the books that they had read – they sought in vain for the ruins of Cicero's house or the exact spot where Caesar fell.[6] Moreover the time of the Roman emperors, who were responsible for building virtually all the structures whose ruins could still be seen, evoked far more ambivalent feelings than did the Roman republic.

The city of Rome had in its earlier days produced heroes such as Cincinnatus, Regulus and Marcus Curtius who gave no thought to their own comfort, the Roman tradition claimed, but devoted themselves to the good of the state. Cincinnatus was proverbially content with the frugal life of a small-holder, though he had served as Rome's leading general. Regulus returned to certain death at the hands of his Carthaginian enemies to avoid dishonour for Rome (his return is the subject of a painting by Benjamin West, fig. 18 on p. 57), while Marcus Curtius leapt, never to be seen again, into a chasm in the Roman forum, in order to assure Rome's future (see fig. 19 on p. 58 for Benjamin Haydon's recreation of this moment). These heroes flourished when Rome was a small city-state. But Rome went on to become capital of a great empire. And, in the opinion of ancient Roman historians, the city's moral atmosphere

Fig. 3 J.M.W. Turner, *Cicero at his villa*, 1839
Oil on canvas, 36½ × 48½ ins (92.7 × 123.2 cm). Private collection

deteriorated as its material wealth increased. Romans became avaricious. Their new wealth made them soft, stimulating desires for sensual indulgence and material possessions. Luxury, it was claimed, just as it had ruined other great powers, would one day ruin Rome.

This mode of thought, widespread in ancient authors, was influential in later periods. The fall of Rome, on this account, though the city itself was not sacked by the Goths until the early fifth century AD, was preceded by centuries of moral decline which made the collapse of the empire inevitable. This moral view of Roman history remained widely current in the eighteenth and early nineteenth centuries (Edward Gibbon's *History of the Decline and Fall of the Roman Empire*, 1776–88, offered a more complex perspective but has often been seen as belonging to this tradition). Michael Liversidge discusses below the influence of Count Volney's *The Ruins; Or a Survey of the revolutions of empires* (which first appeared in English translation in 1795 and remained popular in the first decades of the nineteenth century). Roman history was presented as an example and a warning to later civilizations.

The Romans of the empire were traditionally credited with a wide range of vices. The establishment of autocratic rule was

perceived both as a consequence of and as a contribution to declining morals. Absolute government repressed the talents of Roman subjects. Commerce and art alike fell into decay. Emperors such as Caligula, Nero and Domitian were famously tyrannical. The Roman people's tendency to cruelty was exacerbated by the provision of bloody gladiatorial games as entertainment (nineteenth-century fascination with this aspect of Roman civilization is reflected in such paintings as Simeon Solomon's *Habet!*, cat. 44). Christianity developed and spread under Roman rule but the pagan Roman authorities were to become notorious for their cruel and relentless persecution of the early Christians – another favourite subject for painters of the later nineteenth century (see, for instance, J.W. Waterhouse's *St Eulalia*, cat. 58). The Roman Colosseum was venerated in later centuries as a site of Christian martyrdom.

This prevailing view of the moral character of the Roman empire (as opposed to the republic) had a significant effect on judgements concerning the aesthetic value of material remains from this later phase in Roman history. John Murray's *Handbook for Travellers in Central Italy* (London 1843), like Baedeker's one of the leading guides to the city for later nineteenth-century tourists, divided Roman art and architecture into three chronological phases, the time of the kings (a very shadowy early period in Roman history), that of the republic and that of the emperors – virtually no monuments came into the first category, few into the second, the vast majority into the third. Murray's introductory remarks emphasized the decadence of Roman imperial architecture:[7]

"Compared with the unity and simplicity of earlier times, everything appears exaggerated. Another peculiarity is the general adoption of the Corinthian style, not indeed in its original purity, but with a variety of ornament which clearly marks the decline of art."

We might see the lavish Corinthian capitals in Alma-Tadema's *Un jongleur* of 1870 [cat. 48] as conveying a sense of Roman architectural decadence. Decadence, then, was to be traced in the material remains of ancient Rome as much as in the surviving accounts of Roman moral failings.

The buildings and works of art produced under the Roman

emperors were seen as decadent not only in comparison with those of the Republican period but also, in the later eighteenth and nineteenth centuries, with those of ancient Greece. For a variety of reasons, ancient Greece aroused increasing interest in these decades. The Romantic movement celebrated originality in literature and art; the ancient Romans were often decried as mere copiers of the more original Greeks. Greek literature was less accessible (comparatively few schools in nineteenth-century Britain offered it) and therefore more prestigious. In political terms, ancient Rome had been appropriated by the French, both during the Revolution (Roman terminology was used for many new institutions) and in the time of Napoleon, who took over many of the symbols of Roman imperial power as well as occupying the city of Rome itself.[8] Increasingly artists, writers and political thinkers in Britain were turning to ancient Greece rather than ancient Rome for inspiration.

Yet Rome still had power to move the visitor. Murray's *Handbook* describes the view over the city from the Capitoline hill:[9]

"There is no scene in the world more impressive or magnificent than that commanded from this spot. It is not inferior in historical interest to the glorious panorama from the Acropolis of Athens, while it surpasses it in those higher associations which appeal so powerfully to the feelings of the Christian traveller."

Rome, where so many martyrs had died for their faith, had, of course, become the supreme Christian city. However, Rome's present religious character might also evoke mixed feelings in the British traveller, for the city was capital of the Roman Catholic Church. Visitors from the Protestant countries of northern Europe could never completely disentangle their responses to the remains of pagan antiquity from their responses to Catholic Rome, particularly since, until 1871, the pope was also the secular ruler of the city. The impoverished state of the inhabitants, the lack of investment in infrastructure, the extensive censorship were all occasions for critical comparison with the prosperous, well regulated and liberal societies of northern Europe. Many northern visitors also took pleasure in tracing continuities between the religious practices of the ancient

pagans and what they saw as the superstitious rituals of the modern Italians. The Roman Catholic church had somehow gone native – authentic Christianity had to be looked for elsewhere. Such perceptions of religious difference on the part of British visitors were heightened by the fact that Britain had been at war with France, Europe's leading Catholic power, for much of the eighteenth and early nineteenth centuries. The debate over Catholic emancipation in Britain (granted in 1829) further stimulated interest in questions of religion and national identity.

British attitudes to ancient Rome, then, were complex. Rome represented both republican virtue and imperial decadence. Its ruins symbolized both the evanescence of all human achievements (the greatest empires must fall) and also the durability of their remains. Rome was a sign both of the triumph of Christianity and of the continuing authority of pagan culture. All these associations played their part in artists' representations of Rome's ruins and in the way such pictures were viewed (see further Michael Liversidge's essay below).

As the range of pictures in this exhibition amply demonstrates, however, artistic responses to Rome changed significantly during the course of the nineteenth century. Views of Roman ruins were still painted or sketched (Augustus Hare in his guidebook *Walks in Rome* of 1870 advises visitors of the best times of day to attempt particular views). But they no longer commanded such widespread appeal. From the mid-1860s a number of Britain's leading artists undertook to paint very different images of ancient Rome – recreations of Roman life, with a large cast of characters and full of exquisitely researched detail. Here, too, imagination was deployed to conjure up the ancient Romans. Now, however, they were not shadowy heroes but vividly present fine ladies, wretched beggars, erudite art-collectors, suffering martyrs and charming children.

These changes in the representation of ancient Rome should be seen in the context of changes in the specific social and cultural significance of Roman antiquity over this period. Attitudes to ancient Rome were also necessarily implicated in more general changes in representations of the past. In earlier centuries accounts of past times had often been dominated by the search for moral example. This element was by no means absent from later nineteenth-century representations, but encounters with the past might also be expected to offer erudite recreations of the material texture of a vanished world and, in particular, a sense of sympathy with people of earlier times.

Travel to the Continent for Britons was severely disrupted by the Revolutionary and Napoleonic wars of 1793–1815 (though Eustace managed to take advantage of the interval of 1802–03 to make the visit to Rome on which he based his guidebook). Once Italy was again accessible to travellers, their numbers increased steadily, while their social composition also underwent a significant change. Most visitors in the first part of the nineteenth century, as in earlier periods, were upper-class young men, though some women also travelled to Italy (the writers Charlotte Eaton and Anna Jameson, for instance, went there in the years immediately after the end of the war). But by the middle part of the nineteenth century travel to Rome was no longer so much dominated by men of the upper classes. It is notable that while the reactions to Rome of eighteenth-century travellers are remarkably uniform, diversity of response is a feature of nineteenth-century accounts of travels in Italy.[10] Arthur Clough's poems *Amours de Voyage* (1858), for instance, express the traveller's *ennui* at the over-familiar sights of Rome. Italian travel was becoming less socially exclusive. In consequence, it became somewhat less fashionable among Britain's intellectual élite, who still went to Italy but made more of journeys to places further afield, such as Greece or Egypt. Rome, people complained, was overrun with ignorant tourists. A view of Roman ruins hanging on the wall of one's house was losing its connotations of cultural exclusivity.

The rise of photography, as Michael Liversidge points out, was another reason for the decline in demand for artists' views of Roman ruins. By the 1860s, travel guides advised tourists where photographs of ruins might be purchased (for an example, see fig. 4). In travellers' accounts of their responses to the city of Rome one may also detect a sense that the ruins themselves conformed less easily to ideas of the picturesque than they had once done. The nineteenth century witnessed great developments in archaeological knowledge of the city. Extensive excavations, particularly in the Forum and Colosseum, were organized during the French occupation of 1809–14

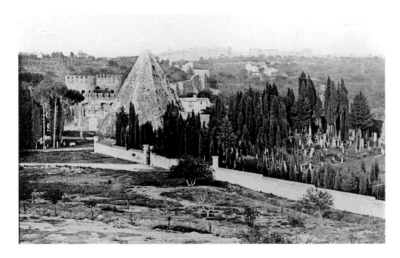

Fig. 4 *The Aurelian Wall, Pyramid of Cestius and Protestant Cemetery*
Photograph (anonymous), *ca.* 1870
University of Bristol Library (John Addington Symonds Collection)

(Charlotte Eaton disapproved strongly of the French rearrangement of the area around the Colosseum).[11] These excavations were continued, if on a rather less lavish scale, when the pope was restored to power.

A more drastic transformation of the city's ancient remains, however, took place under the new government of united Italy from the 1870s. Rome's new role as the capital of Italy meant that modern life would inevitably intrude on the city's appearance. Quiet, picturesque spots all around the city were destroyed forever by the construction of vast numbers of new buildings. The new government sought to proclaim its place as heir to the greatness of Roman antiquity by sponsoring excavations of the city's most politically resonant sites – and by building the Victor Emmanuel monument which occupied a large part of the ancient Capitoline hill. Augustus Hare complained bitterly about the Victor Emmanuel monument and other new buildings. Excavations aroused more mixed feelings. The Forum, he writes in the 1900 edition of *Walks in Rome*, "While gaining in historic interest… has greatly lost its beauty since the recent discoveries. Artists will lament the beautiful trees which mingled with the temples, the groups of *bovi* and *contadini* reposing in the shadow, and above all the lovely vegetation which imparted light and colour to the top of the ruins."[12]

But these were perhaps not the only reasons for the declining appeal of ruin scenes. Just as physical access to Rome increased during the course of the century, so too did access by way of the imagination. A medium of great importance here was the historical novel. Sir Walter Scott's novels, set in the Britain of earlier centuries, gained enormous popularity throughout Europe, but especially in Britain, in the early nineteenth century. Scott's novels both responded to and stimulated a desire for a different sort of encounter with the past from that available in supposedly factual accounts of earlier times.[13] Scott was concerned exclusively with vernacular history but his son-in-law, John G. Lockhart, was the author of *Valerius, a Roman Story* (1821), the first historical novel to be set in ancient Rome. Much more successful than Lockhart's work, however, was Edward Bulwer-Lytton's *The Last Days of Pompeii* (1834), reprinted many times in subsequent decades (and the inspiration for a number of pictures in this exhibition and catalogue).[14]

In the developing fashion for novels one may trace a shift away from the Romantic emphasis on Rome's desolation to a preoccupation with repeopling Roman antiquity. Novelists took up the concern to sympathize with the past. In some ways this perhaps made ancient Rome a less promising subject than, for instance, medieval Scotland (an important part of Scott's terrain). Bulwer-Lytton, in his 1834 preface to *Last Days*, defends his Roman subject-matter in the following manner:[15]

"With the men and customs of the feudal time we have a natural sympathy and alliance; those men were our own ancestors – from those customs we received our own … We trace in their struggles for liberty and for justice our present institutions… But with the classical age we have no household and familiar associations. The creed of that departed religion, the customs of that past civilisation, present little that is sacred or attractive to our northern imaginations … Yet the enterprise, though arduous, seemed to me worth attempting … It was the first century of our religion; it was the most civilized period of Rome; the conduct of the story lies amidst places whose relics we yet trace."

Achieving sympathy with the past is clearly proclaimed the goal of the historical novelist. This is to be achieved in part through

selecting a location familiar to some readers. At the same time, an implicit parallel is drawn between the height of Roman civilization and the height of British civilization – the time in which Bulwer-Lytton's readers live. In particular Bulwer-Lytton emphasizes the religious interest offered by his story. Christianity was to be the link which bound the nineteenth century to the first.

A preoccupation with early Christianity is common to many nineteenth-century historical novels set in the ancient Roman world. Charles Kingsley's *Hypatia; Or Old Foes with New Faces* (1854) was also immensely popular and many times reprinted. Kingsley's novel, set in fifth-century Alexandria, paints a picture of the conflict between the ultimately limited virtues of pagan philosophy and the potentially deadly passions unleashed by some sects within the early Church (Kingsley's novel reflects his concern at the shift towards Roman Catholic beliefs and practices among his contemporaries within the Anglican Church). Others chose to use the ancient Roman historical novel as a vehicle for the propagation of different theological views. John Henry Newman's *Callista: A Sketch of the Third Century* (1873) told the story of a pagan woman who converts to Christianity and suffers martyrdom. It was intended as a Roman Catholic response to Kingsley.

The status of the novel as a genre remained somewhat problematic. Bulwer-Lytton and Kingsley were established literary figures. The respectability of their writing was reinforced by the display of erudition made possible by the choice of an ancient Roman setting. Less well known writers also sought to authorize their work through the use of ancient settings. Wilkie Collins, for instance, chose to set his first novel *Antonia; Or, the Fall of Rome* (1850) in Roman antiquity. An ancient Roman setting could serve to make palatable a complex theological argument. It might also be used to confer legitimacy on salacious subject-matter. Bulwer-Lytton's *Last Days* contained a somewhat lurid description of a Roman orgy (hosted by the evil priest of Isis, Arbaces). The account of a young woman being torn apart in Kingsley's *Hypatia* was criticized by contemporaries for its gruesomeness.

The reading public's passion for historical novels developed in tandem with a new interest in the history of everyday life.[16]

Serious scholars of antiquity wrote learned works on subjects such as dress and eating habits which had once been dismissed as trivia beneath the attention of the proper historian (who should be concerned with high politics and warfare). Archaeology played an important role here, offering a new approach to antiquity. Increasingly systematic excavations and studies of material remains facilitated the exploration of areas which were only tangentially discussed in ancient literature. Such studies also reinforced a sense that objects could bring one into direct contact with the past in a way that literary texts could not.

The responses of travellers to Italy reflect this developing interest in the history of everyday life. Frances Trollope writes, in her *A Visit to Italy* (1842), of the thrill afforded by a visit to the ruined city of Pompeii: "I shall never feel sent back to ages past by the columns and pediments of ancient Rome as I did by the shop-counters, the oil-jars and the ovens of Pompeii".[17] Pompeii seems to have become particularly fashionable as a tourist destination after Sir Walter Scott, visiting the city in the company of the archaeologist Sir William Gell in 1832, had termed it "the city of the dead" (Gell's own publications also did much to stimulate visitors' interest in Pompeii).[18] In the latter part of the nineteenth century particularly, curators, most notably the masterful Giuseppe Fiorelli, took great care to present the site of Pompeii in as much detail as possible, in some cases showing objects found *in situ* (rather than removing them to the Naples Museum). An article in the *Quarterly Review* of 1869 comments with great approval on the small museum set up in Pompeii itself to illustrate the manners and daily life of the former inhabitants. It included such objects as a sucking-pig still in the baking pan.[19] For those who could not manage to go to Italy themselves, there was even a Pompeian house exhibited in Crystal Palace in London.[20]

Pompeii seemed to accommodate visitors' desire for an unmediated encounter with the past. In Rome itself, by contrast, it was virtually impossible to overlook the traces of intervening centuries. George Sala in 1869 writes of the disappointment many visitors felt on seeing the streets of Rome. They expected to see ancient shopfronts and pavements but were faced instead with dirty modern streets. He explicitly links

their disappointed expectations with the reading of historical novels:[21]

"Lord Lytton is responsible for much of the sadness thus engendered by the destruction of fondly cherished illusions. *The Last Days of Pompeii* sent everybody, in person or in imagination, to that wonderful place. The novel so exquisitely and so truthfully portrays the city, that the houses of Glaucus and Pansa, the theatre and the gladiators' wine shop have become as indelibly pressed on the readers' minds as the forms of the dead Pompeians on the hot ashes with which they were stifled. Bulwer has made Pompeii his own. The *Last Days* are the best possible guidebook to the disinterred city."

In Rome, the reality of ancient ruins could not stand comparison with the fictional recreation of Roman life.

There was, then, a new interest in the everyday life of the ancient Romans but the more traditional association of Rome with empire remained important. During the course of the nineteenth century, Britons became increasingly aware of their own imperial role. For instance we find in histories of Rome written during the nineteenth century an increasing interest in the mechanics of imperial rule – and also a growing emphasis on contrasts between Roman rule and British rule. Charles Merivale's eight-volume *History of the Romans under the Empire* (1850–64) praised some features of the Roman empire, such as the involvement of the 'middle classes' in administration (which was also perceived to be a characteristic of the British empire). Yet in general Merivale was critical of the Romans. In implicit contrast to the British of later centuries, they made use of slaves, failed to promote commerce and suppressed Christianity. His account of the failings of the Roman empire could be read as an exhortation to the imperial British to avoid Roman vices, as well as offering a reassuring assertion of the basic differences between the two empires.

Attitudes to the Roman empire were made more complex also by the knowledge that Britain itself had once been a province of that empire. Antiquarian researches into the material traces of the British past acquired a new impetus in the course of the nineteenth century; the remains of Roman Britain received their share of attention. Studies of Britain's role

as a far-flung province of a vast and multifarious empire might prompt musings on the parallels (and the differences) between the Roman empire and Britain's developing imperial power. J.C. Bruce wrote in 1851 in his study of Hadrian's Wall:[22]

"Another empire has sprung into being of which Rome dreamt not… In that island where, in Roman days, the painted savage shared the forest with the beast of prey a lady sits upon her throne of state, wielding a sceptre more potent than Julius or Hadrian ever grasped! Her empire is threefold that of Rome at the hour of its prime. But power is not her brightest diadem. The holiness of the domestic circle irradiates her. Literature, and all the arts of peace, flourish under her sway. Her people bless her…."

The British empire is characterized by commerce, culture and Christian domestic virtue, in contrast to the crude military might of the Romans. Yet, as in Merivale's *History of the Romans*, these contrasts are not intended merely to comfort British readers with a sense of their own superiority. Bruce's book concludes with the following advice:[23]

"We can hardly tarry, even for an hour, in association with the palmy days of the Great Empire, without learning, on the one hand, to emulate the virtues that adorned her prosperity, and, on the other, to shun the vices that were punished by her downfall. The sceptre which Rome relinquished, we have taken up."

Britons, though superior in their taste for trade, their religious faith and their pure domesticity, could still learn something from the Roman example. The greatness of Rome, so long an object of study to the British upper classes, offered a model for the potentially superior might of Britain.

The study of ancient Rome may, by the latter part of the nineteenth century, have lacked the intellectual glamour of the study of ancient Greece. Its academic respectability was retained, even enhanced, particularly by developments in archaeology and the study of inscriptions. Ancient Rome preserved a large measure of its cultural authority. Elizabeth Prettejohn emphasizes below the extensive critical attention devoted to pictures with Roman subject-matter, which were celebrated for their archaeological erudition.

The recreations of ancient Rome which become so popular in the later nineteenth century may often be read as commenting on the moral complexion of the Roman empire, as Elizabeth Prettejohn observes. Like historical novels set in ancient Rome, such pictures took as their themes the luxury and sexual laxity of the ancient Romans, their taste for cruel entertainments and the religious conflict between pagan and Christian. Pictures, such as Waterhouse's *St Eulalia*, represent Christians oppressed by Romans, while others represented Britons oppressed by Romans. Nineteenth-century British Christians would have a double motive for identifying with Rome's mistreated enemies rather than with their oppressors. Such images allowed viewers to sympathize with the persons represented (the ideal followed alike by historical novelists and painters of historical scenes). And there was also the implication that Britons, when conquerors themselves, in contrast to the Romans, would display Christian mercy and benevolence to their subjects.

Yet it is difficult to see pictures recreating Roman life as entirely concerned with offering a disapproving view of Roman vices. Sir Lawrence Alma-Tadema, who painted so many pictures set in antiquity, wrote to a friend, "I have always endeavoured to express in my pictures that the old Romans were human flesh and blood like ourselves, moved by the same passions and emotions".[24] Scenes of Roman domesticity invited the viewer to take pleasure in a world of delicate luxuries, summoned up with painstaking attention to erudite detail – and also to identify with those who inhabited this world.

Even pictures representing the most notorious Roman voluptuaries and sadists might be read as morally ambiguous rather than condemnatory. Just as the historical subject-matter of novels had served to give legitimacy to accounts of orgies and flayings, that of paintings served to license the visual display of violent and sexually arousing subjects. Some nineteenth-century critics took artists to task for failing to make appropriate moral judgements. Harry Quilter, for instance, writing in 1892, severely criticized Alma-Tadema's *Roses of Heliogabalus* for not offering an explicitly moral perspective on ancient depravity.[25] Comparisons had already been drawn by the critic Wilfred Meynell in 1879 between the supposedly amoral aestheticism

of the writer Walter Pater and the luxuriant materialism of Alma-Tadema's work.[26] Pater himself was later to write a historical novel set in ancient Rome, *Marius the Epicurean: His Sensations and Ideas* (1885), which, while largely concerned with the developing Christian sensibility of its central character, also offered seductive descriptions of the material detail of the pagan world. Pater's description of the triumph of Marcus Aurelius, for instance, seems the visual equivalent of Alma-Tadema's *Triumph of Titus*, painted the same year. There are also striking similarities between the description of a spring festival, the Ambarvalia, in the opening chapter of *Marius* and Alma-Tadema's picture of 1895, *Spring*.[27]

Pater's aestheticism, though highly influential in some circles, did not command a widespread popular following in the closing decades of the nineteenth century. Nevertheless Roman luxury was perhaps no longer thought so deserving of condemnation as it had once been. Luxury might be approved (or at least tolerated) as a stimulus to commerce. And commerce had played a crucial role in securing Britain's position as a leading industrial nation. Historians such as T.B. Macaulay, in his *History of England* (1848–61), celebrated material prosperity as a cause for national pride – a necessary prerequisite for improved education, health and the general well-being of the population.

The later nineteenth century saw an increasing preoccupation with the material dimension of Roman civilization. Luxury objects and domestic paraphernalia feature in many novels and paintings, as we have seen, but others chose to focus on the less glamorous (and perhaps worthier) remains of Roman antiquity. I noted above the increasing interest on the part of scholars in the mechanics of Roman administration. Details which were too prosaic to be included in the great historical narratives of Roman writers such as Tacitus were now gleaned from archaeological and epigraphic sources. Romans were admired for their achievements in engineering and communications – studies were made of Roman sewers, heating-systems, aqueducts and roads, while Roman defence systems had a particular interest for the ruling classes of a newer empire often afflicted with border difficulties.

This interest, too, was reflected in British painting. Sir Walter Trevelyan and his wife Pauline commissioned William Bell

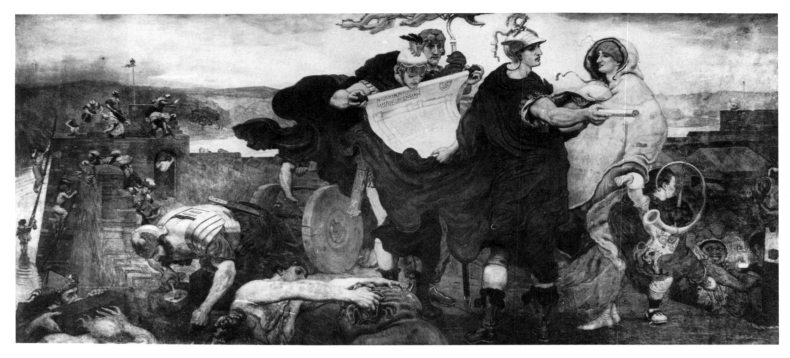

Fig. 5 Ford Madox Brown, *Building the Roman fort at Mancenion*, mural in Manchester Town Hall
(Photograph: Manchester Central Library Local Studies Unit)

Scott to paint a series of pictures for their house in Northumberland, Wallington Hall, beginning with *Building a Roman wall* (1855–60), in which a Roman officer, buffetted by the northern wind, is shown directing the work of British labourers in the construction of Hadrian's great wall, still a testament to Roman engineering 2,000 years later [fig. 1 on p. 9]. The series culminated in a painting entitled *The Nineteenth Century*, which was intended as a representation of the idea of progress and focussed particularly on the engineering achievements of local industries in Newcastle. Progress here was crucially linked with industry. The Romans, by implication, even if outdone by the Britons of later centuries, were still to be admired for the peace and civilization secured in part at least through their construction of walls, forts, roads and towns. Some years later, Ford Madox Brown, a friend of Scott's, obtained a commission to create a series of frescos for the newly

built Manchester Town Hall, illustrating scenes in the history of the city. The first in the series, *Building the Roman fort at Mancenion* (1879–80) showed, like Scott's Roman wall picture, a Roman officer overseeing Britons (and Roman soldiers) as they worked on the fort [fig. 5].[28] The officer's family is accompanied by Nubian slaves – a subtle reminder of the vast extent and varied population of the Roman empire. Later frescos in the series emphasized British engineering achievements, such as the opening of the Bridgewater Canal. Here too, then, an implicit parallel was set up between the ancient Romans and nineteenth-century Britons. The modern viewer was invited to identify with the Roman – not the voluptuary lounging in his bath but the soldier striving in an inhospitable climate, far from home, to bring the protection of a great empire to the benighted barbarian.[29]

NOTES

I would like to thank Michael Liversidge, Charles Martindale, Elizabeth Prettejohn and Helen Small for bibliographical help and for thought-provoking comments on earlier drafts of this essay.

1 Jonathan Gathorne-Hardy, *The Public School Phenomenon, 597–1977*, London 1977, p. 137.

2 1821 edn., p. 57.

3 For the Grand Tour generally, see Jeremy Black, *The British and the Grand Tour*, London 1985, and Jeremy Black, *The British Abroad. The Grand Tour in the Eighteenth Century*, Stroud and New York 1992.

4 Anne Janowitz, *England's Ruins: Poetic Purpose and the National Landscape*, Oxford 1990, pp. 30–40.

5 1820, II, p. 74.

6 Cf. Murray 1843, p. 266.

7 Murray 1843, p. 268.

8 Frank Turner, 'Why the Greeks and not the Romans in Victorian Britain?' in G.W. Clarke (ed.), *Rediscovering Hellenism: The Hellenic Inheritance and the English Imagination*, Cambridge 1989, pp. 61–81.

9 Murray 1843, p. 263.

10 James Buzard, *The Beaten Track: European Tourism, Literature and Ways to Culture 1800–1918*, Oxford 1993, pp. 6, 82, 169.

11 1820, I, p. 136.

12 1900 edn., I, p. 115. Cf. p. 68 on the Capitol and p. 153 on the Colosseum.

13 Stephen Bann, *Romanticism and the Rise of History*, New York 1995.

14 On this and other nineteenth-century works of fiction set in Pompeii, see Wolfgang Leppmann, 'Pompeii', in *Fact and Fiction*, London 1968.

15 1873, pp. v–vi.

16 Cf. Bann. *op. cit.* note 13, pp. 23–24 on the influence of Scott's historical novels on the practice of historiography.

17 Frances Trollope, *A Visit to Italy*, London 1842, II, p. 261.

18 Cf. Laurence Goldstein, 'The impact of Pompeii on the literary imagination', *Centennial Review*, no. 23, 1979, pp. 227–41. Mme de Staël's novel *Corinne*, published in 1807, had earlier celebrated the superior spiritual power of the remains of Pompeii, compared with those of Rome. The novel was to become required reading for more educated visitors to Italy throughout the nineteenth century. It is frequently quoted, for instance, in Augustus Hare's *Walks in Rome*.

19 *Quarterly Review*, no. 115, April 1869, pp. 312–48.

20 *Ibid.*, p. 344.

21 G.A. Sala, *Rome and Venice, with other Wanderings in Italy in 1866–7*, London 1869, p. 426.

22 *The Roman Wall*, London 1851, pp. 41–42.

23 1851, pp. 449–50.

24 Vern G. Swanson, *Sir Lawrence Alma-Tadema: The Victorian Vision of the Ancient World*, London 1977, pp. 43–44.

25 *Ibid.*, p. 61.

26 *Ibid.*, p. 60.

27 Cf. Louise Lippincott, *Lawrence Alma-Tadema: Spring*, Santa Monica 1990, pp. 11–12 and 19.

28 See Teresa Newman and Ray Watkinson, *Ford Madox Brown and the Pre-Raphaelite Circle*, London 1991, pp. 172–86.

29 Cf. Sam Smiles, *The Image of Antiquity: Ancient Britain and the Romantic Imagination*, New Haven and London 1993, pp. 143–44; and now Paul Barlow, 'Local disturbances: Madox Brown and the Problem of the Manchester Murals', in Ellen Harding (ed.), *Reframing the Pre-Raphaelites: Historical and Theoretical Essays*, London 1996.

"City of the soul": English Romantic Travellers in Rome

TIMOTHY WEBB

The writers of what we now regard as the English 'Romantic' period (approximately 1780–1830) are traditionally associated not with the city but with the natural world. Although prose writers such as Lamb, Hunt, Hazlitt and De Quincey were responsive to the imaginative claims of the city, and especially of London, most major poets, with the notable exception of Blake, ignored or minimized the city or exercised their energies by concentrating on the anxieties the city generated. (A symptomatic case is provided by Wordsworth's treatment of Paris and London in *The Prelude*.) The subject of Rome was not exempt from such anxieties: the status of 'the Eternal City' was recurrently perceived as ambiguous, paradoxical or problematic, and the major Romantic accounts of it characteristically qualify the celebratory with the sense of something darker, more challenging, less amenable to classification. Rome was self-contradictory, discordant, a city of the dead tainted, despite its superficial animation, by the odour of mortality. Yet Rome exercised its attraction on many English writers and visitors of the period and its impact can be traced in letters, journals, memoirs and a variety of travel writings as well as in poetry, fiction and art. Samuel Rogers, Lady Morgan, Coleridge, Wordsworth and Hazlitt all engaged with the subject of Rome, but the richest and most creative examples were those of Byron and Shelley.

Byron saluted the city as "Rome! my country! city of the soul!" in an impassioned declaration of allegiance which acknowledged that the "Lone mother of dead empires" was the appropriate refuge for "The orphans of the heart".[1] This crystallizes the magnetism of the city for wanderers like Childe Harold and for his displaced or unrecognized heroes – intellectual or political exiles such as Dante whose passports were not in keeping with the dictates of their heart or their conscience. For Shelley, Rome was the "Capital of the World", the "metropolis of taste and memory still", "a scene by which expression is overpowered: which words cannot convey".[2] Although there were few, if any, English equivalents to the Roman sections of Goethe's *Italian Journey* or Germaine de Staël's *Corinne* or Stendhal's *Rome, Naples et Florence* in its two versions, the Fourth Canto of Byron's *Childe Harold* offers a sustained engagement with post-Napoleonic Italy and an imaginative recreation of

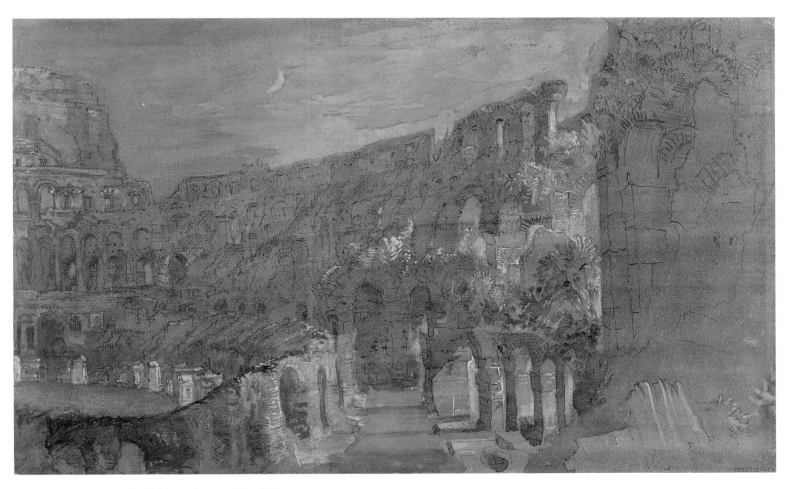

Fig. 6 J.M.W. Turner, *The Colosseum by moonlight*, 1819
Watercolour and bodycolour on white paper prepared with grey wash, 9 × 14¹/₂ ins (22.9 × 36.7 cm)
Courtesy Tate Gallery, London (Clore Gallery for the Turner Collection)

Rome; it is a text described by Jerome McGann as "central… in the iconography of Romanticism", and was to affect the responses of more than one generation of readers and of travellers.[3] In the case of Shelley, Rome did not achieve such obvious and definable centrality but it made a deep impression on him and it is a major presence in *Prometheus Unbound, The Cenci* and *Adonais,* in travel letters and in unfinished but intriguing stories.

For the English Romantics, as for so many others, Rome was a city of the imagination and an idea; for most, it was also a topographical reality. Political circumstances ensured that, in most cases, direct experience of the city was postponed until the fall of Napoleon, although Beckford enjoyed an epiphanic visit to St Peter's in 1780 and Coleridge immersed himself in Roman detail in 1806 until his visit was brought to a sudden conclusion when English visitors were expelled from the papal territories by Napoleonic edict. Letters, journals and memoirs record that, in many respects, Romantic visitors carried on the pleasurable round of activities which had formed the daily routine of their predecessors on the Grand Tour: visits to churches, concerts, the opera, galleries, salons, *conversazioni* and the gatherings of polite society; the acknowledged spectacles of contemporary Roman life; and the ruins, vistas and points of historical and antiquarian interest established by convention. Everyone walked among the ruins, preferably by moonlight [fig. 6]. Among others, Byron and Hobhouse and the dying Keats all took exercise on horseback. Almost everybody seems to have attended church ceremonies, particularly in the Sistine Chapel and especially, when possible, during Easter week. Coleridge was present at a number of services including the beatification of a Jesuit, although his Protestant conscience was sometimes affronted by the prominence accorded to the "illuminated cross" and by other Catholic "mummeries". Even Shelley was eager to acquire tickets for a performance of the *Miserere.* Pius VII was frequently visible: Mary Shelley and Claire Clairmont met him walking on their way from the Baths of Caracalla and Thomas Moore recorded that he "looked like a dying man in a rich dressing gown".[4] The theatre of Roman life was often at its most compelling in the streets. Byron, for example, recorded the morbid fascinations of a triple execution

with a Dickensian animation not surpassed by Dickens himself in *Pictures from Italy*: the ceremony was "altogether more impressive than the vulgar and ungentlemanly" system at Newgate. This double perspective with its comparative evaluation can be parallelled by the concerns of observers in earlier historical periods, but Byron's account includes the behaviour of the observer himself in a self-analysis which is both objective and ironical:[5]

"The pain seems little – & yet the effect to the spectator –& the preparation to the criminal – is very striking & chilling. – The first turned me quite hot and thirsty – & made me shake so that I could hardly hold the opera-glass (I was close – but was determined to see – as one should see every thing once – with attention) the second and third (which shows how dreadfully soon things grow indifferent) I am ashamed to say had no effect on me – as a horror – though I would have saved them if I could."

Authenticity of response was highly prized by some English visitors who liked to distinguish themselves from the superficialities of tourism. Even in the eighteenth century the pressures of following received opinion on works of art and an approved and well worn itinerary left increasingly little room for individuality of response.[6] Gallery fatigue, both physical and mental, was also a recurrent hazard. The end of the Napoleonic era had subjected Italy to a new invasion. In 1823 Byron looked back to more comfortable times when the country was still free from companies of English tourists uncritically dependent on the advice of their guidebooks: "the second-hand Society of half-pay economists – no pay dandies – separated wives, unseparated *not* wives – the Starke – or Invalid – or Forsyth – or Eustace or Hobhouse travellers – as they are called according to their Manual".[7] Byron's friend Thomas Moore wittily captured the effects of this new phase of tourism: "Go where we may, rest where we will,/Eternal London haunts us still". Ironically, Byron's own account of Italy in *Childe Harold* would soon achieve the status of a poetic guidebook and further encourage the flow of tourists. Personally, Byron tried when possible to avoid "this tribe of wretches". So in 1817 he chose not to visit Rome because "at present it is pestilent with English, – a parcel of staring boobies, who go about gaping and wishing to be

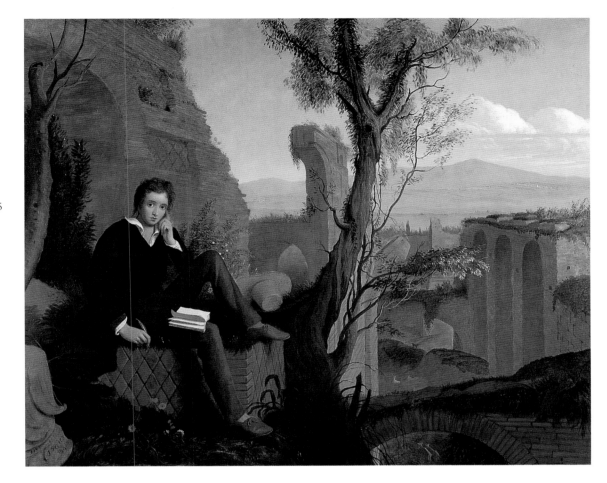

Fig. 7 Joseph Severn, *Percy Bysshe Shelley in the Baths of Caracalla*, 1845 Oil on canvas, 39¹/₂ × 48⁵/₈ ins (100.5 × 123.5 cm) Keats–Shelley Memorial House, Rome

at once cheap and magnificent". Shelley's experiences were different but his attitudes had much in common with those of Byron. At Rome in 1819 he prided himself on not being in touch with "English society": "The manners of the rich English are something wholly insupportable, & they assume pretences which they would not venture upon in their own country". Correspondingly, his travel letters aimed at a freshness which was uncontaminated by the example of the guidebooks: "The tourists tell you all about these things, & I am afraid of stumbling upon their language when I enumerate what is so well known".[8]

In many ways, Rome resisted the normal definitions of a city. It was "at once the Paradise,/The grave, the city, and the wilderness" as Shelley expressed it in *Adonais* (1821), his elegy for Keats. While "The grave" must include a specific acknowledgement of Keats's resting-place in the Protestant Cemetery, it also constitutes one of the four elements in the composite identity of a city which provides a location for Shelley's engagement with the problems of mortality and the durability of poetic influence and reputation. Shelley's first impressions of Rome in December 1818 indicate how little it conformed to prevailing conceptions of the urban:[9]

"Rome is a city as it were of the dead, or rather of those who cannot die, & who survive the puny generations which inhabit & pass over the spot which they have made sacred to eternity. In Rome, at least in the first enthusiasm of your recognitions of antient times, you see nothing of the Italians. The nature of the city assists the delusion, for its vast & antique walls describe a circumference of sixteen miles, & thus the population is thinly scattered over this space nearly as great as London. Wide wild fields are enclosed within it & there are grassy lanes & copses winding among the ruins, & a great green hill lonely & bare which overhangs the Tiber. The gardens of the modern palaces are like wild woods of cedar & cypress & pine, & the neglected walks are overgrown with weeds."

This picturesque evocation suggests that the attractions of Rome were partly created by its capacity to admit the pastoral and by the unplanned and unrepressed fertility of life among the ruins, "the deformity of their vast desolation softened down by the undecaying investiture of nature".[10] Travellers like Shelley were attracted by the ease with which an observer could be isolated from the urban press which characterized "the long long streets" of a "million-peopled City vast" such as London.[11] Many of the most powerful Romantic engagements with Rome tended to eliminate or to marginalize contemporary Romans and to find solitude and space for imaginative engagement with the spirit of the city and its history. It was no accident, too, that Rome was a "City of the Dead" (a phrase which Shelley overtly borrowed from Germaine de Staël)[12] since Romantic writers were often more comfortable with cities when their animation was, at the least, suspended.

This tendency to concentrate on the ancient city and to avoid the modern or to approach it as a series of *lontani* is captured by Joseph Severn's posthumous portrait of Shelley in the Baths of Caracalla [fig. 7]. Severn seems to claim Shelley as a Roman writer by implying the centrality of his contact with the flowery wilderness of those ruins which inspired him to write: "Rome has fallen, ye see it lying/Heaped in undistinguished ruin:/Nature is alone undying".[13] Specifically, Severn's portrait is a tribute to *Prometheus Unbound* which, as the Preface tells us, was chiefly written "upon the mountainous ruins" of the Baths where "the effect of the vigorous awakening spring… and the new life with which it drenches the spirits even to intoxication, were the inspiration of this drama". Severn had nursed Keats in his final illness and his sketch of the tangle-haired head of the young poet on his death-bed is a rather different Roman portrait; his idealized figure of Shelley lacks that directness and hauntingly unassuming immediacy. By contrast, Severn's Shelley has something in common with Tischbein's beautifully harmonized picture of Goethe posing among the sources of his inspiration in the Campagna, yet it is also very different in feeling: the hatless Shelley (whose leghorn or straw hat is casually within reach) is at ease in this outdoor setting and his personal informality is not only historically authenticated but is a sign of that liberated artistic spirit which enabled him to engage constructively with the Greek model of his play. Shelley's preference for writing in the open air might align him, however tenuously, with the Turner whose watercolours of Roman scenes were produced only a few months after Shelley had left the city.

The city's larger and more abstract claims to a hold on the imagination were enumerated by Coleridge in a *Morning Post* essay of 24 February 1798 on the "Insensibility of the Public Temper".[14] Coleridge lamented that the extraordinary events of the years since the outbreak of the French Revolution in 1789 had desensitized public response to seismic political events to such an extent that "the entry of General Berthier into Rome is now heard with almost as much indifference, as we should read of the entry of the *Seiks*, or the King of *Candahar* into *Samarcand*". Faced with the French occupation of Rome and the proclamation of a republic on 15 February, Coleridge memoralized the significance of the city to western civilization in an act of willed remembering and imaginative resistance:

"We read without emotion that the armies of France have entered the city of Rome; that city which, in ancient times, was the civil, and in modern times, the spiritual metropolis of Europe, which is endeared by so many recollections and associations to the statesman, the soldier, the admirer of the arts, and the man of letters; of which the name alone calls before our imagination every sort of literary and martial glory, and which

in the eyes of many men is still rendered august and venerable, by being the seat of the principal Minister of that religion, which has been for many ages professed by the majority of civilized nations."

This essay and the occasion of its writing vividly illustrate how responses to Rome were informed, directly or indirectly, by the evolving narrative of revolutionary Europe. The threat to Rome clarified the significance of the city to western civilization and reminded Coleridge both of its history and of its present vulnerability. He could not forget that the model of Roman republicanism had exercised its influence on the French Revolution nor that Napoleon had overtly acknowledged this influence in his shaping of the new France.[15] The religious significance of the city was almost as highly charged and as controversial as the political. Coleridge pays careful tribute to the felt authority of Rome as a spiritual centre but his tactful generalizations do not entirely conceal the fact that, for many English observers, the history of 'modern' Rome could not easily be separated from the presence and influence of the Roman Catholic Church, which may have been in decline since the death of Clement XIV but which could still excite a range of negative reactions.

As Coleridge's description illustrates, the concept of 'Rome' was heavily freighted with cultural, historical and literary associations. For some visitors, this was a source of comfort and stability by which classical texts were transformed into topographical realities which, although foreign, were reassuringly familiar. This transformation often had the effect of blurring the division between text and topography so that the traveller had the experience of turning over the pages of classical literature among the ruins of Rome while the reader at home could become a mental traveller and encounter the Italian scene through the medium of classical or historical allusion. This is perfectly exemplified by Henry Sass in *A Journey to Rome and Naples, performed in 1817* (1818), one of the books in the library of J.M.W. Turner which helped to shape his view of 'classic ground':[16]

"What various feelings animated me! What throbs filled my breast, when about to visit the country of the Horatii and Curatii, of Junius Brutus, of Mutius, of Cincinnatus, of Camillus, of Virginius, of Fabricius, of Regulus, of Scipio, of the Gracchi, of Caesar, Cicero, and Seneca, of Brutus, and Augustus, of Virgil, Horace, Ovid, and Quintilian, of the Antonines! What delight to range over the hills of Rome − the Palatine where Romulus was found − the Aventine where the Romans so often made a stand for liberty − the Capitoline where sat an assemblage of gods, as the Roman Senate has been described."

The predictability of this catalogue in its almost claustrophic bareness must have been part of its appeal to a certain kind of reader, for whom the names required no glossing or translation. The "throb" of the sentimental traveller was produced by this controlled exhibition of cultural security working together with a gratifying sense of recognition and a melancholy intimation of the passage of time. In such responses, the culturally inherited sometimes tended to balance or even outweigh the impressionistic, the visual and the immediate. Writing of Italy, Samuel Rogers claimed that "the memory sees more than the eye", where "memory" must signify a force which is part of a shared culture rather than a faculty so individual and rooted in personal experience as Wordsworthian 'memory'. Sometimes, however, one detects a sense that even this generalized memory could carry its own frictions. Observing the Forum and remembering the differences between the virtues of republican Camillus and the behaviour of the emperors, Shelley exclaimed, "alas, what a contrast of recollections", while Byron suggested that these traces of the past could be confusing or unsettling when he wrote "Rome is as the desert, where we steer/ Stumbling o'er recollections".[17]

Some readers resisted complicity with this classical culture while others felt excluded from its values, which were often interpreted as hierarchical, warlike and aggressively masculine. These critics included the young Blake, for whom the city always remained a distant ideal but who had once planned to study art in Rome following in the footsteps of admired friends and contemporaries such as Romney, Flaxman, Fuseli and Cumberland. Blake believed that Italy was "an Envied Store-house of Intellectual Riches" but his admiration did not prevent

his passionate denunciation of "the silly Greek & Latin slaves of the Sword", his association of Rome with "Empire" or "Tax", and his assertion that "We do not want either Greek or Roman Models" since "The Greek & Roman classics is [*sic*] the Antichrist". Because of their propensity to "War and Dominion", "Rome & Greece swept Art into their maw & destroy'd it", or, as he put it with blunt epigrammatic force, "The Classics! it is the Classics, & not Goths nor Monks, that Desolate Europe with Wars".[18]

The classical was also resisted with unusual force by Lady Morgan, whose experience of Rome was physically immediate and highly critical. Considering the emotional effect of the approach to Rome through "the fearful and continuous waste, which reaches to the gates of the Imperial City", she reported an untraditional reaction: "The heart of the classic traveller throbs high with raptures – the heart of humanity throbs too, but with a far different emotion". Her book pays particular attention to the Tarpeian Rock which was approached "through a dirty yard over piles of rubbish and heaps of manure". It was futile, says Lady Morgan, "to conjure up one classical vibration, to affect one of those *thrills* which vibrate in the hearts of all true Corinnas, when the very sound of the *Tarpeian Rock* meets their ear". She goes on to examine the brutality connected with such "classical recollections", makes comparisons with the English system of execution and, in the name of "every true woman's heart", rejects the "throb of pleasure" and "the affected raptures" excited by such places. This satirical indignation is aimed at 'classical' travellers such as Henry Sass whose emotional identification blinded them to social, political and human realities. At the Mamertine Prison she is equally resistant to the authority of Roman Catholicism: "the combinations of the present and the past give impressions which hurry away the few who, on these classic and holy sites, dare to think and feel for themselves".[19] It is not surprising that her *Italy* infuriated the reviewers almost as greatly as her *France*: not only did she express political views which were uncomfortable and uncompromising, but her reading of the classical was radically feminizing in its refusal to accept the authority of a tradition from which women had been largely excluded and which, in her view, endorsed and perpetuated a system of oppression.

Here the self-indulgent throbs of the sentimental traveller are corrected by the better regulated heart-beat of the true humanitarian, secure in her belief that sometimes an 'unlearned' female has a surer instinct than an unthinking classicist.

Rome was not only a source of contradiction to those who were uncomfortable with the classical tradition, but its complexities presented themselves in many other forms. An interesting but slightly unusual case is that of William Hazlitt, who complained that the visitor to Rome was "for the most part lost in a mass of tawdry, fulsome *common-places*":[20]

"It is not the contrast of pig-styes and palaces that I complain of, the distinction between the old and the new; what I object to is the want of any such striking contrast, but an almost uninterrupted succession of narrow, vulgar-looking streets, where the smell of garlick prevails over the odour of antiquity, with the dingy, melancholy flat fronts of modern-built houses, that seem in search of an owner. A dunghill, an outhouse, the weeds growing under an imperial arch offend me not; but what has a green-grocer's stall, a stupid English china warehouse, a putrid *trattoria*, a barber's sign, an old clothes or an old picture shop or a Gothic palace, with two or three lacqueys in modern liveries lounging at the gate, to do with ancient Rome?"

As for the ancient city, Hazlitt conceded the claims of the Colosseum, the Pantheon and the Arch of Constantine but qualified his admiration by noting with critical emphasis that Rome was "great only in ruins". For him the city was disappointing because it conflicted with "the Rome which I expected to see", the eternal city of the European imagination. In contrast Hazlitt was satisfied by the picturesque beauty of Ferrara where "no sordid object intercepts or sullies the retrospect of the past"; this "classic vestige of antiquity" was not "degraded and patched up like Rome with upstart improvements, with earthenware and oil-shops".[21]

The tone of Hazlitt's pungent and provocative resistance is rivalled by that of Lady Morgan but her criticism is animated by a wider set of contrasts and a different set of objectives. Where Hazlitt laments the absence of the ideal, Lady Morgan often takes a malicious pleasure in demystifying the classical by enforcing comparisons. The Capitol, "the nucleus of Roman

glory, the centre of the universe" is "scarcely larger than the usual space allotted for the lantern-house and dusty garden of a London citizen". Not only is there a corrective contrast between the received image and historical reality, but the attritional process of time has produced an architecture of ironies whose moral is easily deciphered:[22]

"… her few imperfect ruins rise amidst mounds of rubbish – the monuments of her crimes and her corruption, of her degradation and slavery – the structures of her worst days under the empire of her tyrants! Even sites have changed their aspects. The paradise of Latium (the Latium of Virgil and of Pliny), is an infected desert; Lavinium is the tomb of its famished inhabitants; and the port of Ostium, a nest of pestilential caverns, the dens of galley-slaves, and the asylum of murderers."

Lady Morgan is as hostile to the Roman Catholic Church as she is to the Roman Empire, and she enforces a further moral in her acid observation of the contrast between the beauty and magnificence of St Peter's and the images of misery, disorder and degradation which mark all its avenues of approach and "are the elements out of which its grandeur sprang":[23]

"… every narrow avenue is thickly colonized with a race of beings marked by traits of indigence or demoralization; and every dark dilapidated den teems with a tenantry, which might well belong to other purlieus than those of the church. It is thus that the altars of St. Peter's are approached, as they were raised, upon the *necks of the people*. Here the streets of the filthiest city in Europe are found filthiest!"

The recording of such contradictions is deliberately adversarial. Lady Morgan enforces a brutal contrast between the architectural splendour of the Pantheon and its present appearance as "an old clothes-shop", its "pavement, sprinkled with blood and filth", exhibiting "the entrails of pigs, or piles of stale fish". She rejects Eustace's claim that modern Rome had communicated to Europe "those greatest blessings of which human nature is susceptible – civilization, science, and religion"; instead, she sees the city as "the *immondezzaio* [rubbish dump] of that world, of which she was once the mistress".[24]

A further set of contrasts can be found in Shelley's correspondence. After his first, brief, visit to Rome in December 1818, Shelley reported his difficulty in coming to terms with first-hand experience of Italy. Writing to his friend Leigh Hunt, whose knowledge of Italy was still based exclusively on the evidence of art and literature, he offered a disturbing map which gave expression to a sense of division both in Italy and also perhaps in himself:[25]

"There are two Italies; one composed of the green earth & transparent sea and the mighty ruins of antient times, and aerial mountains, & the warm & radiant atmosphere which is interfused through all things. The other consists of the Italians of the present day, their works & ways. The one is the most sublime & lovely contemplation that can be conceived by the imagination of man; the other the most degraded disgusting & odious."

Here Shelley appropriates a formula which had been used by Chateaubriand to distinguish between classical and papal Italy and applies it to suggest another kind of fracture which seemed painfully evident to many travellers. His contempt for modern Italians is partly the result of an English difficulty in coming to terms with alternative mores and an alternative lifestyle.

The existential and moral challenge is further explored in one of his travel letters to Peacock where Shelley provides a picture of contemporary Rome which moves from precise but evocative description to despairing analysis:[26]

"In the square of St. Peters there are about 300 fettered criminals at work, hoeing out the weeds that grow between the stones of the pavement. Their legs are heavily ironed, & some are chained two by two. They sit in long rows hoeing out the weeds, dressed in party-coloured clothes. Near them sit or saunter, groupes of soldiers armed with loaded muskets. The iron discord of those innumerable chains clanks up into the sonorous air, and produces, contrasted with the musical dashing of the fountains, & the deep azure beauty of the sky & the magnificence of the architecture around a conflict of sensations allied to madness. It is the emblem of Italy: moral degradation contrasted with the glory of nature & the arts."

Shelley's "moral degradation" is both a critique of the institutions of power and a disgusted response to the condition of

"fallen Italy", whose "filthy modern inhabitants" were equal to neither the high achievements of the past nor the political challenge of the present. The chain gang (which may have inspired a metaphysical passage in *Prometheus Unbound*) is well attested by other witnesses. According to Mary Shelley, they were "propping the Coliseum & making very deep excavations in the forum"; Lady Morgan (who, like Mary Shelley, identified them as "galley-slaves") noticed them during her tour in 1819–20, while in 1826 Hazlitt observed chained convicts in "striped yellow and brown dresses in the streets of Rome".[27]

Such intimations that Rome might challenge or destabilize the observer through its discords or contradictions had caused Goethe to acknowledge it as *das gestaltverwirrende Rom* (form-confusing Rome) in a formulation suggesting both the fragmented appearance of the city and many of its monuments [see cat. 4] and the difficulty of relating it to any systematic intellectual model of interpretation. The lack of unity so strikingly captured by some of Piranesi's *Vedute* [see fig. 8 and cat. 3] with their contrasts of ancient and modern and their vast empty spaces seemed to resist any straightforward reading. Such an apparent chaos of juxtapositions and conflicting forces would later exercise its unsettling effect on fictional travellers of the Victorian period such as Clough's Claude in *Amours de Voyage* (1858*)* and Dorothea Brooke in George Eliot's *Middlemarch* (1871–72*),* a Victorian heroine whose Roman experience can be dated to approximately 1830. Romantic travellers sometimes attempted to cope with these complexities by favouring one of its polarities – ancient rather than modern, Roman rather than Roman Catholic, republican rather than imperial, past rather than present. The difficulties of negotiating such a relationship were accorded iconic expression in the Fourth Canto of Byron's *Childe Harold,* which oscillates between the positive and the satirical, the sentimental and the cynical, in its reading of Roman ruins and the compressed page of Roman history which they encode. Byron claims for the city of his soul a universal and idealized status closely connected to a sense of vanished power and to the collapse of civilizing order, which involves the observer himself in the stratified debris of history:

That page is now before me, and on mine

His country's ruin added to the mass
Of Perish'd states he mourn'd in their decline,
And I in desolation: all that *was*
Of then destruction *is*; and now, alas!
Rome – Rome imperial, bows her to the storm,
In the same dust and blackness, and we pass
The skeleton of her Titanic form,
Wrecks of another world, whose ashes still are warm.

Byron's own inability to distance himself from this network of historical connection may be related to his recurrent Whiggish tendency to use the ruins of Rome as a moral for the instruction of contemporary 'Albion'. Yet even such pragmatic possibilities are compromised by intimations of something more troubled, less easily soluble. The complex images of his stanza present the dark epiphany of a traveller who has lost that positive sense of coherence and connection which animated writers like Sass. This experience is suggestively if negatively related to what James Buzard has called "saturation", that sense that a setting is "so densely 'saturated' in historical and emotional significance that each step of the ground seems able to evoke the most powerful feelings".[28] This rewarding sensation is illustrated by Anna Jameson's *Diary of an Ennuyée* (1826) which presents Rome as a place "where it is impossible to move a step without meeting with some incident or object to excite reflection, to enchant the eye, or interest the imagination".[29] But such apparent richness could easily transform itself into a sense of satiety: "the Roman Forum, in all its majesty of desolation, starts upon the view, fills the mind, and saturates the imagination even to surfeit".[30] Romantic travellers were recurrently conscious of their footing as they trod on the remains of the past. So in *Childe Harold* the density is not so comforting; the evidence of the past is just as treacherous to the step and as elusive of interpretative purchase as the sites of the ruins themselves:

Cypress and ivy, weed and wallflower grown
Matted and mass'd together, hillocks heap'd
On what were chambers, arch crush'd, column strown
In fragments, chok'd up vaults, and frescos steep'd
In subterranean damps, where the owl peep'd,

Deeming it midnight: – Temples, baths, or halls?
Pronounce who can; for all that Learning reap'd
From her research hath been, that these are walls –
Behold the Imperial Mount! 'tis thus the mighty falls.

In some ways Rome itself was a dictionary of quotations, a shifting and allusive text which could puzzle or even alienate. It was difficult to achieve a proper understanding of such confused and imperfect evidence with its recessions of absence. In this mood Byron seems to despair of the advances in historical understanding which were noted by de Staël as one positive response to the prevailing sense of chaos and of death. The "Severe research" which Wordsworth was to regret in his later sonnets on Niebuhr and Roman history was compromised, or at least ironically qualified, by Byron's recognition that accurate interpretation is intermittent and inconsistent, if not illusory:

The double night of ages, and of her,
Night's daughter, Ignorance, hath wrapt and wrap
All round us; we but feel our way to err:
The ocean hath his chart, the stars their map,
And Knowledge spreads them on her ample lap;
But Rome is as the desert, where we steer
Stumbling o'er recollections; now we clap
Our hands, and cry 'Eureka!' it is clear –
When but some false mirage of ruin rises near.

Behind much of the Italian Canto of *Childe Harold* there is a dissolving sense of the authority and presence of death which is expressed by the Colosseum, "This long-explored but still exhaustless mine/Of contemplation" (1150–51). This "enormous skeleton" (1281) at the heart of the city signals the power of Rome while its bony anatomy is an inescapable reminder of the passage of time. Whatever its attractions, and whatever the force of its cultural and historical associations, Rome recurrently evoked in its visitors a pervasive sense of mortality which was sometimes sentimental or nostalgic but which could be gothic, haunting or oppressively immediate.[31] Such constant signs of death could not easily be separated from fear of illness, and particularly the dangers of malaria which were a constant worry to all travellers. Those who approached the city across the Campagna encountered a "fearful and continuous waste", "the tomb of those who might venture to inhabit it".[32] The signs of destruction were everywhere: "None of the movement which belongs to the approach of a great city, distinguishes the proximity of that once greater than all".[33] The Protestant Cemetery, which was a regular part of the itinerary for many tourists, and where Keats and Shelley were to be buried, provided eloquent documentary evidence of the fragility of human life. In November 1819 Shelley wrote anxiously to the Irish painter Amelia Curran, who had probably painted the portrait by which he is best known (based on Guido Reni's portrait of Beatrice Cenci) when they were neighbours in Via Sistina, and who had reportedly suffered an attack of malaria: "It [Rome] is more like a sepulchre than a city; beautiful, but the abode of death".[34] Amelia Curran would have known that this epigrammatic judgement was forged by the pressure of personal experience and reflected the loss of the Shelleys' son William to malaria earlier in the summer, an event which precipitated their own departure from "the pestilential air of Rome"[35] and which in due course left its traces on *Adonais*. Sometimes the literal was easily translated into the metaphorical. In his essay on "English Students at Rome" (1826) Hazlitt asserted provocatively: "There is a species of *malaria* hanging over it, which infects both the mind and the body". The larger context of Hazlitt's argument makes it clear that in his view the intellectual atmosphere of Rome was not a favourable environment for aspiring modern artists since it was inimical to creativity: "There is a languor in the air; and the contagion of listless apathy infects the hopes that are yet unborn". The anxiety of influence and the negative effects of authority too passively received turned Rome not into a source of inspiration, but into a cemetery of the artistic: "Rome is the very tomb of ancient greatness, the grave of modern presumption".[36] Lady Morgan was less interested in artistic potential than was Hazlitt, but in her polemic against the dangers of certain kinds of classicism she also employed the metaphor of sickness and death. For example, she claimed that "even the most Gothic traveller, with a mind steeped deepest in Romanticism" was influenced by associations "which render Rome a subject of suspicion to all who dread the infection of pedantry, the epidemia of pretension". [37]

Sometimes the pervasive presence of death was given local particularity in the form of a funeral procession:[38]

"Every hour there passed through the streets of Rome the veiled, white-clad brotherhood that escorts the dead to church: it is as if ghosts bear the dead, who lie on a kind of litter, their faces uncovered, with only a pink or yellow satin cloth thrown over their feet; and children often amuse themselves playing with the icy hands of the person who is no longer alive."

This spectacle "at once terrifying and ordinary" was the result of a contagious malady which had spread fatally through two households but here, as elsewhere in Romantic writing, the funereal resonance suggests a significance which may carry wider social implications. Writing in 1814, Samuel Rogers was engaged in providing an account of "perhaps the richest view of a Metropolis in the World" (supported by a quotation from Milton) when he is interrupted by the tolling of the *suono dei Morti*; this introduces a passage in parentheses which records the funeral of the Marchesa de Caligula, "her body uncovered on a golden bier" accompanied by white dresses and umbrellas, a procession which soon is "gone like a dream".[39] Experiences like this must have informed 'A Funeral', one of the numerous short poems out of which Rogers later constructed the panoramic perspectives of *Italy*. 'A Funeral' focusses on Italian mourning rituals and includes a description of a funeral procession, "The living masked, the dead alone uncovered". Faced by such unfamiliar and disturbing practices, the poet reflects that encounters with the "Spectre" of Death in "a foreign clime" carry an emotional charge of particular potency:

> His form and fashion here
> To me, I do confess, reflect a gloom,
> A sadness round; yet one I would not lose;
> Being in unison with all things else
> In this, this land of shadows, where we live
> More in past time than present, where the ground,
> League beyond league, like one great cemetery
> Is covered o'er with mouldering monuments;
> And, let the living wander where they will,
> They cannot leave the footsteps of the dead.

The generalizing interpretation reminds us that for Rogers, as for many of his contemporaries, the morbidity of Rome reflected a condition which could be observed in all parts of Italy. For Shelley, Florence was "the ghost of a republic". The associations of Venice are powerfully present in Byron and Shelley and are suggestively compressed in the image of the gondola, that "funereal bark" which had already evoked the coffin and the hearse for observers in the late eighteenth century; such signs of mortality had acquired greater significance and force with the extinction of the Venetian Republic lamented in Wordsworth's celebrated ode. For those who made the journey to Naples, "the city disinterred" of Pompeii raised troubling questions of death and resurrection. The "land of shadows" was also a land of ghosts. This spectral existence compounded a sense of the haunting and inescapable presence of the past and a recognition of the insubstantiality of the present. Writing from Naples in January 1819, Mary Shelley recorded a distaste for contemporary Italians which matches that of her husband, but which is here given a particular edge by her choice of image:[40]

"The Italians are so very disagreeable... – There is no life here – They seem to act as if they had all died fifty years ago, and now went about their work like the ghostly sailors of Coleridge's enchanted ship – except indeed when they cheat."

Like many images of Italy at this period, this response was partly driven by a feeling of political frustration. Mary Shelley's ghostly crew have much in common with their Greek contemporaries as observed by Byron and other philhellenic travellers in the years before the War of Independence.

The sense of death was accorded particular emphasis in *Corinne* which conducted its readers through the cities of Rome, Naples and Venice and which posited a philosophy for encounters with the dead. The heroine is a poet, an *improvvisatrice* whose status is publicly recognized when she is crowned on the Capitol in a scene which left its mark on aspiring woman writers, both poets and novelists. Corinne marks the occasion by delivering an improvisation on "The Glory and Bliss of Italy" in which she celebrates the achievements of the Italian past and the fostering influence of an environment in

which "sense impressions blend with ideas". But her rapturous patriotic ode appears to modulate to a darker tone when she introduces the subject of "death in the midst of celebration":[41]

"Elsewhere there is scarcely room for the rapid race and passionate desires of the living. Here the ruins, the barren ground, the empty palaces, leave vast spaces for the ghosts to walk. Is Rome not now the land of tombs!... All these wonders are monuments to the dead. Our idle life is scarcely noticed; the silence of the living is a tribute to the dead: they endure and we pass on."

Corinne restores the balance she has disturbed by suggesting a healing perspective:[42]

"Perhaps one of Rome's secret charms is that she reconciles the imagination to the long sleep of the dead. Here is resignation for the self and less pain for those one loves. The southern peoples picture death in less sombre colours than those who dwell in the north. Like glory, the sun warms even the tomb.
Under this beautiful sky, frightened spirits are less hounded by the chill and solitude of the grave along with so many funeral urns. It seems as if a crowd of ghosts awaits us; and from our lonely city to the city underground, the transition seems rather gentle."

The immediate occasion of this reconciling philosophy is the presence of Oswald, the Scottish nobleman who becomes Corinne's lover and who may be roughly approximated with British interests in the larger political allegory which underlies the novel, according to which Corinne herself (though half-English by birth) can be equated with Italy. At a later stage in their relationship Corinne takes Oswald on a conducted tour which she concludes by referring to "the pleasures of research" and noting that in Rome "there are many distinguished men concerned only with discovering new relationships between history and the ruins". Oswald responds by enthusiastically endorsing the value of this kind of archaeological enquiry: "It is as if you bring back to life what you discover, as if the past reappears beneath the dust that is buried in it". The didactic narrator also proposes an approach to the reading of ruins which is not constrained by those "moral principles" and that "sense of

justice" which had inhibited Oswald, but which is informed by imaginative insight:[43]

"No doubt all these modern buildings mingled with the ancient debris are intrusive; but a portico standing beside a humble roof, small church windows cut out between columns, a tomb sheltering a whole rustic family, evoke an inexplicable mixture of great and simple ideas, an inexplicable pleasure of discovery which keeps us constantly interested. On the outside, everything about most of our European cities is ordinary, everything is prosaic, and more often than any other, Rome offers the mournful sight of poverty and degradation. But suddenly a broken column, a half-wrecked bas-relief, stones linked to the indestructible style of ancient architects, remind you that there is an eternal power in man, a divine spark, and that you must never grow weary of lighting it in yourself and of rekindling it in others."

Although de Staël did not write in English, her novel had an immediate European impact and provided a philosophy of ruins which forms a context for both Shelley and Byron. A suggestive point of comparison can be found in their various attempts to come to terms with the presence of the Colosseum. Byron was himself associated with the Colosseum from the moment when Manfred's soliloquy recreated the experience of being alone in the "gladiators' bloody Circus" by moonlight.[44] This somewhat gothic speech with its blue midnight, stars shining through the rents of ruin, watchdog baying and owl's long cry so impressed some of Byron's readers, such as Henry Matthews, that they felt it had usurped any further literary possibilities. But it was only in *Childe Harold* that Byron accorded the Colosseum that extensive poetic treatment which could claim to rival the representations of Piranesi and Turner.

Byron's Colosseum is presented as part of a continuous engagement with contemporary Italy in terms of its history. The description of the Colosseum is the core of Byron's account of Rome just as Rome is the centre of his account of Italy. He is acutely conscious of the connection between tombs and ruins and the state of an Italy still awaiting its independence. The Preface to the final Canto records poignantly how "we ourselves, in riding round the walls of Rome, heard the simple

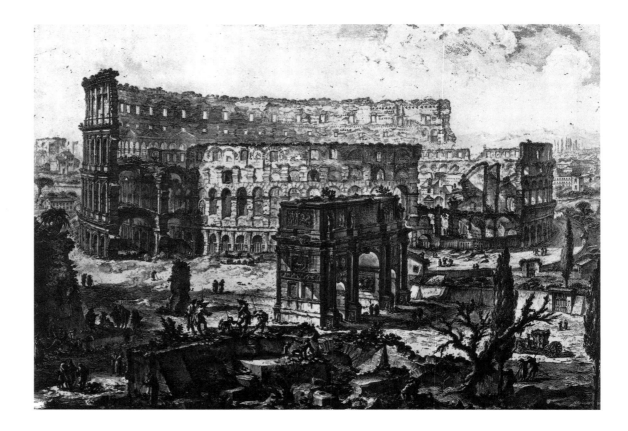

Fig. 8 Giovanni Battista Piranesi, *The Arch of Constantine and the Colosseum*, 1760
Etching, 15 × 21¼ ins (38 × 54 cm), from the *Vedute di Roma* series

lament of the labourers' chorus, '*Roma! Roma! Roma! Roma non è più come era prima*'", a "melancholy dirge" which he contrasts with the "bacchanal roar of the songs of exultation still yelled from the London taverns" at the defeat of Napoleon and the betrayal of better aspirations in the "transfer of nations" by the Holy Alliance. In the face of such universal evidence that Italy was still in a fallen condition, Byron placed particular emphasis on the significance of tombs and sepulchres. In doing this, he was in keeping with Foscolo's *Dei Sepolcri* (1807) which had bravely acknowledged the importance of monuments for the preservation of the national memory. Yet *Childe Harold* recurrently insists on the importance of memory and on the ultimate durability of genius in a way which includes the political but also seems to reach beyond it towards an affirmation of the power of the creative which anticipates Shelley's claims in *Adonais*.

Byron's imaginative interpretation of the Colosseum brings many of these concerns to a sustained but complicated and perhaps contradictory focus. At first he seems to revisit *Manfred* and to suggest a positive reading of the ruins rather in the manner of *Corinne*:

> Arches on arches! as it were that Rome,
> Collecting the chief trophies of her line,
> Would build up all her triumphs in one dome,
> Her Coliseum stands; the moonbeams shine
> As 'twere its natural torches, for divine
> Should be the light which streams here, to illume
> This long-explored but still exhaustless mine
> Of contemplation...

This experience leads him to reflections on human frailty and on the contradictory functions of Time, which is both a "beautifier of the dead" and "an avenger"; in turn, this promotes

a characteristic self-revelation. The poet who had earlier described himself as "A ruin amidst ruins" now recognizes among the tributes to Time identifiable in the Colosseum his own "Ruins of years". Although he remains conscious of "the Roman millions" who once crowded the amphitheatre, the very thought of multitude returns him to himself: "My voice sounds much − and fall the stars' faint rays/On the arena void − seats crush'd − walls bow'd −/And galleries, where my steps seem echoes strangely loud". This is part of an extraordinary process of internalizing or perhaps of self-projection which leads him to concentrate on his own troubled history and to use "the colossal fabric" as a site to enact the dramas of his own psyche, invoke Nemesis and pronounce a curse of forgiveness on his enemies. He concludes by imagining an act of magic which is appropriate to the azure gloom of midnight: "Then in this magic circle raise the dead:/ Heroes have trod this spot − 'tis on their dust ye tread". Yet this magical resurrection remains little more than a rhetorical gesture and Byron's lapse into selfish concerns seems to extinguish any "divine sparks" which had been intimated in earlier stanzas.

Shelley's concern with the Colosseum takes particular shape in two neglected prose pieces which might be related to each other and which could be seen as engaging in dialogue with Byron.[45] The first is a description of the Arch of Titus which has traditionally been included among his essays on works of art but which in fact is a brief, but suggestive, fragment of an unnamed story. This begins by concentrating on the imagery of the two panels which portray the taking of Jerusalem by Titus in AD 67 [see fig. 12 and cat. 3]. On one side is a procession of the victors bearing in their "profane hands" the holy candlesticks, the tables of shew-bread and "the sacred instruments of our eternal worship", and on the other the triumphant emperor standing in his four-horse chariot surrounded by his tumultuous army while magistrates, priests, generals and philosophers are dragged in chains beside his wheels. Images such as this deeply affected Shelley since, rather like the colossal figure of Ozymandias, they represented the icons which power had erected to celebrate its own greatness. The Roman triumph in particular became for him a kind of allegory of power in action: writing of the Arch of Constantine in a letter of March 1819 he exclaimed, "Never

were monuments so completely fitted to the purpose for which they were designed of expressing that mixture of energy & error which is called a Triumph" [see fig. 8].[46]

The Arch of Titus is not, it seems, an enduring monument to the achievements which it celebrates, and the vista of the Colosseum seen through its arch offers an inescapable and ominous emblem of the inevitability of collapse and the ultimate insubstantiality even of the massively substantial:

"This arch is now mouldering to its fall, and the imagery almost erased by the lapse of fifty generations. Beyond this obscure monument of our destruction is seen the monument of the power of our destroyer's family, now a mountain of ruins. The Flavian Amphitheatre has become an habitation of owls and dragons. The power of whose possession it was once the type, and of whose departure it is now the emblem is become a dream and a memory. Rome is no more than Jerusalem."

That the Arch of Titus is now itself almost a ruin is an irony which gains added point from the fact that it triumphantly signals the destruction of the temple at Jerusalem, as if the arch itself were imperially immune from the action of time: "On one side the walls of the temple split by the fury of the conflagration, hang tottering as in the act of ruin". But this ruin within a ruin now points not to the difference but to the similarity between Rome and Jerusalem, indeed between all imperial cities. The biblical language adds another dimension to the irony since the owls and dragons are taken directly from Isaiah's vindictively joyous prediction of the destruction of Jerusalem (34: 13):

"And thorns shall come up in her palaces, nettles and brambles in the fortresses thereof; and it shall be an habitation of dragons, and a court for owls."

Like the poet's voice in *Ozymandias*, Isaiah seems to insist on the durability of ruins, on their permanent value as awful reminders of the final end of human vanity. The biblical moralization at the expense of empire is fairly predictable and can be found, for example, in Eustace's reflections on the Palatine, but in Shelley the irony is more sharply pointed since the narrator who speaks of "the desolation of our City" and "the power of

our destroyer's family" is, like Isaiah, a Jew himself. This witness is not an unidentified traveller as in *Ozymandias* but a citizen of Jerusalem; he has come to the city of the conqueror where he can triumph in the satisfaction of recognizing the processes of time which have brought down the mighty and humbled even the humbler of Jerusalem. It is even possible that he may be the Wandering Jew who haunted the imaginations of the Romantic poets and of Shelley in particular.

Shelley's description of the Arch can be compared with Turner's versions of the same monument [fig. 12, cats. 3–6] which deliberately extract moral significance by altering the topographical facts so as to emphasize a contrast between Roman antiquity and the practices of contemporary Roman Catholicism. Shelley is also concerned with ironical contrasts but he adopts a different angle and the ironies which he enforces are rather different from those of Turner.

The Colosseum which features significantly in this short fragment also provides the central focus of the longer prose fragment which bears its name. An old man and his daughter enter the amphitheatre at noon on the feast of the Passover and sit on one of its broken columns in silent contemplation:

"It was the great feast of the resurrection, and the whole native population of Rome together with all the foreigners who flock from all parts of the earth to contemplate its celebration were assembled round the Vatican. The most awful religion of the world went forth surrounded by emblazonry of mortal greatness, and mankind had assembled to wonder at and to worship the creations of their own power."

A mysterious third figure is now introduced, a presence "only visible at Rome in night or solitude, and then only to be seen amid the desolated temples of the forum, or gliding among the weedgrown galleries of the Coliseum". He has difficulty in conversing with Italians but speaks Latin and especially Greek with fluency and his dress is "strange, but splendid and solemn". He tells the old man and his daughter that "the spectacle of these mighty ruins is more delightful than the mockeries of a superstition which destroyed them". It is not difficult to guess that the mysterious stranger is a time-traveller from antiquity who laments the passing of imperial glory and the substitution of the Christian religion for the worship of antiquity. Mary Shelley, who had a recurrent interest in resurrections and re-animations, began a story on a similar theme called *Valerius: The Reanimated Roman,*[47] in which the central character is miraculously brought to life nineteen hundred years after his death, in a world which he speaks of as "fallen Italy". Although he was a Roman by birth, Valerius now feels that he is in "a strange city with unknown customs", dominated by the alien influence of the Catholic Church. His reaction is to retire to the Colosseum as to a sanctuary which speaks in eloquent silence of the irrecoverable past.

Percy Shelley's story of the ruins is, like that of Mary Shelley, a fragment but enough of it survives to show that it takes a significantly new direction. Although it involves a confrontation between a visitor from classical antiquity and the disagreeable realities of contemporary Rome, its main focus of attention is the blind old man who cannot see the Colosseum but who is able to recreate the scene through the evidence of his other senses and through a kind of intuitive, imaginative sympathy. To his mind's eye the ruined Colosseum is "A nursling of man's art abandoned by his care and transformed by the enchantment of Nature into a likeness of her own creations, and destined to partake their immortality!". This ruin is now indistinguishable from the productions of nature: "Changed into a mountain cloven into woody dells which overhang its labyrinthine glades, and shattered into toppling precipices. Even the clouds intercepted by its craggy summit feed its eternal fountains with their rain". This description, which closely resembles the accounts of the Baths of Caracalla in the Preface to *Prometheus Unbound* and in Shelley's letters, eventually leads the old man to a declaration of faith, which is also an eloquent exposition of the significance and value of ruins:

"It is because we enter into the meditations, designs, and destinies of something beyond ourselves that the contemplation of the ruins of human power excites an elevating sense of awfulness and beauty. It is therefore that the Ocean, the glacier, the cataract, the tempest, the volcano have each a spirit which animates the extremities of our form with tingling joy. It is therefore that the singing of birds and the motion of leaves, the

Fig. 9 Giovanni Battista Piranesi, *The Pantheon, ca.* 1751
Etching, 15¹/₃ × 21¹/₂ ins (39 × 54.5 cm), from the *Vedute di Roma* series

sensation of the odorous earth beneath and the freshness of the living wind around is sweet. And this is Love. This is the religion of eternity whose votaries have been exiled from among the multitude of mankind."

This passionate prose immediately suggests the eighteenth-century endeavour to define the operations of the sublime, to which it is heavily indebted. Yet, quite evidently, the old man's speech is much more than an outburst of aesthetic rapture; it is in the end an affirmation of religious belief arising from an intense experience of the presence of nature in the life and works of man. The "religion of eternity" is in marked contrast both to "the most awful religion in the world" which is celebrating the feast of the Resurrection and to the dark rituals of the Roman state. Whatever its own instabilities, and however much the sentiments might be distanced from a direct Shelleyan affirmation, this reading of the Colosseum seems to discover a positive value in the ruins which can be closely related to the ideas of Corinne and which offers a positive alternative to Byron's more introverted and cynical philosophy. The old man refers to "a circle which comprehends as well as one which

mutually excludes all things that feel". The shape of the Colosseum itself transformed by the agency of nature and the imagination here becomes an image not of human futility but of possible hope. The magic circle is transcended by the circumference of love.[48]

This positive approach to the reading of ruins was undoubtedly shaped by the example of Count Volney, whose visionary study *The Ruins; or a Survey of the revolutions of empires* was one of the four books from which Frankenstein's monster received his extra-mural education. Ruins could be read to signify the essential transience of empire and authority but they could also offer intimations of a more positive kind. It is no accident that *Prometheus Unbound*, Shelley's revolutionary play, was not only influenced by his experience of Roman ruins but represents the overthrow of tyrannical power and the regeneration of man by an architectural vista strongly reminiscent of the *Vedute* of Piranesi [see fig. 9]:[49]

> "Thrones, altars, judgement-seats and prisons; wherein
> And beside which, by wretched men were borne
> Sceptres, tiaras, swords and chains, and tomes
> Of reasoned wrong, glozed on by ignorance,
> Were like those monstrous and barbaric shapes,
> The ghosts of a no-more-remembered fame,
> Which from their unworn obelisks look forth
> In triumph o'er the palaces and tombs
> Of those who were their conquerors, mouldering round.
> These imaged to the pride of kings and priests
> A dark yet mighty faith, a power as wide
> As is the world it wasted, and are now
> But an astonishment; even so the tools
> And emblems of its last captivity,
> Amid the dwellings of the peopled earth
> Stand, not o'erthrown, but unregarded now."

This is the setting for a bloodless revolution and it is significant that the poet who so disliked "the Cimmerian ravines" of cities should choose a Roman setting for the enactment of this momentous change. Rome may have been a desert, a city "girt with its own desolation" but it also provided a more constructive text for those who knew how to read it. It is entirely

appropriate that *Prometheus Unbound* is itself a play which is based on a fragmentary original and in which the imaginative momentum arises from a need to build upon the ruins.

NOTES

1 George Gordon, Lord Byron, *Childe Harold's Pilgrimage*, Canto IV, 694–96 (text cited throughout from Jerome J. McGann (ed.), Lord Byron, *The Complete Poetical Works*, 7 vols., Oxford 1980–93, II, pp. 120–86).

2 Frederick L. Jones (ed.), *The Letters of Percy Bysshe Shelley*, 2 vols., Oxford 1964, II, pp. 181, 85.

3 Jerome J. McGann, 'Rome and its Romantic Significance', in Annabel Patterson (ed.), *Roman Images*, Baltimore and London 1984; reprinted in *The Beauty of Inflections: Literary Investigations in Historical Method and Theory*, Oxford 1985, p. 315. McGann's essay is largely devoted to European engagements with Rome.

4 For Coleridge, see Donald Sultana, *Samuel Taylor Coleridge in Malta and Italy*, New York 1969, pp. 383–84, 390–94; for Mary Shelley, see Marion Kingston Stocking (ed*.), The Journals of Claire Clairmont*, Cambridge, Mass., 1968, p. 100; for Moore, see Wilfred S. Dowden (ed.), *The Journal of Thomas Moore*, 6 vols., London and Toronto 1983–91, I, pp. 246–47.

5 Leslie A. Marchand (ed.), *Byron's Letters and Journals*, 2 vols., London 1973–82, V, pp. 229–30.

6 Patricia Mayer Spacks, 'Splendid Falsehoods: English Accounts of Rome, 1760–1798', *Prose Studies*, vol. 3, 1980, pp. 203–16.

7 Andrew Nicholson (ed.), Lord Byron, *The Complete Miscellaneous Prose*, Oxford 1991, p. 191.

8 Byron, *Letters and Journals*, V, p. 187; Shelley, *Letters*, II, pp. 94, 85.

9 *Letters*, II, p. 59.

10 *Letters*, II, p. 85.

11 Shelley, *Rosalind and Helen* (1819), lines 944–45.

12 *Letters*, II, pp. 59, 68.

13 Thomas Hutchinson (ed.), *The Complete Poetical Works of Percy Bysshe Shelley*, corrected edn., London 1970, p. 588.

14 David V. Erdman (ed.), Samuel Taylor Coleridge, *Essays on His Times in* The Morning Post *and* The Courier, 3 vols., London and Princeton 1978, I, pp. 20–23.

15 *Essays on His Times*, I, p. 312.

16 Cited in Cecilia Powell, *Turner in the South: Rome, Naples, Florence*, New Haven and London 1987, pp. 6–7.

17 Samuel Rogers, *Italy*, London 1830, p. 243; Shelley, *Letters*, II, p. 86; Byron, *Childe Harold*, IV, 726–27; for "recollections" see also *Childe Harold*, IV, 670.

18 G.E. Bentley, Jr., *Blake Records*, Oxford 1969, pp. 27–28; Geoffrey Keynes (ed.), *The Complete Writings of William Blake*, London 1966, pp. 601, 480, 777, 480, 786, 778.

19 Sydney Owenson, Lady Morgan, *Italy*, 2 vols., Paris 1821, II, pp. 307, 308, 320, 322, 329. *Italy* also appeared in French and German in 1821.

20 P.P. Howe (ed.), *The Complete Works of William Hazlitt*, 21 vols., London and Toronto 1930–34, X, p. 232.

21 *Works*, X, pp. 232, 265–66.

22 *Italy*, II, pp. 315–16, 312.

23 *Italy*, II, pp. 348–49.

24 *Italy*, II, pp. 323–24, 326, 324. For Eustace's claim, see *A Classical Tour through Italy*, 4 vols., London 1815, I, pp. 343–44.

25 Shelley, *Letters*, II, p. 67.

26 Shelley, *Letters*, II, pp. 93–94.

27 *Prometheus Unbound*, II, IV, 19-23; Betty T. Bennett (ed.), *The Letters of Mary Wollstonecraft Shelley*, 3 vols., Baltimore and London 1980–88, I, p. 83; Lady Morgan, *Italy*, II, p. 336; Hazlitt, *Works*, X, p. 255.

28 James Buzard, *The Beaten Track: European Tourism, Literature and the Ways to 'Culture' 1800–1918*, Oxford 1993, p. 185f.

29 Cited in Buzard, *The Beaten Track*, p. 185.

30 Lady Morgan, *Italy*, II, p. 327.

31 See Lady Morgan's account of her reactions to the Colosseum: "its beauty and its purport recall some highly wrought urn of precious ore, destined to enshrine the putrid remnants of mortality", *Italy*, II, p. 333. See also Goethe's reaction to Rome: "… the museums and galleries are only Golgothas, charnel-houses, chambers of *skulls* and torsoes – but what skulls etc.!", cited in Nicholas Boyle, *Goethe: The Poet and the Age,* I: *The Poetry of Desire (1749–1790)*, Oxford 1991, p. 437.

32 Lady Morgan, *Italy*, II, pp. 307, 304.

33 Lady Morgan, *Italy*, II, p. 307.

34 Shelley, *Letters*, II, p. 159.

35 Mary Shelley, *Letters*, I, p. 100.

36 Hazlitt, *Works*, XVII, pp. 134, 141, 140.

37 Lady Morgan, *Italy*, II, pp. 310–11.

38 Germaine de Staël, *Corinne, or Italy*, trans. Avriel H. Goldberger, New Brunswick and London 1987, p. 282.

39 J.R. Hale (ed.), *The Italian Journal of Samuel Rogers*, London 1956, p. 212.

40 Mary Shelley, *Letters*, I, p. 85; see Shelley, *Ode to Naples, Lines written among the Euganean Hills.*

41 *Corinne*, p. 30.

42 *Corinne*, p. 31.

43 *Corinne*, p. 65.

44 *Manfred*, III, IV, 1–45; Henry Matthews, *Diary of an Invalid* (1820): "Drove at midnight to see the Coliseum by moonlight; but what can I say of the Coliseum? It must be *seen*; to describe it I should have thought impossible, if I had not read *Manfred*… his description is the very thing itself" (pp. 158–59).

45 Shelley's essays are cited from D.L. Clark (ed.), *Shelley's Prose: The Trumpet of a Prophecy*, corrected edn., Albuquerque, New Mexico, 1966, reprinted London 1988; both fragments have been corrected from the manuscript.

46 Shelley, *Letters*, II, p. 86.

47 Charles E. Robinson (ed.), Mary Shelley, *Collected Tales and Stories*, Baltimore and London 1976, pp. 332–44. See also 'Rome in the First and Nineteenth Centuries', *New Monthly Magazine* X (1824), p. 217f. This anonymous essay has sometimes been attributed to Mary Shelley and bears a suggestive resemblance to *Valerius*.

48 Shelley may also have been influenced by a passage in *Manfred* which provides an alternative to the ultimate cynicism of *Childe Harold*'s reflections on the Colosseum: "And thou didst shine, thou rolling moon, upon/All this, and cast a wide and tender light,/Which soften'd down the hoar austerity/Of rugged desolation, and fill'd up,/As 'twere, anew, the gaps of centuries;/Leaving that beautiful which still was so,/And making that which was not, till the place/Became religion, and the heart ran o'er/With silent worship of the great of old! – /The dead, but sceptred sovereigns, who still rule/Our spirits from their urns" (III, IV, 31–41). Manfred's speech may also have left its traces on *Adonais*. For a suggestive discussion of the dialogue between Byron and Shelley, see Charles E. Robinson, *Shelley and Byron: The Snake and Eagle Wreathed in Fight*, Baltimore and London 1976; for possible instabilities and tensions in Shelley's story, see Timothy Clark, 'Shelley's "The Coliseum" and the Sublime', *Durham University Journal*, Shelley Special Issue, ed. Michael O'Neill, N.S. vol. 54, July 1993, pp. 225–35.

49 *Prometheus Unbound* (1820), III, IV, 164–79, cited from Timothy Webb (ed.), Percy Bysshe Shelley, *Poems and Prose*, London 1995.

Rome portrayed: "to excite the sensibility, and to awaken the admiration of mankind"

M.J.H. LIVERSIDGE

Archibald Alison's *Essays on the Nature and Principles of Taste*, first published in 1790, contains a passage which vividly describes what Rome (and by inference Roman sites and remains generally, especially in Italy) meant to the 'sensible' traveller in the eighteenth and nineteenth centuries:[1]

"And what is it that constitutes that emotion of sublime delight, which every man of common sensibility feels upon the first prospect of Rome? It is not the scene of destruction which is before him. It is not the Tyber, diminished in his imagination to a paltry stream, flowing amid the ruins of that magnificence which it once adorned. It is not the triumph of superstition over the wreck of human greatness, and its monuments erected upon the very spot where the first honours of humanity have been gained. It is ancient Rome which fills his imagination. It is the country of Caesar, and Cicero, and Virgil, which is before him. It is the mistress of the world which he sees, and who seems to him to rise again from her tomb, and to give law to the universe. All that the labours of his youth, or the studies of his maturer age have acquired, with regard to the history of this great people, open at once before his imagination, and present him with a field of high and solemn imagery, which can never be exhausted. Take from him these associations, conceal from him that it is Rome that he sees, and how different would be his emotion!"

The context for this is Alison's discussion of the different effects on the imagination produced by invoking the cultural associations connected with particular objects or places so that they become transfigured in the viewer's mind, arousing thoughts and emotions that are evocatively suggestive. The reference to Rome is used as an example of the way such associations prompt an imaginative response proceeding from the "… delight which most men of education receive from the consideration of antiquity, and the beauty that they discover in every object which is connected with ancient times… There is no man in the least acquainted with the history of antiquity, who does not love to let his imagination loose on the prospect of its remains, and to whom they are not in some measure sacred, from the innumerable images which they bring."[2] What Alison says about the actual prospect of Rome and the physical

right Detail of fig. 11

38

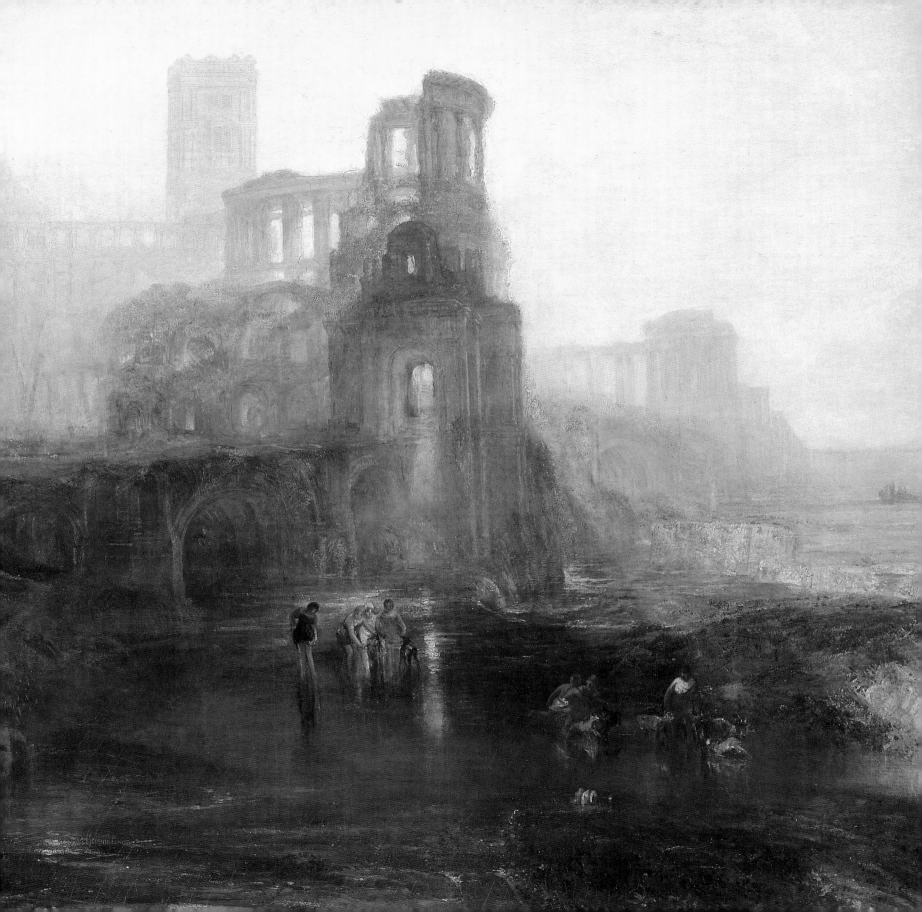

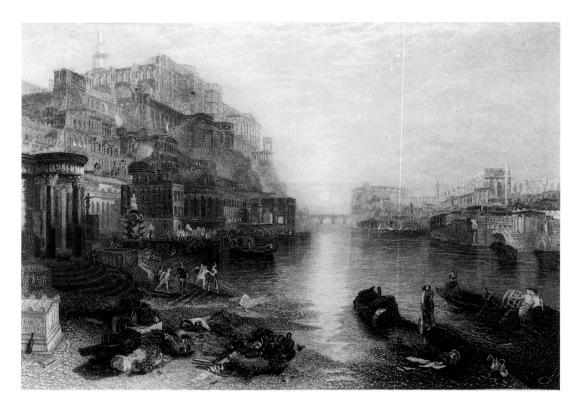

Fig. 10 After J.M.W. Turner, *Ancient Italy: Ovid banished from Rome* Engraving by J.T. Willmore, 1842, after the painting of 1838

remains of antiquity can equally be applied to pictures of them. His book is particularly informative about the sensations and sensibilities with which painted views of Roman subjects were invested by both artists and their audience in the nineteenth century – especially so since his ideas were an important and formative influence on the Romantic vision which received its definitive expression in the period between the 1790s and 1850s when his work was most widely read.

Later in the same book Alison turns his attention to discussing the difference between historical writing and the poetic treatment of history. Here his remarks might be applied to paintings in which the Romantic imagination manifested itself through historical 'reconstruction', as for example it does in pictures like John Martin's *Destruction of Pompeii and Herculaneum* [cat. 15] or *Ancient Italy: Ovid banished from Rome* by J.M.W. Turner [fig. 10]. The point Alison argues is that the poet (and, by analogy, the painter) should capture the imagination by evoking more general effects and creating a suitable atmosphere in order to convey the action and content of a subject, whereas the historian must be confined by the particulars which narrate and expound the detail of events:[3]

"In describing the events of life, it is the business of the historian to represent them as they really happened; to investigate their causes, however minute; and to report the motives of the actors, however base or mean. In a poetical representation of such events, no such confusion is permitted to appear. A representation destined by its nature to affect, must not only be founded upon some great or interesting subject, but in the management of this subject, such means only must be employed as are fitted to preserve, and to promote the interest and sympathy of the reader. The Historian who should relate the voyage of Aeneas, and the foundations of Rome, must of necessity relate many trifling and uninteresting events, which could be valuable only from their being true. The Poet who should attempt this subject, must introduce only pathetic or sublime

events… and must spread over all that tone and character of dignity which we both expect and demand in a composition, destined to excite the sensibility, and to awaken the admiration of mankind."

Essentially, therefore, what Alison advocated was the intervention of the imagination to promote the faculty of feeling: sensation and effect should be deployed so that the reader (or viewer) would respond with both mind and emotions.

Much the same distinction could be made between a view which is merely topographical, that is prosaically descriptive in its accuracy ("the tame delineation of a given spot" as the painter Henry Fuseli defined topography in one of his Royal Academy lectures),[4] and one in which atmosphere and incidental accessories are employed to heighten effect or add associational interest to render a particular scene as it might be experienced by a sensitively informed visitor. These are the properties which perhaps most clearly distinguish the radiant studies and finished watercolours by Turner and Samuel Palmer, for example, from the more conventional drawings of Samuel Prout. But even with paintings and drawings in which the primary purpose is seemingly to record, such as those by Prout, Charles Eastlake and David Roberts, the associations attaching to so many of the places and objects portrayed added an imaginative dimension to the way in which they were viewed. What distinguishes different artists' achievements is perhaps more a matter of technical facility than of intention. In other words, to separate representing Rome from imagining Rome is to make an artificial distinction. In Alison's words, paintings are meant "not only to speak to the eye, but to affect the imagination and the heart".[5]

Another book which also appeared in the 1790s and similarly provides an important source for understanding the various nuances of meaning that views of Rome and Roman remains communicated to the nineteenth-century audience is Count Volney's *The Ruins; or a Survey of the revolutions of empires*, first published in Paris in 1791 and translated into English by 1795.[6] Its popularity is evident from the eleven editions which appeared in England up to 1840. The reading of classical antiquity which it expresses profoundly affected the nineteenth-

century response to ancient remains. The metaphorical and symbolic interpretation of the ruins left behind by great empires it encouraged had a particular resonance in the context of the history and politics of Europe in the aftermath of the French Revolution and Napoleon's empire, and for nineteenth-century Britain its representation of the archaeological legacy of the classical past as a *memento mori* for imperial greatness had an obvious contemporary significance.[7] Reflecting on the ruins of Palmyra, for example, Volney experiences sensations of nostalgia for the grandeur that has decayed to reveal the transitoriness of power and civilization:[8]

"A mournful skeleton is all that subsists of this opulent city, and nothing remains of its powerful government but a vain and obscure remembrance… What glory is here eclipsed, and how many labours are annihilated! Thus perish the works of men, and thus do nations and empires vanish away!"

Volney's *Ruins* combine romantic ideas about the potential of ancient remains to invoke notions of past greatness with moralising thoughts associating ruins with human frailty and transience. In their decay they serve as an emblem to remind the contemporary world of its own vulnerability. As the crumbling remains of antiquity are reclaimed by time and nature they inspire wonder and melancholy reflection.[9] The same ideas are most obviously conveyed in painting when, for example, Turner and Palmer contrast past and present in their *Ancient Rome* and *Modern Rome* pairs [cats. 10–11, 29–30], but they are also implicit in the whole range of picturesque or documentary views and historical reconstructions of Roman subjects (as also of other antique lands and civilizations) which were produced during the first half of the nineteenth century. In Byron's words, they express the thought that "A world is at our feet as fragile as our clay".[10]

The range of literary sources that can be used to reconstruct how people responded to ancient remains in the nineteenth century, and therefore how they 'read' and reacted to them when they were represented in pictures, is vast and varied. Travel books are especially revealing. The demand for these dramatically increased in the years following 1815 when Continental travel resumed again after the Napoleonic Wars.

The eighteenth-century Grand Tour had previously established a long tradition of guidebooks and journals which drew attention to the historical and literary associations of Italy's classical landscape, but between 1793 and 1815, when England was almost continuously at war with France and European travel virtually ceased, few new books appeared. There were one or two exceptions, notably the Reverend John Chetwode Eustace's *A Classical Tour through Italy. An. MDCCCII*, written after a visit made during the brief interlude which followed the Peace of Amiens (1801–02) and first published in 1812. Another was Joseph Forsyth's *Remarks on Antiquities, Arts and Letters during an Excursion to Italy in the years 1802 and 1803*, which appeared in 1813. A second brief flurry of visitors reached Italy in 1814 during Napoleon's abdication and retirement to Elba, but only after 1815 did the number of travellers become a major exodus. Continental touring and the social composition of those who went abroad were very different in the nineteenth century compared with before 1793. Many more tourists now belonged to the middle classes, more women travelled, and gradually as communications improved and places to stay became more plentiful and more comfortable tourism became an ever more popular pastime. By the 1820s there were regular steamer crossings of the English Channel, and by mid-century the railway network made travel much more accessible to a less élite though still cultured public.[11] Travel books correspondingly proliferated. Those which appeared in the first half of the century tend to contain the most suggestively romantic and associational accounts of Roman antiquities and sites.

A characteristic example of the genre is *The Diary of an Invalid* by Henry Matthews from 1820.[12] His observation that "… it is the deeds that have been done, and the men that did them – the Scipios, and the Catos, and the Brutuses – that invest the ruins of Rome with their great charm and interest…" is borne out time and again when he describes the scene before him.[13] Arriving in Rome on 11 December 1817, Matthews noted that "The English swarm every where… It seemed like a country town in England at an assizes". The next day he saw the Forum:[14]

"The Roman forum is now the *Campo Vaccino*, the papal Smithfield; but it is still the finest walk in the world; and I doubt whether, in the proudest days of its magnificence, it could have interested a spectator more than it now does – fallen as it is from its high estate. Nothing can be more striking, or more affecting, than the contrast between what it was – and what it is. There is enough in the tottering ruins which yet remain, to recall the history of its ancient grandeur… Here Horace lounged; – here Cicero harangued; – and here now, the modern Romans count their beads – kill their pigs – cleanse their heads – and violate the sanctity of the place by every species of abomination."

The Palatine Hill, where formerly the Palace of the Caesars stood, "… is now a desert, full of ruins, and fragments of temples, and baths – presenting an awful picture of fallen greatness…" amid fertile market gardens growing cabbages and artichokes.[15] Some days later on the Capitol Matthews recalls from Virgil's *Aeneid* (IX, 448) that the Romans had named it "*Capitoli immobile saxum* … in the pride of their national vanity… But what is now become of their eternal empire…?" and his thoughts turn to recent history: "Heaven be thanked, the bonds of Roman dominion are broken; and it is to be hoped, that any future attempt to revive their plans of universal conquest may be as unsuccessful as the late imitation of them by the French…".[16]

While Rome itself aroused thoughts of past greatness and power, the Roman sites of southern Italy – Pompeii and the scenery of the Bay of Naples – stirred different emotions. Pompeii "… is like a resurrection from the dead; – the progress of time and decay is arrested, and you are admitted to the temples, the theatres, and the domestic privacy of a people who have ceased to exist for seventeen centuries. Nothing is wanting but the inhabitants. Still, a morning's walk through the solemn silent streets of Pompeii, will give you a livelier idea of their modes of life than all the books in the world." What struck Matthews most forcibly at Pompeii was the intimate picture of Roman life it recreated in his imagination – "… even to the skeleton, which was found with a purse of gold in its hand, trying to run away from the impending destruction, and exhibiting 'the ruling passion strong in death' in the last object

Fig. 11 J.M.W. Turner, *Caligula's Palace and Bridge*, 1831
Oil on canvas, 54 × 97 ins (137 × 246.5 cm). Courtesy Tate Gallery, London (Clore Gallery for the Turner Collection)

of its anxiety". Far more of Pompeii had been revealed through excavations than had been visible in the eighteenth century, and the poignancy of its remains made it a particularly popular and affecting place to the visitor: "I lingered amongst its ruins till the close of evening; and have seldom passed a day with feelings of interest so strongly excited, or with impressions of the transient nature of all human possessions so strongly enforced, as by the solemn solitudes of this resuscitated town".[17] Around the Bay of Naples the landscape, with its ruins of ancient villas beside the sea set amid natural beauties described by the Latin poets, was one of the most romantic experiences Italy afforded. Pozzuoli and Baiae were particular favourites, "… where all is fairy ground. Here you may wander about with Virgil and

Horace in your hand, and moralize over the changes that time has produced. How are the mighty fallen! Here the great ones of the earth retired, from the noise and smoke of Rome, to their voluptuous villas. Baiae was the Brighton, the Cheltenham – or, perhaps, with more propriety, the Bath of Rome, for it was a winter retreat."[18]

Moral emblems and metaphors inspired by ancient remains abound in travel books describing Italy. Paintings were invested with the same sentiments. By far the most complex and original pictorial responses to Rome's appeal to the nineteenth-century imagination are to be found in Turner's extraordinary evocations of history distilled from his own experiences of the Italian landscape and the classical sites he visited, reinforced by

the literary influences which he absorbed. Turner's vision of Italy and its Roman past owed much to what he read. By 1819 when he first went there he certainly knew Eustace's *Classical Tour*, Forsyth's *Remarks on Antiquities*, Henry Coxe's *A Picture of Italy, being a Guide to the Antiquities and Curiosities of that Interesting Country* (London 1818) and a book by his friend Henry Sass, *A Journey to Rome and Naples performed in 1817* (London 1818): in all of them the usual connections between ruins and decadence and the conventional contrasts between ancient and modern are made.[19] The most powerful stimulus to his imagination came from the Fourth Canto of Byron's *Childe Harold's Pilgrimage*, published in 1818 and entirely devoted to Italy. The vivid intensity of mood and sensation with which Turner endowed his Italian paintings finds its closest parallel in the Romantic emotions and visual splendours conjured up by Byron.[20]

All these literary impulses, combined with his own imaginative capacity to invent subtle pictorial allusions that impart associative meanings to his compositions, come together in those canvases in which Turner invokes the glories of the past in his most poetically sublime manner. An example is *Caligula's Palace and Bridge* shown at the Royal Academy in 1831 [fig. 11]. The subject, treated here in the most fantastic and fanciful way, is supposed to be the bridge constructed by Caligula across the Bay of Baiae in defiance of a prophecy that his prospect of becoming emperor was as remote as the possibility of his ever driving by chariot from one side of the bay to the other. To achieve the feat, Caligula made a bridge of boats on which he laid a road – but Turner has imagined it differently, as a collection of grandiose ruins that testify to the folly and destructive extravagance of one of history's most notoriously decadent rulers. When the picture was exhibited it was accompanied by some lines of poetry of Turner's own composing (ascribed in the catalogue to his appropriately titled, but never completed, *Fallacies of Hope*):

> What now remains of all the mighty bridge
> Which made the Lacrine lake an inner pool,
> Caligula, but mighty fragments left,
> Monuments of doubt and ruined hopes

> Yet gleaming in the Morning's ray, that tell
> How Baia's shore was loved in times gone by?

The reference to Baiae alerts the reader-viewer to the historical reputation of the place as the resort of supreme dissipation in ancient times, nowhere more censoriously described than by J.C. Eustace:[21]

"Baiae became the receptacle of profligacy and effeminacy, of lust and cruelty, as far beyond the bounds of nature as the power of the imperial monsters was above human control… its retreats defiled by obscenity, and stained with blood, were doomed to devastation… and the most delicious region the sun beholds in his course, is now a desert, and seems destined to expiate in ages of silence and desolation the crimes of the last degenerate Romans."

Turner's painting is an imaginary fantasy created as the vehicle for a meditation upon Rome's downfall; it conjures with historical association in the poetically creative way that Archibald Alison had advocated in his *Essays on the Nature and Principles of Taste*. Its poetry was particularly admired by one of the critics who reviewed the Royal Academy exhibition:[22]

"In *Caligula's Palace and Bridge*, one of the most magnificent and extraordinary productions of the day, how admirably has the artist embodied the conceptions of the poet – Ay, he has done more than embody the conceptions of the poet; the creation of fancy and genius, the picture is full of the breathings of poesy – it is poesy itself. The air tint – the distances – are magical; for brilliancy, and depth, and richness, and power, it can hardly be surpassed."

The allegory is completed by the inclusion of contemporary figures and shipping, and by the sun rising through early morning vapour, to suggest transience and the contrast with modern Italy – themes commonly encountered in the travel books of the period.

Religion was another commonplace feature of travel writing about Rome in the nineteenth century. Two topics in particular are consistently repeated. One is the sanctity of specific sites like the Colosseum where so many Christian martyrs had

perished. Another, reflecting Anglican suspicion of Catholic idolatry, viewed the rituals and superstitions of the modern Roman Church as inherited from pagan practices. Thus the splendours of papal Rome and the religious ceremonies that occurred amid the remains of antiquity could be represented as modern vanities no less spiritually and morally undermining than those of the vanished civilization they had replaced; indeed, Catholicism was to some observers the culprit principally responsible for modern Italy's condition. These views were the subject of an influential book by the Reverend J.J. Blunt published in 1823, *Vestiges of Ancient Manners and Customs, discoverable in Modern Italy and Sicily*, and they recur frequently in later writers. The argument is summarized in the Reverend M. Hobart Seymour's *A Pilgrimage to Rome*, written in 1848 to refute the catholicizing tendencies of the Oxford Movement:[23]

"There are many persons whose tastes and studies have always been allied to the classics. On visiting the present city of Rome, they discern... in all the religious ceremonies and customs of the place, a striking similarity to the ceremonies and customs of the ancient and heathen inhabitants, as striking as that which they find in the walls, the baths, the temples, the arches and other relics of the past. They conceive that the ruins of baths, temples, and arches, are not more certainly the remains of edifices of heathen times, than are the religious ceremonies, opinions and customs of the place, the remains of the religion of heathen times."

Catholic ritual had originated with the appropriation of pagan practices:

"It was the fruitful source, from which issued a large portion of the evils and corruptions that now defile the Church of Rome. Her invocation of saints, her worship of images and pictures, her pomps and ceremonies, and all her priestly vestments, have had their birth in a system which has but changed the name, but not the nature, of the old religion. The things that were worshipped in pagan times under one name, are now in Christian times worshipped under another... The name of Paganism has faded before the name of Christianity; the names are changed; but the religion — the worship - is essentially the same."

Catholicism thus contributed to the conflation of past and present, added a note of continuity, and accounted for the state of modern decline which to many observers was the most enduring lesson Italy had to teach.

Religious associations and sentiments also coloured the response to particular places and monuments in Rome. The Colosseum especially aroused such thoughts. Again Seymour is typical:[24]

"Notwithstanding the wasting process of centuries of decay — notwithstanding the rude and rough vandalism of the northern conquerors — notwithstanding the yet worse barbarism of the Roman nobles of later times, in abstracting the stones from it, as from a quarry, to build their palaces, and notwithstanding the long and unpardonable neglect of the popes, the priests, and monks of Rome — the Coliseum still remains the noblest and most magnificent pile of ruins in that city of ruins. Whether the pilgrim ranges around it, or traverses its broad arena, or ascends its long flights of steps, or circles around its highest ranges, or examines its massive and noble architecture, it presents to the mind, what must be felt to be one of the greatest wonders of the world. And then as he stands and looks down into the arena, and thinks of the scenes so often transacted there; — as he thinks of those gladiatoral fights where the bloodiest butcheries of man by the hands of man, and for the amusement of man, were constantly perpetrated - as he thinks of those sad and fearful times when men, who held the same faith and hope with ourselves, were exposed, for no other crime than love for the Saviour, to the claws of tigers, and the teeth of lions, and there with heroism and fidelity meekly surrendered their lives and proved themselves the truest and the noblest of heroes; as the pilgrim stands above and looks down upon the theatre of such scenes, the darkest tragedies the world has ever gazed on — as he looks down from the crumbling heights, and the grass-grown ruins, he will marvel that a people could exist to take pleasure in such scenes: and he will bless God for having removed the sceptre and broken the power, and scattered the magnificence, of that concentration of brutal tyranny, and of savage cruelty — the empire of Rome."

When painters included religious figures in their depictions

of ancient sites they were not necessarily simply adding incidental details of local character for purely picturesque effect. In one of Turner's most majestic Roman views, the *Forum Romanum, for Mr Soane's Museum*, shown at the Royal Academy in 1826 [fig. 12], the friars beneath the Arch of Titus on the left and the procession of monks in the Forum (passing along the old pagan Via Sacra) may be intended to draw attention to the popular (English) equation of Roman Catholicism and Roman decadence. It is also a magnificent example of how Turner adjusted – with considerable licence – the reality of Rome's topography to a large exhibition performance. There are many discrepancies between the actual configuration of the Forum's remains and their arrangement in the painting: the relationship between reality and imagination is admirably demonstrated, and once again the poetic takes over from the purely descriptive to work its magic on the viewer. It is above all a picture which reveals how Rome could be experienced and imaginatively transformed. Turner, like Byron, is of course exceptional in the visionary intensity he brings to the subject – both painter and poet possessed extraordinarily acute visual sensibilities – but even the more accurately prosaic pictures of Rome by artists like David Roberts or Samuel Prout were capable of eliciting the same subjective sensations that the travel writers manifest in their descriptions.[25]

Poetry exerted a major influence on English perceptions of Rome in the eighteenth and nineteenth centuries. Many of the conventional ideas about symbolic ruins and their associated meanings are already to be found in, for example, John Dyer's *The Ruins of Rome* (1740) and James Thomson's *Liberty* (1748). In these the silent witness of ancient remains to the corruption and luxury that had destroyed the world's greatest empire is emphatically expounded, as well as the political moral for the modern world: liberty and civilization are extinguished when arbitrary power and the pursuit of pleasure take root. Thomson also vividly contrasts the past with the present, though it is republican rather than imperial Rome he uses as his model of virtue to compare with the picture he draws of Italy and the Eternal City as models of contemporary dereliction. Romantic poets expressed the same sentiments, recent history having if anything sharpened their perception of the analogies as first

Napoleon's invasions and occupation of Italy and then the political settlement imposed on the country had left its states impoverished and subdued. Thus in Byron's *Childe Harold's Pilgrimage* the ruins of Rome are symptomatic of history's eternal cycle:[26]

> There is the moral of all human tales;
> 'Tis but the same rehearsal of the past,
> First Freedom, and then Glory – when that fails,
> Wealth, vice, corruption, – barbarism at last.
> And History, with all her volumes vast,
> Hath but *one* page; …

What distinguishes the Romantic poets from their predecessors, though, is the way they describe sensation and communicate feeling. When Byron's Fourth Canto to *Childe Harold* appeared in 1818 it changed the experience of Italy for a whole generation and encouraged a more rhapsodic as well as more profoundly thought-provoking reaction. Less elevating than Byron, but from 1830, when an edition illustrated by Turner was published, almost as popular, was *Italy* by Samuel Rogers.[27] A failure when it had first appeared, the vignettes designed by Turner for the 1830 reissue made it a huge success and influenced many other artists' interpretations of Italian scenery and Roman subjects. Measured against Byron it is no match for his powerful imagination or poetic expression, but nonetheless it impressed on readers from the 1830s through to the end of the century a sensually heightened feeling for the history and beauties of Italy, as a passage from the section on Rome illustrates:[28]

> Thou art in ROME! the City, where the Gauls,
> Entering at sun-rise through her open gates,
> And through her streets silent and desolate,
> Marching to slay, thought they saw Gods, not men;
> The City, that, by temperance, fortitude,
> And love of glory, towered above the clouds,
> Then fell – but, falling, kept the highest seat,
> And in her loneliness, her pomp of woe,
> Where now she dwells, withdrawn into the wild,
> Still o'er the mind maintains, from age to age,
> Her empire undiminished…

Fig. 12 J.M.W. Turner, *Forum Romanum, for Mr Soane's Museum*, 1826
Oil on canvas, 57 ³/₈ × 93 ins (145.5 × 237.5 cm). Courtesy Tate Gallery, London (Clore Gallery for the Turner Collection)

The artists who painted Roman scenes, at least until the middle of the century, were as influenced by the travel books and poetry they read as those who saw their pictures were. Plenty of evidence survives in artists' letters and memoirs to show that their responses to Rome conformed to the standard conventions of the day. Thus Thomas Uwins, for whom modern Rome was "... the city where Superstition sits enthroned, and Blasphemy claims the character of holiness...", found the ancient remains "... the place of so many interesting and so many distressing recollections..."; and at Pompeii it was the daily life and dissipation of the Romans that caught his attention:[29]

"Here are shops which furnish the necessaries of life, theatres for amusement, temples for the worship of the gods, villas and noblemen's houses, with all the contrivances for luxury... and display the awful spectacle of a town suddenly arrested in all the business and bustle of worldly occupations. And it is the more awful because many of the paintings and works of art discovered ... display a moral degradation which cannot be contemplated without pain. Here Cicero spent much of his time, and here the philosophers discoursed on the beauty of virtue. But how little they were able to do in the great work of regenerating their fellow-men! Such licentious things are found painted on the walls... Were it not for these damning proofs of the true

Fig. 13 Charles Eastlake, *Italian scene in the Anno Santo, pilgrims arriving in sight of Rome and St Peter's: Evening*, 1827
Oil on canvas, 32¼ × 41¾ ins (81.9 × 106 cm)
Philadelphia Museum of Art (photograph courtesy Christie's, London)

state of things, there is really something so beautiful in … all the buildings … that a mind delighted with the contemplation of innocence might easily persuade itself that here … a race of beings dwelt who were intellectual, refined and pure."

Other artists whose letters reveal similarly romantic responses include Charles Eastlake and Joseph Severn; Samuel Palmer, on the other hand, barely mentions antiquities except in passing, though he is lyrical about landscape and Italian light.[30]

When William Boxall, a young painter from Oxford, was in Italy from 1833 to 1836 he wrote regularly to his friends and family describing his reactions in terms that are predictably associative and prejudiced, but he also clearly reveals how Turner's vision affected the way Rome and Italy generally were viewed.

"Today I have been … amid the gigantic ruins of the Colosseum in which place the primitive Christians were torn to pieces by lions and tigers, and among the desolated columns of the Forum Romanum. I have seen the triumphal arches of Septimius Severus, of Titus, and of Constantine perishing and decaying – while the same sun that had watched their beginning with his enduring glory was sinking down in his tranquillity and splendour, and gilding their ruin and decay."

On another occasion he writes of how "… the ruins of departed Rome stand like gigantic shadows in a fading dream … A thousand associations crowd upon the mind strangely mixing the grandeur and barbarity of its past inhabitants …": the Colosseum inevitably brought to mind the early Christians and before them the gladiators "… and the Roman ladies who sat

down amid the blood of the combatants to their feasts and rejoicings". In the south the landscape was Turner's: "The glories of the dream are in his works – and his own poetic mind completes and perfects what to the heedless and ignorant traveller is a desolate waste… He is the great Poet of Italy – without his influence it would be a desert."[31]

Many eighteenth-century British artists who went to Italy concentrated on painting the landscape and picturesque antiquities as Grand Tour souvenirs. Others were principally concerned with studying classical art and the great masters in order to perfect their understanding of the grand manner and the rhetoric of history painting. Their nineteenth-century successors naturally carried on the same traditions, but new subjects drawn from contemporary life also appeared. The characters, customs and costumes of the local populations of different states or regions, and the occupations of city, town and countryside were much more extensively described by writers and, especially from the 1820s onwards, frequently occur in paintings. An early example of the genre is M. Bonaiuti's *Italian Scenery: Representing the Manners, Customs and Amusements of the Different States of Italy* (London 1806), which consists of a series of engraved plates accompanied by extended captions. It was not just the colourfully picturesque nature of these subjects which appealed to the British: their representation of modern Italians as simple peasants leading a primitive rural life, or subsisting in urban poverty, observing their religious superstitions or subservient to the Catholic clergy, all confirmed the image of Italian society as inferior, oppressed and impoverished. As time passed the emphasis turned more to the curiosity and enchantment of local character, but still in 1846 when *Pictures from Italy* by Charles Dickens was published the country and its people are portrayed as the victims of centuries of political and ecclesiastical "neglect, oppression and misrule".[32] Thus, when painters like Charles Eastlake, Joseph Severn, Thomas Uwins and Penry Williams first made contemporary Italian subjects popular in the 1820s the reasons why they were successful with the public are not solely to do with their anecdotal or illustrative character. A typical example is Charles Eastlake's *Italian scene in the Anno Santo, pilgrims arriving in sight of Rome and St Peter's: Evening*, painted for the Duke of Bedford and shown at

Fig. 14 Thomas Uwins, *A Neapolitan saint manufactory*, 1832
Oil on canvas, 29 ½ × 34 ins (74.9 × 86.4 cm)
Leicestershire Museum and Art Gallery, Leicester

the Royal Academy in 1828 [fig. 13].[33] The simple piety of the Neapolitan peasants united with a distant view of Rome might be regarded now as no more than a straightforward genre subject, but when it was painted there would have been many who read it as an image of Catholic credulity and of the Roman church as a corrupting influence. Certainly these sentiments are very forcefully expressed in the observations Thomas Uwins made of Italian society, and make it very clear that his picture of *A Neapolitan saint manufactory* (Royal Academy 1832) [fig. 14] is intended to show up the mistaken beliefs and idolatry of Italy's religion.[34] As the Reverend J.J. Blunt had argued in his *Vestiges of Ancient Manners and Customs*, image worship and the veneration of shrines encouraged by the Catholic faith were regarded by virtuous Protestants as a legacy carried on from pagan religion, and the workshop Uwins depicted could be seen as a modern version of its ancient equivalent in which votive offerings for ritual purposes had been similarly mass-produced. Later on tastes changed and the type of painting

Fig. 15 Keeley Halswelle, *The fan seller*, 1869
Oil on canvas, 16 × 24 ins (40.6 × 61 cm)
Corporation of London, Guildhall Art Gallery

Fig. 16 Keeley Halswelle, *The letter writer*, 1869
Oil on canvas, 14¹/₂ × 24 ins (36.8 × 61 cm)
Corporation of London, Guildhall Art Gallery

inaugurated by Eastlake, Uwins and their colleagues evolved into the more sentimentally appealing or anecdotal Victorian vision of Italian life, no doubt reflecting the altered circumstances of tourism in the second half of the nineteenth century – works such as Keeley Halswelle's pair of *The fan seller* and *The letter writer* done in Rome in 1869 [figs. 15 and 16].[35]

Representations of Rome, Italian scenery and contemporary life became progressively popularized over time. The publication of illustrated travel books and collections of picturesque views (such as the *Landscape Annuals* of the 1830s to which topographical artists like Samuel Prout and David Roberts contributed) were largely responsible for the change. Another factor must have been the exhibition of Roman scenes as popular entertainment in London. One especially successful form of visual spectacle enjoyed by a large public in London was the panorama, and from the 1820s until mid-century there were several showing Rome, specific ancient monuments, and sites like Pompeii or the Bay of Naples. These were invariably accompanied by explanatory texts and souvenir pamphlets which explained the historical associations and so educated their audience into reading pictorial imagery and responding accordingly. Robert Burford's panorama of the Colosseum shown in 1839 was described as "… a striking image of Rome itself in its present state… a splendid and a melancholy monument of past greatness". Pompeii was always a popular subject (there were two showing simultaneously in rival establishments in the Strand and Leicester Square in 1824), and Burford's 1845 Bay of Naples was another typical production, exhibiting its scenic beauty and emphasizing the historic landscape:[36]

"A magnificent display of all the pomp of nature and art… which cannot but excite in the spectator… emotions of admiration and delight that border on enthusiasm… Nor is it for its great natural beauty alone that Naples is so justly celebrated… It is of high antiquity, and to the historian abounds in classical recollections and associations, and its vicinity presents numberless ruins of former greatness, and memorials of the crimes and follies of mankind. Poets have sung its praises in all ages; Homer and Virgil here conceived their brightest and most glowing descriptions, and in the Campagna placed their imaginary

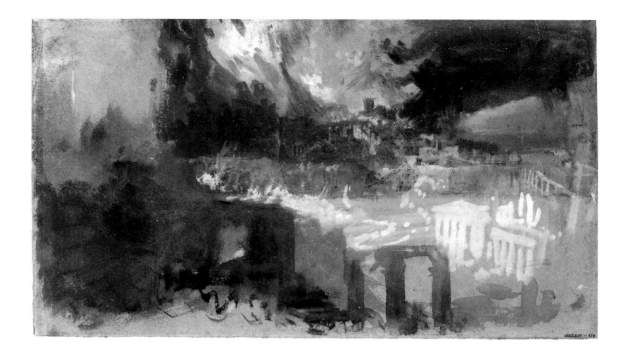

Fig. 17 J.M.W. Turner, *Rome burning, ca.* 1834
Bodycolour on brown paper,
8fi × 14fi ins (21.6 × 36.8 cm)
Courtesy Tate Gallery, London
(Clore Gallery for the Turner Collection)

heaven and hell... the great, the good, the voluptuary, and the sensualist, have at all periods made it their residence."

The reopening of the Crystal Palace on its new site in 1854 provided a further stimulus to popular interest in the ancient world with its historical courts designed by the architect Matthew Digby Wyatt, including a Roman Court and a Pompeiian Court both replete with reconstructions. About the same time photography was just beginning to make its impact and over the years that followed painted views, especially of Rome, changed considerably both in conception and in their connotations for the viewing public.[37] The imaginative emphasis shifted to the kinds of historical reconstruction that Alma-Tadema, Poynter and their contemporaries produced.

For the earlier nineteenth-century artist Rome as subject and idea afforded a rich variety of different approaches and meanings. It was interpreted through correspondences, contrasts and comparisons between its own past and present and with Britain. It was an integral part of British culture, and it exerted a powerful imaginative impulse on British art and liter-ature. Its contemporary resonance persisted through education, and its presence in the consciousness of the time could some-times produce an unexpected response. It seems that this was the case with Turner in 1834 when he witnessed the burning of the old Houses of Parliament. From the vivid sketches he made of the ancient medieval Palace of Westminster consumed by fire he painted two of his most dramatic canvases, the oils now in Cleveland and Philadelphia.[38] At about the same time he was apparently prompted by the experience to make a study in watercolour and gouache of *Rome burning* [fig. 17]. Westminster Palace was the seat of British government, the centre of British empire. Might Turner have imagined a corre-lation between these two events? Would a painting of Nero's Rome burning have made an appropriate pendant to Westminster in flames? His sense of history inclined him to make comparisons between past and present, as he was to do with *Ancient Italy* and *Modern Italy* in 1838 and with *Ancient Rome* and *Modern Rome* in 1839, and as he had done with *Dido building Carthage; or the Rise of the Carthaginian Empire* and *The Decline of the Carthagian Empire* (using history as a metaphor for

Napoleon's imperial rise and fall) in 1815 and 1817 respectively.[39] Perhaps when he sketched *Rome burning* he was thinking of another possible pair to draw a contemporary moral from history. If so, it expressively demonstrates how Rome could connect with the British artistic imagination in the nineteenth century.

In much of what was written about Rome, and consequently reflected in paintings, there can be discerned a paradoxical ambivalence. The spectacle of its ancient remains aroused admiration and wonder, but they also spoke of how a once virtuous republic and mighty empire had become enervated by wealth, luxury and political corruption. The modern Church was no better: its splendid buildings and ceremonies were the ostentatious symbols of repression. This was the view of Rome that visitors habitually brought to mind when they surveyed the city, as Charlotte Anne Eaton did when from the Palatine Hill, surrounded by the ruins of the emperors' palaces, she looked across to St Peter's:[40]

"... standing on these ruins which once contained the despot whom all the nations of the earth obeyed and worshipped – we looked to the Vatican, whose now innocuous thunder once shook Europe and hurled monarchs from their thrones – we thought of the singular destiny of a city that has successively been the temporal and spiritual tyrant of the world; and almost anticipated the day when the papal, like the imperial palace, would lie in ruins, and the dominion of the popes, like that of the emperors, be at an end for ever."

The paintings of Rome done by British artists in the nineteenth century both expressed and invoked the same informing presences and cultural values.

NOTES

1 Archibald Alison, *Essays on the Nature and Principles of Taste*, Edinburgh and London 1790, pp. 28–29. Subsequent editions appeared in 1811, 1812, 1815, 1830 and 1853.

2 *Ibid.*, pp. 27–28.

3 *Ibid.*, pp. 106.

4 John Knowles (ed.), *The Life and Writings of J.H. Fuseli Esq., M.A., R.A.*, 3 vols., London 1831, II, p. 217 (Lecture IV, 'On Invention').

5 A. Alison, *op. cit.* note 1, 2nd edn. 1811, II, p. 128.

6 Count Constantin François de Volney, *Les Ruines, ou Méditations sur les Revolutions des Empires*, Paris 1791 (2nd edn. 1792, 3rd edn. 1799). Translated into English as *The Ruins; or a Survey of the revolutions of empires*, London 1795; further editions were published in 1795, 1796, 1801, 1811 (twice), 1822, 1826, 1833, 1835, 1840, 1878. Commentaries on Volney's work also appeared: D. Simpson, *An essay on the authenticity of the New Testament: designed as an answer to Evanson's Dissonance and Volney's Ruins*, London 1793 and 1795; William Hails, *Remarks on Volney's Ruins*, London 1825; R.J. Rowe, *A Dissertation on the Ruins or Revolutions of Empires; being a critical examination and refutation of 'Remarks on Volney's Ruins' by W.A. Hails*, London 1832.

7 There is a convenient modern edition of Volney: George Underwood (ed.), *The Ruins of Empires by Count Volney ... A Revision of the translation of 1795*, London 1921. For a discussion of Volney and ruin imagery, see Robert Rosenblum, *Transformations in Late Eighteenth Century Art*, Princeton 1967, pp. 112–19.

8 G. Underwood (ed.), *The Ruins ... by Count Volney*, London 1921, p. 3.

9 *Ibid.*, p. 5: "Who ... can assure me that their present desolation will not one day be the fate of our nation?"

10 George Gordon, Lord Byron, *Childe Harold's Pilgrimage* (1812–18), Canto IV, 702.

11 For an account of early nineteenth-century Italian travel, see J.R. Hale (ed.), *The Italian Journal of Samuel Rogers*, London 1956, pp. 56–99 ('English Travellers in Italy 1814–1821'). For the later period, the fullest account is John Pemble, *The Mediterranean Passion: Victorians and Edwardians in the South*, Oxford 1987.

12 Henry Matthews, *The Diary of an Invalid. Being the Journal of a Tour in pursuit of health in Portugal, Italy, Switzerland and France in the Years 1817, 1818 and 1819*, London 1820. The popularity of this book is evident from the frequency with which it was reissued: the references which follow are from the edition of 1825 published in Paris.

13 *Ibid.* (Paris 1825), p. 183.

14 *Ibid.*, pp. 56–57.

15 *Ibid.*, p. 58.

16 *Ibid.*, pp. 128–29. I am grateful to my colleague, Charles Martindale, for identifying the reference to Virgil.

17 *Ibid.*, pp. 145–51.

18 *Ibid.*, p. 163.

19 Turner's literary sources are discussed by John Gage, 'Turner and Stourhead: the making of a classicist', *Art Quarterly* XXXVIII (1974), pp. 59–87, and in Cecilia Powell, *Turner in the South. Rome, Naples, Florence*, London 1987. Kathleen Nicholson, *Turner's Classical Landscapes. Myth and Meaning*, Princeton 1990, examines the whole range of Turner's uses of themes from antiquity.

20 See David Blayney Brown, *Turner and Byron*, London (Tate Gallery) 1992, for a comprehensive account of the subject.

21 J.C. Eustace, *A Classical Tour through Italy*, London 1813, pp. 567–68.

22 *La Belle Assemblée*, June 1831, p. 288 (quoted by K. Nicholson, *op. cit.* note 19, p. 252).

23 The Rev. M. Hobart Seymour, *A Pilgrimage to Rome*, London 1851 (4th edn.), pp. 471–74.

24 *Ibid.*, pp. 142–43.

25 For an extended discussion of Turner's *Forum Romanum*, see Cecilia Powell, *op. cit.* note 19, pp. 56–57 and 121–26.

26 Lord Byron, *Childe Harold's Pilgrimage*, Canto IV, 964–69.

27 For Rogers and Turner, see Mordechai Omer, *Turner and the Poets*, London (Marble Hill House, Twickenham) n.d., and C. Powell, *op. cit.* note 19, pp. 131–36.

28 S. Rogers, *Italy. A Poem*, 'Rome', lines 23-33.

29 Mrs (Sarah) Uwins, *A Memoir of Thomas Uwins, R.A. With Letters to his brother during seven years spent in Italy*, London 1858, pp. 111 and 229 (Rome), 249–50 (Pompeii). Uwins was in Italy 1824–31.

30 Lady Eastlake (Elizabeth Rigby), 'Memoir of the Life of Sir Charles Eastlake' in C.L. Eastlake, *Contributions to the Literature of the Fine Arts*, London 1870; David Robertson, *Sir Charles Eastlake and the Victorian Art World*, Princeton 1978; William Sharp, *Life and Letters of Joseph Severn*, London 1892; Raymond Lister, *The Letters of Samuel Palmer*, Oxford 1974, and Edward Malins, *Samuel Palmer's Italian Honeymoon*, Oxford 1968.

31 Quotations are from unpublished letters of 7 December 1833, 7 January 1834 and 12 June 1834 respectively (M.J.H. Liversidge collection).

32 The book was hugely successful, the first edition of 6000 copies selling out within weeks of publication; it and the second edition, also 1846, included four illustrations by Samuel Palmer. See the modern edition with an introduction and notes by David Paroissien (Charles Dickens, *Pictures from Italy*, London 1973).

33 Sold at Christie's, London, *British Pictures*, 11 November 1994, lot 25.

34 See Mrs (Sarah) Uwins, *A Memoir of Thomas Uwins, R.A.*, London 1858; Samuel Palmer's letters from Italy also contain numerous references to religious iniquities.

35 See *The Victorian Vision of Italy 1825–1875*, Leicester Museums and Art Gallery, 1968, for a useful general survey of the subject.

36 Robert Burford, *Description of a view of the city and bay of Naples, by moonlight, with an eruption of Mount Vesuvious: now exhibiting at the Panorama, Leicester Square*, London 1845.

37 *Rome in Early Photographs. The Age of Pius IX. Photographs 1846–1878 from Roman and Danish Collections*, Copenhagen (Thorvaldsen Museum) 1977.

38 Katherine Solender, *Dreadful Fire! Burning of the Houses of Parliament*, Cleveland Museum of Art, Cleveland, Ohio, 1984.

39 National Gallery, London, and Tate Gallery, London. For Turner's interpretation of Carthaginian history in the context of recent European events, see K. Nicholson, *Turner's Classical Landscapes*, Princeton 1990, pp. 103–10.

40 Charlotte Ann Eaton, *Rome in the Nineteenth Century. A Complete Account of the Ruins of the Ancient City, the Remains of the Middle Ages, and the Monuments of Modern Times; with Remarks on the Fine Arts, on the State of Society, and on the Religious Ceremonies, Manners and Customs, of the Modern Romans. In a Series of Letters written during a residence in Rome in the Years 1817 and 1818*, 3 vols., London 1823 (3rd edn.), p. 232. The first edition (when the author was Miss C.A. Waldie) appeared in 1820. Charlotte Eaton's is one of the most comprehensive accounts of Rome, and was much read until the mid-century; a fifth edition was issued in 1852.

Recreating Rome in Victorian Painting: From History to Genre

ELIZABETH PRETTEJOHN

right Detail of fig. 23

In the Victorian period, the tradition of painting the heroic deeds of Roman history dwindled to extinction, while pictures of everyday life in the ancient Roman world proliferated. In terms of the traditional hierarchy of pictorial categories, this meant a drastic devaluation of Roman subject-matter from history painting, at the summit of the hierarchy, to the humble category of genre painting. This shift has ordinarily been attributed to the expansion of patronage and audiences for art in nineteenth-century Britain. It is assumed that the Victorian middle classes, lacking a traditional classical education, were incapable of understanding the recondite subjects of Roman history painting; aware, nonetheless, of the high cultural status of classical antiquity, they favoured scenes of ancient everyday life that required no special erudition to comprehend.

This interpretation had begun to appear before Roger Fry's attack of 1913 on the most famous Victorian painter of Rome, Lawrence Alma-Tadema, but Fry's memorable words did much to establish it as an orthodoxy for the twentieth century. As Fry claimed, the art of which Alma-Tadema was the leading practitioner "finds its chief support among the half-educated members of the lower middle-class":[1]

"His art, therefore, demands nothing from the spectator beyond the almost unavoidable knowledge that there was such a thing as the Roman Empire, whose people were very rich, very luxurious, and, in retrospect at least, agreeably wicked. That being agreed upon, Sir Lawrence proceeded to satisfy all the futile inquiries that indolent curiosity might make about the domestic belongings and daily trifles of those people."

Fry's belittling phraseology served his polemical purpose in 1913, when he was attempting to lead British taste in a new direction. Accordingly, he did not acknowledge that attention to the "domestic belongings and daily trifles" of the ancient Romans was part of a nineteenth-century revaluation, not merely of previous pictorial conventions for representing Roman antiquity, but of the assumptions underlying the high status of Rome in the traditional hierarchy of genres. As this essay will argue, the decline in Roman history painting was no cowardly retreat from a category too sophisticated for Victorian audiences, but a systematic rejection of the notion that the

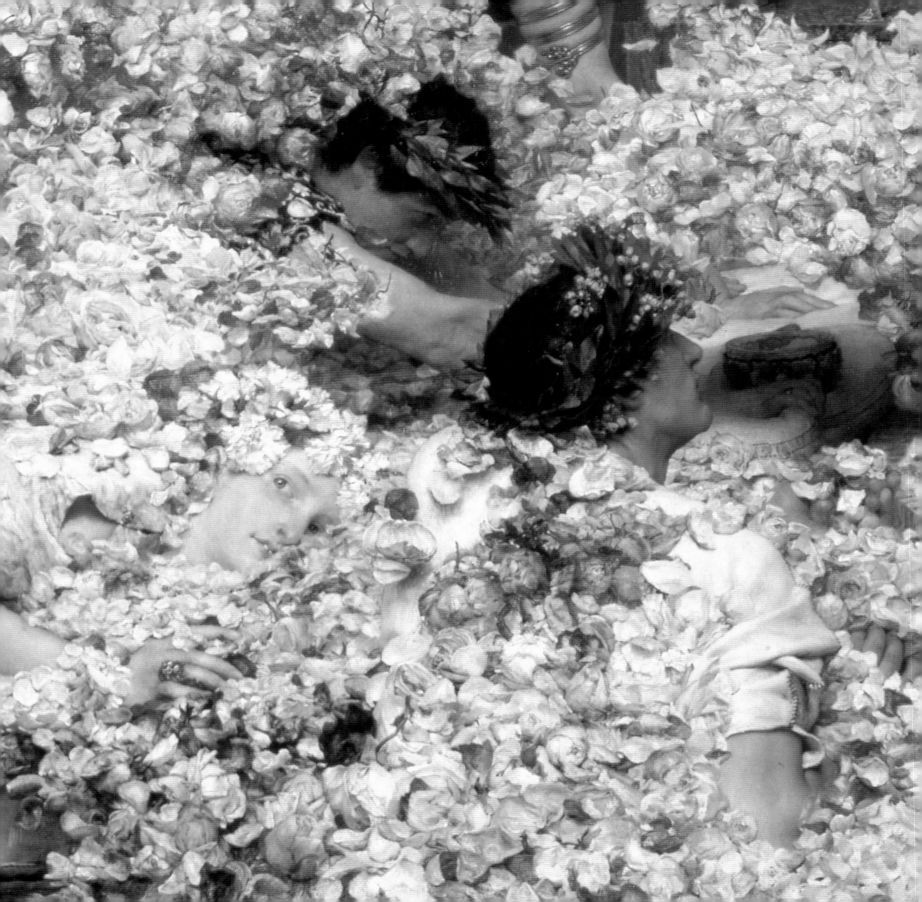

deeds of the Romans could serve as moral exemplars for the modern world.

The substitution of the minutiae of everyday life for the great deeds of heroes was closely linked to the nineteenth century's new approaches to historiography, including the expansion of classical scholarship into new areas such as social history and archaeology. These developments were certainly associated with the assertion of middle-class cultural hegemony in the Victorian period, but it does not follow that the new approaches were less sophisticated than older traditions of historical representation and classical scholarship. Nineteenth-century historiography broadened its scope far beyond the traditional concentration on the major events of political history, while archaeology uncovered an unprecedented abundance and variety of artefacts from the Roman past: both developments provided Victorian painters with a vastly expanded range of source materials, which they were quick to incorporate into their pictures. To 'understand' Victorian paintings of Roman antiquity, audiences needed an education, not less sophisticated, but more diverse than the traditional classical education.

The eighteenth-century tradition of Roman history painting centred on the notion of the *exemplum virtutis*, the exemplary deed of the Roman hero who sacrifices his private interests for the sake of the public good.[2] Roman history painting played a key role in the art theories, developed in Continental academies of painting and codified for England by the first President of the Royal Academy, Sir Joshua Reynolds, in his *Discourses* of 1769–90; together with subjects from ancient Greece and the Bible, Roman history occupied the summit of the hierarchy of pictorial genres. Academic art theory associated the didactic value of heroic subject-matter with magnificence of style. History paintings were expected to be large in scale and elevated in treatment, stressing grandeur of overall design over minutiae of detail.

The Roman history paintings of the 1780s by the French painter, Jacques-Louis David, are the most famous manifestations of the *exemplum virtutis*. However, many art historians have noted that British painters played a leading role in the developing didactic approach to Roman history painting, as early as the

1760s.[3] At the first exhibition of the newly established Royal Academy, in 1769, Benjamin West presented a Roman *exemplum virtutis* of the most elevated description, *The departure of Regulus from Rome* [fig. 18]. Regulus, the Roman consul taken prisoner during the first Punic War, had been sent to Rome by his Carthaginian captors to offer their terms for peace, having promised that he would return to face punishment if his mission failed. Regulus persuaded the Senate to refuse Carthage's terms; West's picture shows him leaving Rome in fulfilment of his promise, knowing that his return to Carthage will result in punishment by torture and death. To dramatize this *exemplum virtutis*, West faithfully followed the prescriptions of academic art theory: the scene is set in a grand public space, with the hero in the centre, taller than the figures around him and dignified in expression and demeanour. His gesture, as he rejects the entreaties of his family, demonstrates his determination to place his public duty above his merely private interests. As David Solkin has noted, this picture was the principal focus of attention at the first exhibition of the Royal Academy, serving as a public statement of the new institution's elevated aims.[4]

The story of Regulus was invoked as a particularly striking *exemplum virtutis* in a number of the classical literary texts, including Cicero and Livy, that were staples of the traditional classical education; the subjects for eighteenth-century Roman history paintings were ordinarily drawn from such texts. In theory, then, they would have been familiar to all men sufficiently high in social class to have received a classical education. In practice, it is likely that even well educated men would have needed assistance in identifying arcane Roman subjects, and exhibition audiences included women and men who were not classically educated; accordingly, the practice of printing an explanatory quotation in the exhibition catalogue became standard.

Nonetheless, the position of Roman history painting at the summit of the hierarchy was inseparable from its notional address to the social class associated with the classical education. Reynolds's *Fourth Discourse* made this explicit: "the great events of Greek and Roman fable and history" were to be preferred because "early education, and the usual course of reading, have made [them] familiar and interesting to all Europe".[5] Reynolds's "all Europe" is class and gender specific, referring to

Fig. 18 Benjamin West, *The departure of Regulus from Rome*, 1769
Oil on canvas, 88 × 120 ins
(229.9 × 304.8 cms)
The Royal Collection,
© Her Majesty The Queen

men whose "early education" consisted of study of the classical literary texts. Moreover, the didacticism of the *exemplum virtutis* was scarcely applicable except to the members of a ruling class; only men in public life were in a position to learn from the example of a Regulus.[6]

The high status of Roman history painting persisted into the nineteenth century. Benjamin Robert Haydon, the English painter most notorious for overweening ambition, chose Roman subjects for many of his largest and most extravagant pictures, such as *Curtius leaping into the gulf* of 1843, ten-and-a-half feet high by seven-and-a-half feet wide [fig. 19]. Haydon's rather wooden figure drawing makes the most of Curtius's stoicism as he sacrifices his life for his country; the colossal horse and rider, hurtling forward with terrifying energy, make an impressive image of heroism despite Haydon's imperfect technique. Although the sublimity of Haydon's conception is

far from the calm neoclassicism of West's approach, the Roman *exemplum virtutis* remains central to the picture's claim to high status.

The project for the mural decorations at the new Houses of Parliament raised the hopes of would-be history painters, including Haydon, for a dramatic initiative in state patronage. The first competition to choose painters for the mural project, in 1843, specified subjects from British history or literature, but a number of the competitors combined this requirement with the high theoretical status of Roman history, by choosing subjects from the Roman occupation of Britain. Indeed, two of the three winners of the highest premium were Roman subjects, Edward Armitage's *Caesar's first invasion of Britain* and G.F. Watts's *Caractacus led in triumph through the streets of Rome*.[7]

In the event, subjects from Roman Britain played a minor role among the works commissioned for the Houses of

Parliament; aspiring painters of Roman history could not depend on state patronage. Furthermore, private patronage proved equally unfavourable. In the 1830s and 1840s middle-class patronage began to burgeon, but there seems to have been little or no demand for large-scale history painting, Roman or otherwise. Victorian middle-class collectors preferred pictures in the categories lower in the academic hierarchy, but associated with bourgeois collecting: portraiture, landscape and genre.

This was not simply a matter of indifference to historical subjects; the more progressive art critics of the early Victorian period displayed a positive antipathy towards the idea of history painting. The most effective opposition came from William Makepeace Thackeray, whose exhibition reviews of the late 1830s and early 1840s made a sustained assault on history painting's pretensions to superiority, often singling out Roman subjects for particular ridicule. In a satirical description of a visit to the Luxembourg Museum in Paris, published in 1839, Thackeray wrote:[8]

"… we have here a vast number of large canvasses, with figures of the proper heroical length and nakedness… There is Brutus, having chopped his son's head off with all the agony of a father, and then calling for number two …."

For Thackeray, Brutus's sacrifice of family affections to public duty is the reverse of edifying; no doubt he would have been equally scathing about Regulus's dismissal of his family's entreaties. Indeed, Thackeray's antipathy to history painting centred on the rejection of the very notion of the *exemplum virtutis*. He consistently advocated a morality of private virtue in direct opposition to the didacticism, centred on public service, of traditional history painting. Thackeray used ridicule to imply that the exceptional deeds of the classical heroes were irrelevant to modern circumstances. Instead, he favoured humbler subjects that taught homelier virtues such as compassion or family affection – virtues that applied not only to the classically educated ruling classes, but to the broader social spectrum of the Victorian audience for art as a whole.

Thackeray was not alone in recommending a new 'middle-class' morality in specific opposition to the old notion of the *exemplum virtutis*; English art criticism increasingly took this

Fig. 19 Benjamin Robert Haydon, *Curtius leaping into the gulf*, 1843
Oil on canvas, 126 × 90 ins (320 × 228.6 cm)
Royal Albert Memorial Museum, Exeter (Exeter City Museums and Art Gallery)

point of view in the 1840s and 1850s. For example, a writer in the period's major art periodical, *The Art-Union*, registered "a protest", in 1840, "against a habit of choosing subjects from the ancient mythology, and more remote history"; such subjects "do not appeal sufficiently to our sympathies".[9] The word "sympathy" was routinely used to advocate painting's appeal to a

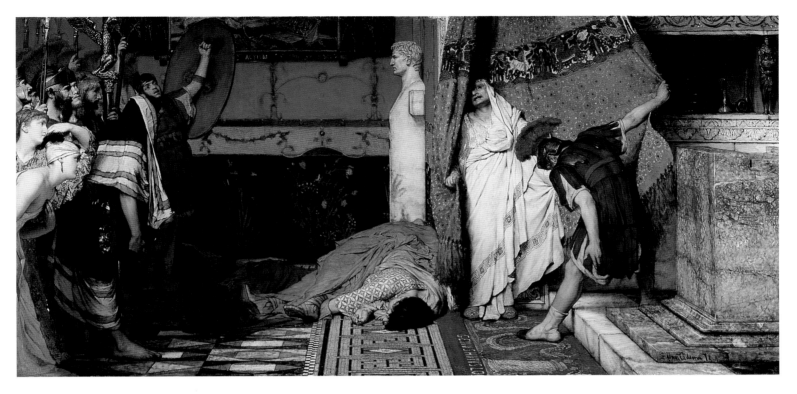

Fig. 20 Lawrence Alma-Tadema, *A Roman Emperor, A.D. 41*, 1871. Oil on canvas, 33 × 68 ½ ins (83.8 × 174.2 cm). Walters Art Gallery, Baltimore, Maryland

wide public, in direct opposition to the address of history painting to a classically educated élite.

The rejection of the *exemplum virtutis* left Roman subject-matter without a role, for a time. The category associated most powerfully with didacticism, in academic art theory, reached its lowest ebb in the heyday of Victorian 'moralising' painting, in the 1850s. The paradox is only apparent; new notions about painting's 'moralising' function had discredited the lofty didacticism of Roman history painting. Indeed, the Roman *exemplum virtutis* never reappeared in Victorian painting.

The rare Roman 'heroes' in later nineteenth-century paintings tend to be unnamed figures, lost to the written historical record, such as the anonymous soldiers in E.J. Poynter's *Faithful unto death* of 1865 and *The catapult* of 1868 [cats. 43, 45]. The commanding officer in *The catapult* occupies a compositional position that is the reverse of heroic, according to the traditions of history painting; he is removed from the central position

traditionally accorded to the 'hero', and placed behind a group of anonymous soldiers. At centre stage is a male nude, certainly a reference to the traditions of history painting, but cast in the role of a common soldier; his pose may resemble those of the warriors on the Parthenon metopes, but his task is merely to assist in turning the windlass.

Poynter's pictures are among the few, in the later Victorian period, that involve military action, a traditional subject for Roman history painting, but they hover ambiguously between the categories of history and genre, since their 'heroes' are anonymous common soldiers. In *The Ides of March* of 1883, Poynter presented Julius Caesar as a 'hero', but a tragic one [cat. 55]. Caesar and Calpurnia are centrally placed but seen from behind and dwarfed by the majesty of the Roman palace; they are illuminated by the fitful light of the comet that portends Caesar's death. The message of the picture is ominous: Caesar's death will mark the beginning of a more despotic phase of

Roman power. Implicit in the glorification of Caesar as 'hero' is a condemnation of the autocratic rule of the Roman empire.

Poynter's sympathetic portrayal of Caesar was exceptional; most late Victorian pictures of Roman history chose to focus on figures who were the reverse of heroic. Alma-Tadema's *A Roman Emperor, A.D. 41* [fig. 20], exhibited in 1871, set the precedent; it presents a grotesque Claudius, cringing behind a curtain as the Pretorian guard approaches to hail him as Emperor. As Poynter had done in *The catapult* three years earlier, Alma-Tadema makes a play on the traditional placement of the hero at centre stage; this position is occupied by a heap of dead bodies, beneath a herm whose sculptured face is the only one in the picture to display the dignified lineaments and stoic resolution appropriate to a Roman hero. Alma-Tadema's title is ironic; it calls attention to Claudius's absurdity in the character of 'a Roman emperor'.

Other painters soon began to adopt the anti-heroic characterization of the Roman emperor. When Haydon had painted Nero in the mid-1840s, he conferred grandeur on the Emperor's depravity: enthroned in majesty, Nero appears playing his lyre as Rome burns beneath him [fig. 21]. However, J.W. Waterhouse's Nero of 1878 [fig. 22] appears a spoilt youth, sprawling on his stomach almost at ground level; in contrast to Haydon's dramatic view of Rome, the great city over which the emperor exerts his tyranny, Waterhouse offers an informal glimpse of a corner of the palace interior, with the pedestals of the statues cut off by the top edge of the picture. The title, however, turns the apparent casualness of the scene into a gruesome shock: *The remorse of Nero after the murder of his mother*.

The period's most extravagant picture of a depraved Roman emperor was again by Alma-Tadema: *The roses of Heliogabalus* of 1888 [fig. 23]. The prettiness of the pink rose-petals has led many observers to miss the more sinister implications of this scene, one among those of which the "inexpressible infamy surpasses that of any other age or country", as Gibbon put it in his account of Heliogabalus's reign.[10] The Emperor and his companions, presumably including the sexual partners of both sexes mentioned prominently in Gibbon, look on as a canopy releases rose-petals to smother the guests below. Suffocation may be accompanied by a sensation of sensual pleasure, and the aban-

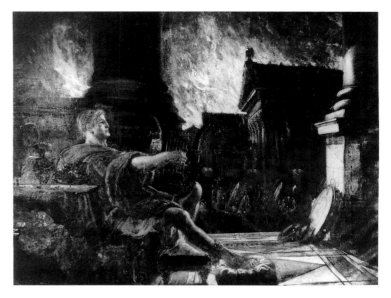

Fig. 21 Benjamin Robert Haydon, *Nero playing on the lyre*, 1846
Oil on canvas, 144 × 108 ins (365.8 × 274.3 cm)
Present whereabouts unknown

doned poses indicate that Alma-Tadema wished to suggest this implication; Heliogabalus is murdering his guests, but he offers them one final moment of ecstasy as they perish. This picture is large-scale by Alma-Tadema's standards, more than four feet high by seven feet wide: the artist was presenting it as a history painting, in clear distinction to his many pictures of Roman everyday life at tiny scale. Nonetheless, this is the reverse of an *exemplum virtutis*; the self-indulgent Heliogabalus cannot be equated even with the demonic majesty of Haydon's Nero. Alma-Tadema parodies the conventions of the traditional Roman history painting to offer what might be described as an anti-history picture.

Alma-Tadema's *An audience at Agrippa's*, of 1876, appears at first glance a more neutral portrayal of a historical figure, the son-in-law of the Emperor Augustus [cat. 51]. However, closer scrutiny suggests that Agrippa is being characterized as a despot: the scribes at the writing-table bow obsequiously before him, while his attendants maintain a respectful distance. In both this picture and its sequel, *After the audience* of 1879 [cat. 52], the petitioners offer costly gifts to Agrippa; the two pictures present

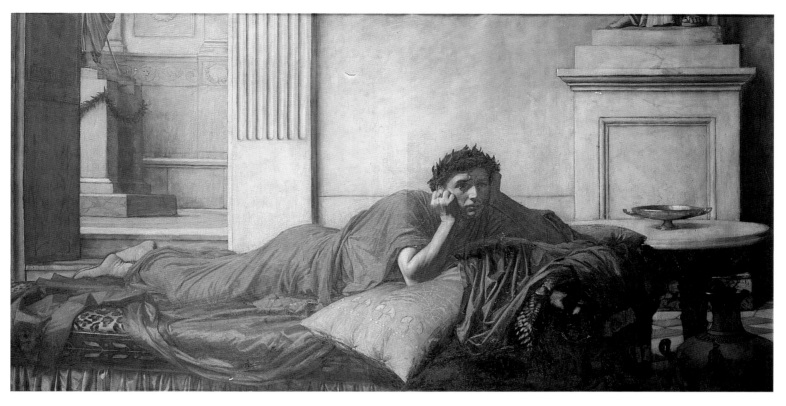

Fig. 22 John William Waterhouse, *The remorse of Nero after the murder of his mother,* 1878
Oil on canvas, 37 × 66 ins (94 × 168 cm). Private collection (photograph courtesy Sotheby's, London)

the world of imperial Rome as one of bribery and corruption.

The emphasis on imperial despotism may help to account for a development that seems at first thought strange, the emergence in later Victorian painting of pictures of martyrdom; this was a traditional category in Continental history painting that had never been common in Protestant England. However, the martyrs of late Victorian painting were presented less as examples of religious virtue than as victims of Roman oppression. An early example, Edward Armitage's picture of 1863, makes Roman imperial guilt explicit in the title: *The burial of a Christian martyr in the time of Nero* [fig. 24]. The picture combines the traditional composition of a Pietà with the archaeologically specific detail of a catacomb setting, into which the pathetically emaciated body of the young martyr is lowered on a rope. Armitage's martyr is a boy, but in later examples the vic-

tim tended increasingly to be female. Although the martyrdom pictures reinstate the *exemplum virtutis*, the emphasis is not on heroic male action, but pathetic female suffering.

The two most striking examples of the period both appeared in 1885: Charles Mitchell's *Hypatia* at the Grosvenor Gallery, and Waterhouse's *St Eulalia* at the Royal Academy [cats. 57, 58]. Hypatia was not, in fact, a Christian saint, but a pagan philosopher who became the victim of internecine religious disputes in the anarchic late Imperial world of fifth-century Alexandria; her story had been made famous by Charles Kingsley's novel of 1853. Indeed, the sensational scene in the novel where Hypatia is stripped naked and torn limb from limb must also have been an inspiration for Waterhouse's depiction of the Christian St Eulalia as a semi-nude figure, although Waterhouse's immediate source was the fourth-century Latin poet Prudentius. Both

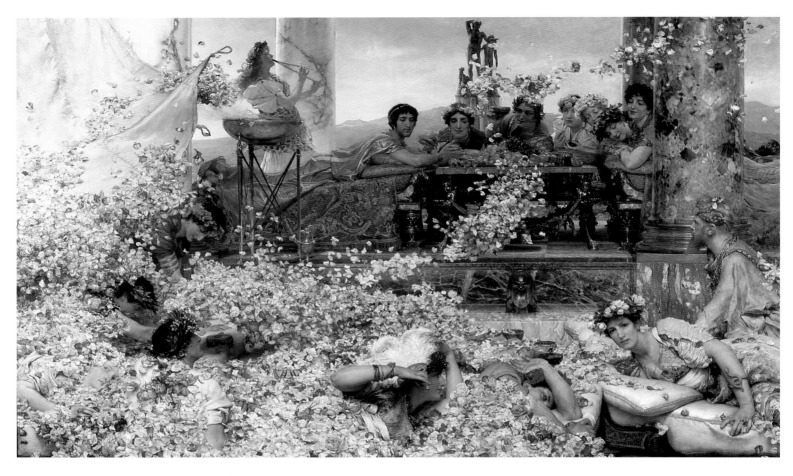

Fig. 23 Lawrence Alma-Tadema, *The roses of Heliogabalus*, 1888
Oil on canvas, 52¼ × 84⅜ ins (132.7 × 214.4 cm). Private collection (photograph courtesy Christie's, London)

literary sources describe the mutilation of the heroine in grue-some terms, but neither Mitchell nor Waterhouse follow the indications of their sources precisely: Hypatia appears at the moment before the crowd approach to tear her body to pieces, while the body of St Eulalia is unmarked by the iron hooks and torches that had been used to torture her. Nonetheless, the potential sensuality of the unmutilated female flesh is used in both pictures to heighten the horror of the violent death in the viewer's imagination.

The combination of nudity and violence in *Hypatia* and *St Eulalia* now appears overtly sensational. However, most art critics of 1885 accepted both pictures as elevated essays in his-

tory painting, and indeed they come closer to the traditional requirements for history painting than virtually any other Roman pictures of the period; both are large in scale, both place the heroine in the traditional central position, and both hero-ines are unequivocally virtuous. However, Mitchell and Waterhouse use the conventions of history painting to empha-size Roman cruelty, not Roman virtue.

The messages of *Hypatia* and *St Eulalia* are not so different, then, from those of the anti-heroic pictures of depraved Roman emperors; both kinds of scene censure Imperial Rome as a world of exceptional wickedness. The painting of events and characters from Roman history, in the late Victorian period,

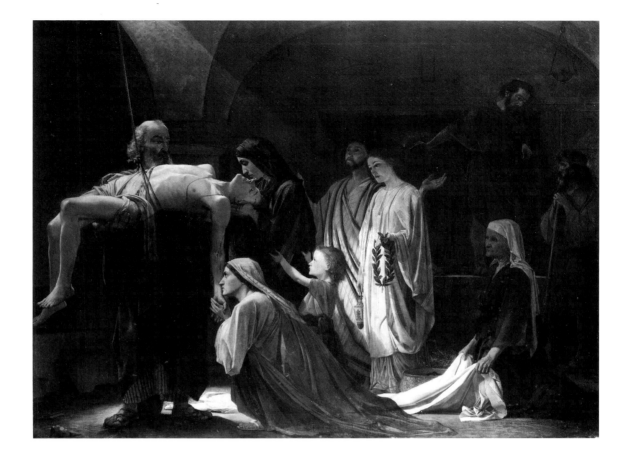

Fig. 24 Edward Armitage, *The burial of a Christian martyr in the time of Nero*, 1863
Oil on canvas, 45 × 60 ins
(114.3 × 152.4 cm)
Glasgow Museums: Art Gallery and Museum, Kelvingrove

involved a reversed version of the traditional didacticism of the Roman history painting, casting the ancient Romans as examples to be avoided rather than emulated. Perhaps one function of the pictures was to mark a contrast between the corruption of Roman imperial power and the enlightened rule of the modern British empire.

However, there is an element of hyperbole in the pictures that cannot be explained so simply. The psychological tension in *Hypatia* and *St Eulalia* between the visual appeal of the unmutilated female nude and the spectator's consciousness of the horrifying tortures inflicted on the historical women is analogous to the contrast, in other pictures, between the magnificence of the Roman surroundings and the villainy of the events transacted within them; *The roses of Heliogabalus* makes its impact through the bizarre discrepancy between the visual luxuriance of the pink rose-petals and the moral anarchy of the subject-matter. In this sense, the pictures of martyrdom, as well as those of depraved Roman emperors, are anti-history pictures. Their subversion of the old notion of the *exemplum virtutis* is not simply a matter of reinterpreting the ancient Romans as vicious rather than virtuous; the pictures trade on the incongruity between their sensational content and the dignified didacticism expected of a Roman history painting. Roger Fry trivialized this aspect of the Victorian painting of Rome when he referred to the figures as "agreeably wicked". It is the 'agreeableness', or more precisely the fascination, of Roman wickedness that distances the pictures from history painting's address to the rational faculties of the classically educated spectator.

Academic art theory made a clear distinction between 'history', the record of important political events enacted by personages of high status, and 'genre', the depiction of the everyday activities of ordinary people. The theoretical superiority of history manifested itself most obviously in grandeur of scale, opposed to the small dimensions considered appropriate for genre, but the hierarchical distinction had implications for every aspect of the picture's contents: the high-ranking characters of history *versus* genre's characters from low life; great deeds *versus* trivial pastimes; grand public spaces *versus* domestic settings; emphasis on the human figure *versus* attention to accessory detail. Genre was linked to the ephemerality of contemporary life, history to events of the past assumed to have universal import.

However, this hierarchy depended on a conception of history that came under challenge in the nineteenth century. Formerly, the past had been conceived as an intellectually derived abstract of events of special importance; in the nineteenth century, new approaches to historiography redefined the past as a world replete with all the varieties of human experience found in the 'real' world as lived in the present. This made a nonsense of the old distinction between 'history' and 'genre'. In the terms of nineteenth-century historiography, a genre scene teeming with 'life-like' accessory detail, such as Alma-Tadema's *Un jongleur* [cat. 48], might appear a more compelling representation of the Roman past than a history painting of an exceptional event, such as West's *Regulus* [fig. 18]. New approaches to historiography gave prominence, or even priority, to the elements associated with genre; the depiction of ordinary people, everyday pastimes, domestic interiors, and accessory details came to seem crucial to studying the complexity of the past.

Many of the paintings of historical subjects discussed above display characteristics of genre painting, even though they represent famous figures from history. The accessory details of the altar and its trappings in Mitchell's *Hypatia* were much praised by contemporary critics for archaeological precision; Alma-Tadema's two pictures of Agrippa's audience present a variety of social classes, from patricians to slaves, as well as a wealth of archaeologically specific detail. Most pictures of emperors presented their private lives rather than their public deeds; Waterhouse's Nero and Alma-Tadema's Heliogabalus appear in domestic surroundings rather than the Senate or Forum. Indeed, many Roman pictures broke down the boundaries between history and genre: Poynter's picture of anonymous Roman soldiers, *The catapult*, covers five times the surface area of Alma-Tadema's picture of a member of the Roman imperial family, *An audience at Agrippa's* [cats. 45, 51]. It is difficult to categorize either picture unequivocally as a history painting or a genre scene.

The vast majority of pictures set in ancient Rome, from the 1860s onwards, can be classified most easily as genre scenes: they are small or moderately sized pictures of anonymous figures, engaged in the activities of everyday life. Nonetheless, there was a certain ambiguity about the pictures' status. Although they were unequivocally low in the traditional hierarchy of genres, their research into Roman social history and their archaeological specificity gave them a claim to consideration as serious explorations of the Roman past. Thus, they were often accorded prominence in exhibition reviews that paid scant attention to other kinds of genre scene; a scene of anonymous figures at leisure in the baths could inspire a learned critical disquisition on Roman bathing customs and the relevant artefacts [cats. 56, 64]. Frequently, more critical ink was spilt over a tiny Roman genre picture by Alma-Tadema than over many larger and more pretentious pictures noticed in the same reviews. If it were possible to calculate a ratio for the amount of critical commentary per square inch of canvas, Roman genre scenes would rank high, perhaps highest among all categories in later Victorian painting.

The Roman genre scene emerged rather suddenly in the mid-1860s; indeed, its birth can be dated to 1865, when six Roman subjects appeared at the Royal Academy, including Poynter's *Faithful unto death* and Simeon Solomon's *Habet!* [cats. 43, 44].[11] One reason for this sudden efflorescence must have been exposure to Continental genre paintings with antique settings; the French painters known as '*néo-Grecs*' had attracted much attention at the International Exhibition held in London in 1862, the first in England of the nineteenth century's vast international exhibitions to display foreign painting.[12]

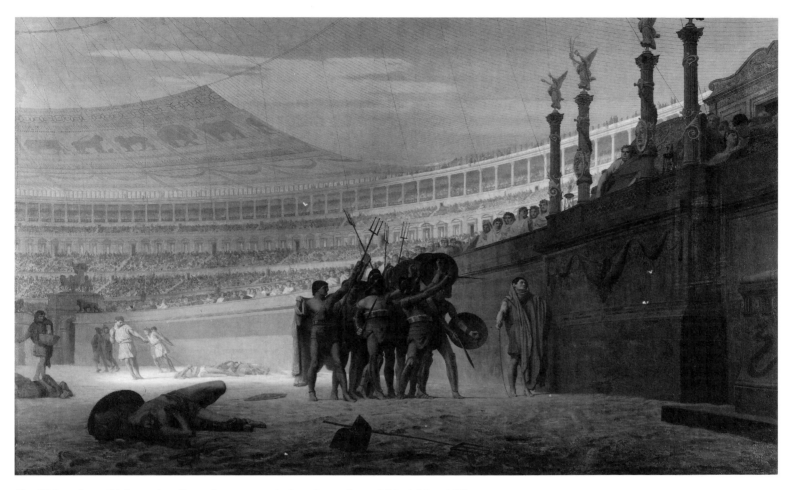

Fig. 25 Jean-Leon Gérôme, *Ave, Caesar Imperator, morituri te salutant*, first exhibited Salon 1859.
Oil on canvas, 36 3/4 × 57 1/4 ins (93 × 145.4 cm). Yale University Art Gallery, New Haven, Connecticut (Gift of C. Ruxton Love, Jr., B.A. 1925)

Solomon's *Habet*! must owe much to the French *néo-Grec*, Jean-Léon Gérôme, whose amphitheatre scene, *Ave, Caesar Imperator, morituri te salutant*, appeared at the London International Exhibition in 1862 [fig. 25]. Although Solomon chooses a close-up view of a few spectators, rather than Gérôme's sweeping panorama of the arena, the theme is analogous. Solomon's title, like Gérôme's, is a Latin exclamation uttered in the amphitheatre; the Roman spectators were said to have cried "*Habet!*" (He has it!) when they thought that a gladiator had been defeated.

The exclamation "*Habet!*" occurs in the amphitheatre scenes of many Victorian historical novels set in ancient Rome; these are another source, not only for Solomon's picture, but for the category of Roman genre in general. In the 1840s and 1850s, the only exceptions to the general dearth of British paintings with Roman settings had been pictures illustrating scenes from Edward Bulwer-Lytton's popular novel of 1834, *The Last Days of Pompeii*.[13] Although the vogue for paintings illustrating specific scenes from novels was waning by the mid-1860s, painters continued to choose general kinds of subject that were familiar

from the pages of historical novels: the amphitheatre scene, the scene where guests admire their host's works of art [cat. 47], and the bath scene [cats. 53, 56, 64] were all stock episodes in Victorian historical novels set in ancient Rome.

Continental painting and British historical novels were two sources, then, for the category of Roman genre scene that began to emerge in the later 1860s. Another source, and the one that ultimately guaranteed the category's success, was Roman archaeology. Travel to Roman archaeological sites continued to increase, but information about Roman archaeology was increasingly available even to those who stayed at home, through the proliferation of publications, often illustrated, that recorded the results of excavations. The publications of the 1860s on Pompeii were followed in later decades by books on the archaeological discoveries in Rome itself; these were extensively reviewed in general periodicals addressed to a broad spectrum of middle-class readers.[14] Moreover, the archaeology columns of general periodicals such as *The Athenaeum* and *The Academy* kept readers apprised of recent archaeological finds, week by week; contributors to these columns included distinguished archaeologists such as Rodolfo Lanciani and Heinrich Schliemann. The painters of the 1860s and beyond not only benefitted from a range of archaeological source-material vastly more comprehensive than had previously been available; they could count on considerable interest, and some degree of knowledge, among their audiences.

The contemporary criticism of Roman genre pictures demonstrates the extent to which the pictures derived their status from their archaeological specificity. Although Alma-Tadema was widely accounted the most sophisticated archaeologist among painters in the later decades of the century, British critics had made archaeological specificity an evaluative criterion for Roman pictures even before Alma-Tadema began to exhibit at the Royal Academy in 1869. All reviews of Poynter's *The catapult* of 1868 eulogized its careful research [cat. 45]. The critic for *The Daily Telegraph*, the morning paper with the largest circulation among the classes that Roger Fry disparaged as 'half-educated', stressed the "intimate technical knowledge of Roman siege operations" displayed in the picture, noting Vitruvius's description of the catapult and the reliefs of Trajan's

column as possible sources.[15] P.G. Hamerton, addressing the middle- to upper-class readership of *The Saturday Review*, was similarly enthusiastic, concluding that "This is historical painting of a rational and valuable kind".[16] For Hamerton and his colleagues, archaeological specificity could confer 'historical' status on pictures that did not represent characters or events documented in the written historical record. Even the reclusive D.G. Rossetti was well aware that Roman pictures derived their status from archaeological specificity; the account he provided of his own Roman subject, *Dîs Manibus* of 1874, stressed its fidelity to the archaeological evidence [cat. 50].

Critical and popular enthusiasm for Roman material objects in painting is related in a general sense to the increasing emphasis on consumerism in the middle-class culture of the later Victorian period. Indeed, classical archaeology might itself be described as a 'middle-class' field, centred on the material object, and allied to the new 'professional' disciplines of science rather than the traditional 'gentlemanly' study of classical texts. The Victorian painters of Rome did not neglect the traditional classical literary texts; indeed, they drew on a wide range of literary sources for data on Roman social life and customs. According to the critic F.G. Stephens, Alma-Tadema consulted Martial's epigrams for the characterizations of the female figures in *Un jongleur* of 1870 [cat. 48], and Victorian painters of ancient Rome were well acquainted with the descriptions of classical antiquities and works of art in the *Natural History* of Pliny the Elder. However, the classical erudition of the pictures was principally a matter of "things" rather than "words", according to the distinction proposed in John Edwin Sandys's history of classical scholarship, published in 1908.[17] This was already evident in Poynter's *Faithful unto death* of 1865. Poynter's anonymous soldier was unrecorded in the classical literary texts; his 'authenticity' was guaranteed, instead, by the physical remains of his skeleton found at Pompeii, a fact stressed by Poynter himself and all of the picture's critics [cat. 43].

The emphasis on Roman 'things' did not go unchallenged. Although it was seldom that an art critic failed to express respect for the Roman painters' careful research, there were complaints, nonetheless, that the painting of ancient Rome was too exclusively 'materialistic'. Alma-Tadema, the painter whose

reputation was most closely tied to archaeological erudition, was particularly vulnerable to such criticism. As Harry Quilter put it in 1884, Alma-Tadema's "sympathy is only with the outward and visible form of antiquity".[18] In 1892, Claude Phillips elaborated a similar complaint:[19]

"The chief drawback to the enjoyment of the Dutch master's accomplished art has been, and indeed still is, his absence of sympathy with the essential, the human side of the subjects which he elects to treat, as distinguished from the sumptuous and interesting *mise-en-scène* in which he invariably enshrines those subjects."

Even at the end of the Victorian period, there may have been a lingering doubt about the propriety of representing Roman antiquity in the guise of the 'low' category of genre, with its traditional emphasis on the minutiae of the everyday environment.

Attacks on the 'materialism' of Roman pictures increased with the critical perception that the category was becoming commercialized. The lively market for Roman pictures after about 1880 encouraged the repetition of saleable subject types, such as Alma-Tadema's scenes of Roman courtship [*e.g.* cat. 59], or Poynter's pictures of lovely women in luxurious Roman settings [*e.g.* cat. 62]. Roman genre pictures proliferated as the older generation was joined by a number of younger painters, such as John William Godward [cat. 63]. Often disparaged as 'imitators' of Alma-Tadema, the younger generation might instead be credited with intelligent judgement of the market for Roman painting. Certain aspects of Roman archaeological specificity, such as the representation of marble and the tessellated floor in receding perspective, became virtually obligatory in later Victorian pictures of Rome. The repetition of these features meant a kind of 'mass production', but did not imply careless manufacture; on the contrary, marble surfaces and tessellated floors were valued precisely for the technical skill involved in their representation. Artists deployed a carefully judged combination of predictability and variation, so that each picture was both unique and immediately recognizable as an example of its type. Critics, collectors, and audiences continued to delight in archaeologically specific Roman objects; even the tiniest pic-

ture contained its own collection of artefacts. Indeed, some archaeological knowledge was necessary to 'understand' even the most unpretentious Roman genre pictures.

An artist's practice in 'mass-produced' categories did not necessarily mean the neglect of more ambitious Roman pictures. Although Poynter was increasingly busy with administrative duties, as well as the production of his saleable pictures of female figures [*e.g.* cat. 62], he occasionally found time for a more important Roman picture, such as *Horae serenae* of 1894 [cat. 61]. The year after he had exhibited a typical example of his popular courtship type, *A silent greeting* of 1891 [cat. 59], Alma-Tadema produced one of his least formulaic Roman pictures, *Unconscious rivals* [cat. 60]. *Unconscious rivals* is one of Alma-Tadema's most spectacular displays of technical skill, not only in the careful painting of detail for which he had always been famous, but in the effects of colour, atmosphere and light: the gradually diminishing illumination of the barrel vault, with its delicate painted decorations, and the glowing yellow highlights on the cold marble limbs of the statue on the right are *tours de force* that might arouse the envy of any painter. Moreover, the design of the picture is among the most sophisticated in the œuvre of a painter whose ingenuity in spatial construction has never been adequately acknowledged. The dramatic plays on scale, juxtaposing the colossal marble forms of the statues with the frivolous ephemerality of the living women, suggest a variety of reflections on the project of reconstructing the Roman past. The famous statue on the right is rendered a fragment, cut off by the right edge of the picture, but it is this statue that survives as evidence of the lost 'reality' of the Roman past.

The role of the statue in *Unconscious rivals* suggests another aspect of the 'materialism' of the Roman pictures: the past, as uncovered by archaeology, consists exclusively of material objects. The Pompeiian excavations brought this characteristic of archaeology to the fore in a particularly compelling way. Although the most trivial household utensils were unearthed intact, the human beings were absent in the most literal sense: the spaces they had occupied remained as holes in the volcanic debris. The holes were a source of fascination for nineteenth-century visitors to Pompeii; in the early 1860s, the director of

the excavations, Giuseppe Fiorelli, developed a procedure for recreating the shapes of the bodies by pouring plaster into the holes.[20] Part of the fascination of the Roman genre scenes, for their original audiences, was that they 'filled the holes' in the surviving evidence about the Roman material environment with impersonations of the lost human inhabitants.

Nonetheless, it was the specificity of the material environment, rather than the presence of the figures, that guaranteed the 'authenticity' of the pictures as reconstructions of ancient Rome. Critics found the reconstructed Roman environment so vivid that ancient Rome seemed to 'live again' in the pictures [see cats. 45, 47]. However, they often found the Roman figures heartless or soulless, and not without reason. In academic art theory, material objects were admissible only as accessories to human actions, but the high status of Roman artefacts in Victorian painting tended to reverse this hierarchy. Indeed, one important function of the human figures was to serve as accessories to the material objects that played the principal role in recreating the Roman past.

Archaeological specificity even took over the didactic function traditionally associated with Roman subject-matter: Roman genre paintings were frequently reproduced in school textbooks and reference books as instructive reconstructions of the Roman past. The human figures were relieved of their roles as *exempla virtutis*, as archaeological 'accuracy' replaced exemplary human behaviour as the didactic rationale for Roman pictures. Moreover, the emphasis on the Roman material environment was inseparable from a characterization of the Roman figures themselves as materialistic or, in Fry's term, "luxurious". Many of the figures in Alma-Tadema's earlier pictures are obsessed with their own material possessions [cat. 47]; the Roman family in *Un jongleur* might be described, in a paraphrase of Oscar Wilde, as living up to their candelabrum [cat. 48].[21] Later pictures showed the Roman figures basking on sumptuous marble terraces, idling in the gardens of their villas on the Bay of Naples, or revelling in the luxury of the baths [*e.g.* cats. 59, 61, 64]. The anonymous figures in Victorian genre pictures of ancient Rome cannot serve as examples even of behaviour to be avoided; their utter amorality destroys the last vestige of the old notion that the ancient Romans could provide a model for behaviour in the modern world.

Roger Fry's comment of 1913 captures many of the essential features of the Roman genre picture. He was certainly right to note the attention to the "domestic belongings and daily trifles" of ancient Rome, and even to associate the category with "middle-class" culture. Moreover, the depicted Romans are certainly "very rich" and "very luxurious". However, Fry was misrepresenting the case when he pretended that Roman genre paintings were comprehensible to the "half-educated"; a great deal of research will be required before modern scholars can 'understand' the pictures' archaeology as thoroughly as their contemporary critics did. Furthermore, in the context of time-honoured conventions for representing ancient Rome, the figures' 'wickedness' may not be as innocuous as Fry presents it. The amoral Romans of Victorian genre painting represent the final stage in the repudiation of the traditional *exemplum virtutis*.

NOTES

1 Roger Fry, 'The Case of the Late Sir Lawrence Alma Tadema, O.M.', *The Nation*, 18 January 1913, pp. 666–67.

2 For the *exemplum virtutis*, see Robert Rosenblum, *Transformations in Late Eighteenth Century Art*, 3rd printing, Princeton, N.J. 1974, chapter II; for the 'civic humanist theory of painting', linking history painting with public virtue, see John Barrell, *The Political Theory of Painting from Reynolds to Hazlitt: 'The Body of the Public'*, New Haven and London 1986, introduction.

3 Rosenblum, *op. cit.* note 2, p. 65.

4 David H. Solkin, *Painting for Money: The Visual Arts and the Public Sphere in Eighteenth-Century England*, New Haven and London 1993, pp. 268–69.

5 Sir Joshua Reynolds, *Discourses on Art*, ed. Robert R. Wark, New Haven and London 1975, p. 58.

6 Barrell argues convincingly that Reynolds himself moved away from the notion of the didactic efficacy of the *exemplum virtutis*; but he shows that history painting's address to a ruling class was assumed in a wide variety of English eighteenth-century texts (Barrell, *op. cit.* note 2, pp. 18–23).

7 For details of the Houses of Parliament competitions and commissions, see David Robertson, *Sir Charles Eastlake and the Victorian Art World*, Princeton, N.J., 1978, pp. 324–44.

8 'On the French School of Painting', *Fraser's Magazine* XX, December 1839, p. 682.

9 'Reflections Arising Out of the Late "Exhibition"', *Art-Union* II, August 1840, reprinted in John Charles Olmsted, *Victorian Painting: Essays and Reviews*, 3 vols., New York and London 1980–85, I, p. 334.

10 Edward Gibbon, *The Decline and Fall of the Roman Empire*, Modern Library edn., New York n.d., I, p. 128.

11 The other four pictures were W.M. Egley's *Glaucus and Ione in the cave of the Witch of Vesuvius* (an illustration of a scene in Bulwer-Lytton's *The Last Days of Pompeii*, private collection); John Everett Millais's *The Romans leaving Britain* (untraced); W.F. O'Connor's *A priestess of Vesta* (untraced); and P.F. Poole's *A suburb of the Roman city of Pompeii, during the eruption (of 79 A.D.)* (untraced).

12 The first of the great International Exhibitions had been held in London in 1851 (the 'Crystal Palace' exhibition), but did not include painting; the Paris Exposition Universelle of 1855 set the precedent for the inclusion of fine art alongside the industrial arts.

13 See Richard D. Altick, *Paintings from Books: Art and Literature in Britain, 1760–1900*, Columbus, Ohio, 1985, pp. 461–62.

14 See, *e.g.*, 'Pompeii', a review of recent publications on Pompeii by the archaeologist A.H. Layard, *Quarterly Review* CXV, April 1864, pp. 312–48; 'Recent Discoveries in Art and Archaeology in Rome', *Quarterly Review*, CXLIV, July 1877, pp. 46–81.

15 'Exhibition of the Royal Academy', *The Daily Telegraph*, 24 June 1868, p. 7.

16 'Pictures of the Year', *The Saturday Review*, 30 May 1868, p. 719.

17 John Edwin Sandys, *A History of Classical Scholarship*, 3 vols., Cambridge 1908, III, p. 89.

18 'Royal Academy of Arts', *The Spectator*, 14 June 1884, p. 789.

19 Claude Phillips, 'The Summer Exhibitions at Home and Abroad', *Art Journal*, N.S., July 1892, pp. 218–19.

20 See the enthusiastic account of Fiorelli's innovations by the English archaeologist, A.H. Layard, 'Pompeii', *Quarterly Review* CXV, April 1864, pp. 331–32.

21 In a widely reported anecdote that may have been apocryphal, Wilde was reported to have said "I find it harder and harder every day to live up to my blue china", referring to the quintessential 'aesthetic' accessory in his rooms at Oxford; see Richard Ellmann, *Oscar Wilde*, London 1987, pp. 43–44.

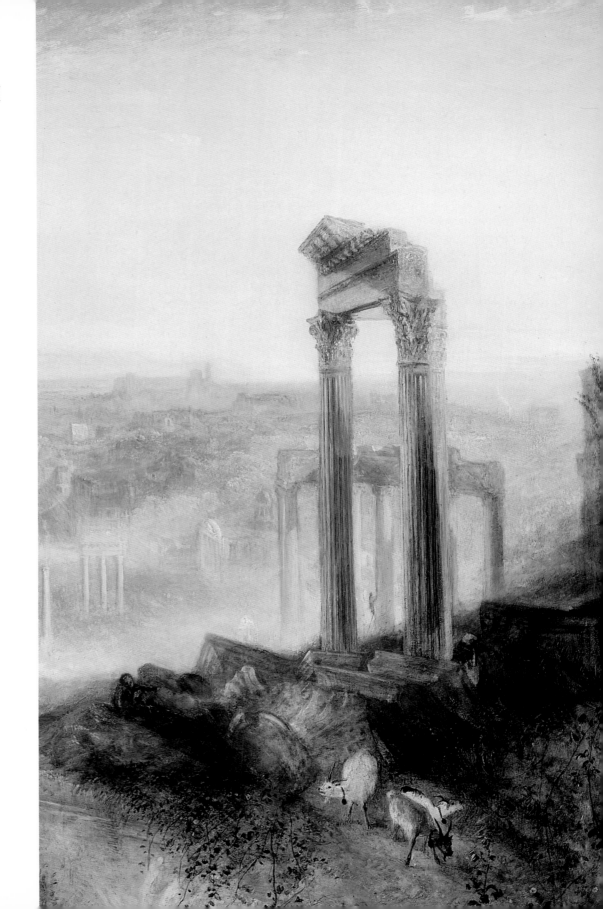

CATALOGUE I

Representing Rome

M.J.H.
LIVERSIDGE

HUGH WILLIAM WILLIAMS
1773–1829

1 *The Temple of Saturn, on the Clivus Capitolinus, overlooking the Roman Forum,* 1820

Watercolour and bodycolour with gum arabic
19 ½ × 25 ¼ ins (49.5 × 64.2 cm)
National Galleries of Scotland, Edinburgh

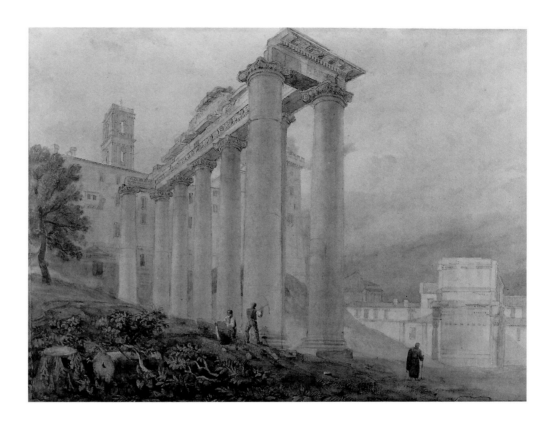

H. W. Williams was one of the first British artists to visit Italy after the Napoleonic Wars had ended. From 1816 until 1818 he was in Italy, Greece and the Ionian islands gathering material for the two-volume *Travels* he published in 1820, followed in 1827–28 by his *Select Views in Greece* which earned him the name of 'Grecian' Williams.[1] A landscape artist trained in Edinburgh in the eighteenth-century traditions of picturesque topography and the classical ideal, his early works are of Scottish scenery quite conventionally rendered, the drawing refined and the colouring delicate. His Italian and Greek subjects, especially those that are composed as prospects with architectural features and antiquities picturesquely set within a general view or landscape, generally display a restrained sensibility. The majority of his paintings, especially his watercolours, are pictorially conservative in their careful draughtsmanship and sensitively rendered light and atmosphere. *Rome with figures dancing in the foreground* [fig. 26] is typical of the artfully composed views Williams painted which

carry on the previous century's tradition of Grand Tour souvenir which revived with the resumption of travel after 1815.

However, in some of his sketches and studies of individual monuments Williams reveals a more ambitious and dramatic response to the grandeur of ancient remains. In this drawing of *The Temple of Saturn*[2] he has taken a viewpoint emphasizing the scale and spectacle of imperial Rome that clearly owes its inspiration to the etchings of Giovanni Battista Piranesi whose great series of *Vedute di Roma* (late 1740s–1770s) and *Le Antichità Romane* (1756) were the first images to present antique remains in such expressively

monumental terms. Piranesi's vision powerfully influenced later artists and encouraged the kind of evocative response which Williams exhibits here.

The drawing shows what remains of the portico of the Temple of Saturn, one of the oldest of the Forum temples but rebuilt after a fire (thought to have been that of 284); behind is the medieval and later Palace of the Senator on the Capitol with Martino Longhi's late sixteenth-century *campanile* rising above it. To the right is the blank masonry of the side of the Arch of Septimius Severus. When Williams was in Rome there were mounds of waste from excavations scattered about the Forum and new

Fig. 26 Hugh William Williams, *Rome with figures dancing in the foreground, ca.* 1822
Watercolour, 18 ³/₄ × 26 ³/₈ ins (47.6 × 67 cm). Worthing Museum and Art Gallery

2 *Reconstruction of the Forum at Rome, as seen from the Mercati Traianei,* 1823

Sepia wash, heightened with white
9 × 13 ²/₅ ins (22.9 × 34.1 cm)
National Galleries of Scotland, Edinburgh

'Reconstructions' and *capricci* (imaginary compositions assembling real monuments which may be shown restored, or picturesque arrangements with invented buildings and fictive remains) were popular with eighteenth-century Grand Tourists and have a long history extending back to the Renaissance. Here, despite its title, Williams has followed the tradition of concocting a purely imaginary scene in which arbitrarily assembled monuments (only one of which, the column resembling Trajan's Column, is apparently a 'real' Roman antiquity) create an impression of Imperial Rome. Even allowing for the imperfect state of archaeological knowledge in the 1820s, it is evident that the drawing is a total fabrication. The foreground theatre or stadium is totally unlike the hemicycles of Trajan's Forum and Market, and the buildings beyond do not resemble anything that Williams had seen when he was in Rome, either in their form or in their configuration. The architectural fantasy therefore presents an entirely imagined idea of what' Rome (or, perhaps, another invented Roman city) may have been like, and is an example of how the nineteenth-

clearances were in progress. Something of the reality and romance of this process of rediscovery is suggested by the figures digging amongst the fragments and overgrown remains in the foreground and by the spoil heap behind the columns – in fact an exaggeration of the state of the site at the time.

After returning from Italy and Greece Williams had an exhibition of his sketches in Edinburgh in 1819, and in 1822 he showed a series of finished works which were critically acclaimed, as had been the illustrations in his 1820 *Travels*: "these classical scenes, more interesting even from their historical association than from their unequalled beauty, have inspired him with higher conceptions of art than even the delicacy and beauty of his pencil could have led us to anticipate".[3]

1 *Travels in Italy, Greece and the Ionian Islands,* 2 vols., London 1820; *Select Views of Greece* was issued in parts 1827–28.

2 The drawing has previously been identified as the Temple of Vespasian, which occupies a nearby site but of which only three columns still stand.

3 *Edinburgh Magazine and Literary Miscellany (The Scots Magazine),* N.S. VI, January 1820, p. 49 (quoted from Duncan Macmillan, *Painting in Scotland. The Golden Age,* Oxford 1986, p. 148).

century mind could recreate from archaeological and literary sources an idealized vision of the classical past. Possibly the drawing was made to be engraved – the careful finish and use of sepia are characteristic of other works by Williams which were intended for reproduction as prints. However, it remains a puzzling design, not least because of the presence in the foreground of the figure seated beside what are clearly Greek vases and a wine-cup.

JOSEPH MALLORD
WILLIAM TURNER
1775–1851

3 *Rome. The Arches of Constantine and Titus, the Meta Sudans, and the Temple of Venus and Rome*, 1819

Pencil, watercolour and bodycolour on white paper prepared with a grey wash
9 × 14½ ins (22.8 × 36.7 cm)
The Trustees of the Tate Gallery, London
(Clore Gallery for the Turner Collection)

Turner went to Italy for the first time in 1819. During a visit lasting several months he spent extended periods in Venice, Rome and Naples, and his travels took in virtually all the major cities and sites that had been included in the standard Grand Tour itinerary in the eighteenth century and by the new generation of guidebook writers in the years immediately following the Napoleonic Wars. As well as in Rome

2

itself, he made numerous pencil sketches and watercolour studies of classical remains at Tivoli, Pompeii and around the Bay of Naples, collecting material which over the years that followed informed his vision of Italy and inspired some of his most intensely poetic and historically suggestive landscapes and subject pictures.

The scenery of Italy and the associations with the past it evoked had already been part of Turner's artistic imagination for at least twenty-five years before he saw it in 1819. Art, literature and history had combined over a long time to create in his mind an idea of the landscape and classical antiquity that inherently shaped his response to what he saw. For Turner, the imagined reality came alive as he travelled, so that even the most descrip-

tively topographical records he made in 1819 seem to be invested with the heightened perceptions of what William Wordsworth much earlier had described in the Preface to *Lyrical Ballads* (1801) as "a mind in a state of vivid sensation". The subtly poetic watercolours of Italian scenery by John Robert Cozens he had copied in the 1790s, and the idealized landscapes of Claude Lorrain and Richard Wilson which he admired all his life, had profoundly affected his pictorial sensibilities. So had his reading: specifically Roman books he owned included a 1686 English translation of Livy's *Roman History*, an edition of Virgil, and Oliver Goldsmith's *The Roman History, from the foundation of the City of Rome, to the destruction of the Western Empire* (1786).[1] Another impor-

3

tant formative influence on Turner's vision of Italy and antiquity had been one of his early patrons, Sir Richard Colt Hoare of Stourhead, for whom he painted his first classical subject, *Aeneas and the Sibyl: Lake Avernus* (1798), in a purely Claudean idiom. Colt Hoare was an expert on the classical world and wrote about his travels in Italy with particular feeling for the historical associations they aroused: his *Hints to Travellers in Italy* (1815) was in Turner's library, his 1819 *Classical Tour through Italy and Sicily* must have been known to the painter, and artist and patron must have exchanged ideas on many occasions over a long association. Certainly Colt Hoare contributed to Turner's development as a painter of landscape histories and was instrumental in encouraging him to think of antiquities (of whatever period) as vehicles for 'sentiment' or associated

meaning in his pictures.[2]

Turner was also already visually familiar with the topography of Italy, especially Rome, before he set off in 1819. In preparing for his journey he had acquired various travel guides, including J.C. Eustace's *A Classical Tour through Italy* (1813), *A Journey to Rome and Naples performed in 1817* (1818) by Henry Sass, *Select Views in Italy* (1792–96) by John ('Warwick') Smith, William Byrne and John Emes, and very probably as well Henry Coxe's *A Picture of Italy, being a Guide to the Antiquities and Curiosities of that Interesting Country* (2nd edn. 1818). From one of them Turner made small pen-and-ink drawings summarily copying the illustrations: all 72 plates by John 'Warwick' Smith from *Select Views* are thus recorded. He also made 22 pages of notes from Eustace's *Classical Tour* in the same sketchbook

before his departure.[3] His detailed knowledge of Roman topography and a selection of Italian views was also developed before he left England by a commission from the architect James Hakewill, author of *A Picturesque Tour of Italy from Drawings made in 1816–1817* (1819–20). For this Turner made twenty watercolours over 1818 and 1819, reworking Hakewill's drawings done in Italy.[4]

The final ingredient that affected Turner's response to Rome and to Italy generally was the appearance in 1818 of the Fourth Canto of Byron's *Childe Harold's Pilgrimage*. Byron's work imaginatively reinforced for Turner the view of modern Italy as a place of melancholy decay and decline, a theme constantly reiterated in the guidebooks he used, while at the same time heightening the visual intensity of his representation of the landscapes and views he depicted.

1 For Turner's books, see Andrew Wilton, *Turner in his time*, London 1987, pp. 246–47.

2 John Gage, 'Turner and Stourhead: the making of a classicist?', *Art Quarterly* XXXVIII, 1974, pp. 59–87; Linda Cabe, 'Sir Richard Colt Hoare, Italy and Turner', in Duncan Bull (ed.), *Classic Ground*, New Haven (Yale Center for British Art) 1981, pp. 17–21.

3 For Turner's use of travel books for his 1819 journey, see John Gage, *J.M.W. Turner, 'A Wonderful Range of Mind'*, New Haven and London 1987, pp. 46–51; Cecilia Powell, *Turner in the South*, New Haven and London 1987, pp. 13–19.

4 Cecilia Powell, 'Topography, Imagination and Travel: Turner's Relationship with James Hakewill', *Art History*, no. 5, 1982, pp. 408–25.

J.M.W. TURNER

4 *Rome. View from the Palatine*, 1819

Pencil, watercolour and bodycolour on white
paper prepared with grey wash
9 × 14½ ins (22.9 × 36.7 cm)
The Trustees of the Tate Gallery, London
(Clore Gallery for the Turner Collection)

That Turner's paintings of historical,
mythological and Italianate subjects
done from his imagination before he
went to Italy in 1819 were a major
influence on how his contemporaries
perceived and experienced the landscape
is evident from a letter written by the
painter Sir Thomas Lawrence from
Rome in 1818: "Turner should come to
Rome. His genius here would be sup-
plied with materials, and entirely conge-
nial with it... He has an elegance, and

often a greatness of invention, that wants
a scene like this for its free expansion;
whilst the subtle harmony of this atmos-
phere, that wraps everything in its own
milky sweetness... can only be ren-
dered, according to my belief, by the
beauty of his tones... It is a fact, that
the country and scenes around me, do
thus impress themselves upon me; and
that Turner is always associated with
them...."[1] On his first visit to Italy
Turner confined himself to topography
and recording in a series of magically
luminous watercolours with bodycolour
the radiant light and subtle atmospheric
effects that he deployed with such trans-
figuring brilliance in his later paintings
to render sensation and poetry. His
coloured sketches possess an immediacy
and spontaneity that might suggest they
were done on the spot, but in fact they

were most likely worked up from the
rapid pencil studies which he made
incessantly to gather information and
from which he then developed his re-
collections, allowing the processes of
selection, memory and imagination to
begin distilling the essentials from what
he had actually seen. Turner was, in any
case, reluctant to work in colour outside
if he might be observed, and there is a
contemporary record in a letter to the
architect John Soane (for whom, though
it was not accepted, Turner painted the
Forum Romanum [fig. 12 on p. 47] in
1826 describing his attitude: "Turner is
in the neighbourhood of Naples making
rough pencil sketches to the astonish-
ment of the Fashionables, who wonder
of what use these rough draughts can be
– simple souls! At Rome a sucking blade
of the brush made the request of going
out with pig Turner to colour – he
grunted for answer that it would take up
too much time to colour in the open air
– he could make 15 or 16 pencil
sketches to one coloured, and then
grunted his way home."[2]

Some of Turner's coloured Roman
views from 1819 are traditionally con-
ventional (like cat. 3), although the qual-
ity of light and freedom of execution
give them a freshness and vivacity that
are unprecedented. Others Turner com-
posed in a particularly original manner,
such as cat. 4. The emphasis on the frag-
ments scattered in the foreground with
the more distant ruins beyond is remi-
niscent of Piranesi's sometimes dramati-
cally picturesque use of such features,
but Turner is also reflecting the power of

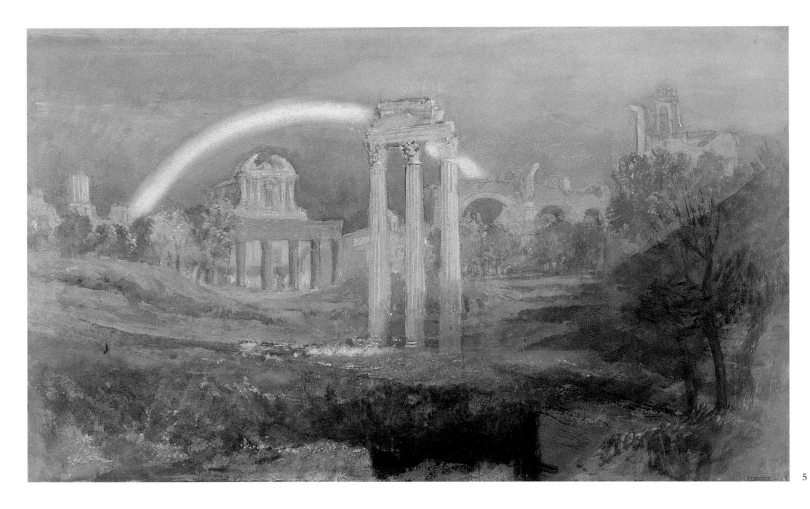

5

fragmentary remains to affect the imagi-
nation, something often commented on
by writers. One particularly famous
example could be seen on the Quirinal:
"There is the fragment of a cornice,
lying in the gardens of Colonna Palace,
which looks as if it had been brought
from Brobdignag; – for no pillars of pre-
sent existence could support an entabla-
ture of such gigantic proportions, as that
of which this cornice must have formed
a part. One might imagine some great

convulsion of nature had swallowed up
the city, and left a few fragments to tell
the tale of its existence to other times…
One may judge of the greatness of the
wreck, from the effects thus produced
by its overthrow."[3]

1 Quoted by A.J. Finberg, *The Life of J.M.W.
Turner, R.A.*, 2nd edn. Oxford 1961, p. 260.

2 A.T. Bolton, *The Portrait of Sir John Soane,
R.A.*, London 1927, pp. 284–85; the letter is
from Soane's son, dated 15 November 1819.

3 Henry Matthews, *The Diary of an Invalid*, 1820
(quoted from Paris edn., 1825, p. 56).

J.M.W. TURNER

5 *Rome. The Forum with a rainbow,*
1819

Pencil, watercolour and bodycolour on white
paper prepared with a grey wash
9 × 14½ ins (22.9 × 36.7 cm)
The Trustees of the Tate Gallery, London
(Clore Gallery for the Turner Collection)

Among the coloured sketches of Rome
dating from 1819 there are two in par-
ticular that seem to capture the spirit

and sentiment of Byron's Romantic vision of the city in *Childe Harold's Pilgrimage*, Fourth Canto, which Turner must have read the year before he set out for Italy: *The Forum with a rainbow* and *The Colosseum by moonlight* {fig. 6 on p. 21]. The shattered remains of the Forum evoked most powerfully the notions of power that had passed away and of an empire that had decayed, while amid the relics of the past modern Italy languished oppressed, impoverished and neglected, the victim of recent Napoleonic conquest and subject to the politics of occupying powers and the corrupting consequences of ecclesiastical and secular despotism. Rome was for Byron the "mother of dead empires" and "An empty urn…/ Whose holy dust was scatter'd long ago". Similar themes were to recur in later paintings by Turner, most notably in the two pairs he exhibited at the Royal Academy in 1838 and 1839, *Ancient Italy* [fig. 10 on p. 40] and *Modern Italy* followed by *Ancient Rome* and *Modern Rome* [cats. 10, 11]. For these Turner had Byron specifically in mind, and in 1819 it seems quite reasonable to associate at least some of his representations of Rome and Italy with the imagery of *Childe Harold*, even though none of the views are illustrations to specific passages. One of the themes that concerned Byron was the idea of freedom and revival that would eventually arise when Italy's nationhood and identity were recovered, and perhaps it is not altogether fanciful in this context to think of Turner using the rainbow arching over the Forum as a sym-

bol of regeneration. Maybe, indeed, given the religious significance associated with the rainbow in Christian iconography and the contemporary (Protestant) opinion of the Church in Rome, Turner might have sensed an irony in the conjunction of a rainbow and the Baroque façade of San Lorenzo in Miranda incorporating the columns of an ancient pagan temple (Antoninus and Faustina). Equally, the passing storm it signifies might contain allusions to the passage of time, transience, and renewal.[1] Similarly, *The Colosseum by moonlight* from the same series (Turner Bequest CLXXXIX, Rome Colour Studies sketchbook), evokes the passage in *Childe Harold* where Byron prescribes the ideal Romantic conditions under which the scene should be experienced:

"… the moonbeams shine
As 'twere its natural torches, for divine
Should be the light which streams here
 to illume."

In both the rainbow and moonlight scenes Turner records his own phenomenal experiences of Rome, but in common with other visitors who had read Byron it seems inconceivable that his visualization of the place was not imaginatively conditioned and enriched by the associations *Childe Harold* exemplified.

1 David Blayney Brown, *Turner and Byron*, London (Tate Gallery) 1992, pp. 128–29.

J. M. W. TURNER

6 *The Roman Forum, ca.* 1827

Pencil and watercolour with pen and brown ink
Vignette $5^1/_8 \times 5^3/_4$ ins (13 × 13.5 cm); sheet
$9^1/_4 \times 12$ ins (23.6 × 30.5 cm)
The Trustees of the Tate Gallery, London
(Clore Gallery for the Turner Collection)

This is one of the original watercolours by Turner from which the engraved vignettes were made for the 1830 edition of *Italy, A Poem* by Samuel Rogers. It was Turner's illustrations, twenty-five in all, that transformed *Italy* into the great publishing success that it became. His vignettes exactly convey what Samuel Rogers set out to do in his poetry – recreate from the landscape and topography of the country the historical associations that different places aroused. In these tiny, condensed illustrations Turner managed to set out the essentials of a scene that summarized visually the text they accompany, gave an authentic sense of place, and suggestively captured (even in the engravings) the atmospherics and character of Italian scenery in all its diversity [see also fig. 28]. The illustrated *Italy* proved hugely popular, and was reprinted in a larger collected edition of Rogers's *Poems* (to which Turner contributed further designs) in 1834: more than 50,000 copies had been sold by 1847.[1] It was, therefore, one of the most formative influences on travellers' perceptions of Italy and their responses to its picturesque scenery, romantic appeal and historic heritage. For many mid-nineteenth-century British tourists,

6

Gibbon's famous description of the scene that prompted him to write *The Decline and Fall of the Roman Empire*: "It was at Rome, on the 15th of October 1764, as I sat musing amidst the ruins of the Capitol, while the bare-footed fryars were singing Vespers in the temple of Jupiter, that the idea of writing the decline and fall of the City first started to my mind".

1 Cecilia Powell, 'Turner's Vignettes and the Making of Rogers' *Italy*', *Turner Studies*, no. 3, 1983, pp. 2–13; C. Powell, *Turner in the South*, New Haven and London 1987, pp. 131–36.

J. M. W. TURNER

7 *The Castle of Sant' Angelo, Rome*, 1832

Watercolour
Vignette 6¾ × 8¼ ins (17 × 21 cm); sheet 9¼ × 8⅞ ins (23.5 × 22.5 cm)
The Trustees of the Tate Gallery, London

Turner was in Rome for a second visit in 1828–29 when he stayed for several months and, while he was there, painted some large canvases, three of which he publicly exhibited. These comprised a mythological subject, *The vision of Medea* (Tate Gallery, London), an historical picture, *Regulus* (Tate Gallery, London), in which he imaginatively reconstructed ancient Carthage in a composition based on Claude Lorrain's seaport scenes with magnificent classical architecture and iridescent lighting, and a magically luminous *View of Orvieto* (Tate Gallery, London) with contemporary genre figures set in a landscape that poetically

Rogers afforded an introduction to Italy before they went there, so his poetry and Turner's vignettes acquired a particular hold over how Italy was imagined and experienced; many more took Rogers with them as an essential accompaniment to their journey. The vignette of *The Forum*, which figures as the headpiece to the poem *Rome*, typifies Turner's extraction and synthesis of elements to create a single image definitively evoking his subject: a view through the Arch of Titus looking along the Forum with its various monuments subtly rearranged with considerable licence in order to achieve an appropriate anthology, a procession of friars passing across the Via Sacra, the medieval Palace of the Senator and Renaissance *campanile* of the Capitol in the background, creating a whole history framed in miniature. Wrapped in an alluring atmosphere, it works on the viewer's imagination in a way that recalls Edward

captures the life of modern Italy alongside allusions to its ancient past. The three paintings together reflect the range of Turner's response to classical antiquity: a figurative literary theme exemplifying his reading of the classics, a scene from ancient history (the story of Regulus, the Roman hostage who returned to Carthage at the cost of his own life in fulfilment of his oath, having heroically convinced the Senate to reject an offer of peace) that epitomized the moral virtues of Rome before its decline, and a landscape evoking the poetic beauties and nostalgic sensibilities that Italy as the classic land represented. Having just completed the set of illustrations for *Italy* by Samuel Rogers [cat. 6] Turner was evidently inspired to revisit the sites that had profoundly affected his imagination, and following his second tour to Italy his vision of its landscape and history intensified in its romantic interpretation, culminating in a series of masterpieces painted in the 1830s [figs. 3 (on p. 11), 10, 11 (on pp. 40, 43)]. A similar enrichment of his vision can be found in his more topographical scenes, of which the Roman vignettes he designed for William Finden's *Landscape Illustrations to the Life and Works of Lord Byron* (1832–33) and the publisher John Murray's illustrated edition of Thomas Moore's *The Works of Lord Byron: illustrated with his Letters and Journals, and his Life* (1832–34) are characteristic examples.[1] The view of *The Castle of Sant' Angelo*, showing Hadrian's Mausoleum with the bridge across the Tiber leading to the entrance to the

7

Vatican with the statues of angels holding the instruments of the Passion designed by Bernini in the 1670s and the dome of St Peter's in the distance, encapsulates the continuity of classical with Christian Rome that so often fascinated visitors; the colourful and picturesque foreground figures, including the cart drawn by white oxen which were a common sight around the city and a Punch and Judy puppet show, add a contemporary note to animate the scene. The engraved version first appeared as the title illustration to the eighth volume of Murray's edition of Moore's *Life*, and subsequently in Finden's *Landscape Illustrations*. It relates

to *Childe Harold*, IV, CLII–CLIV:

Turn to the mole which Hadrian rear'd
 on high,
Imperial mimic of old Egypt's piles
…
But lo! the dome – the vast and wondrous dome,
To which Diana's marvel was a cell –
 … Majesty,
Power, Glory, Strength, and Beauty all
 are aisled
In this eternal ark of worship undefiled.[2]

1 David Blayney Brown, *Turner and Byron*, London (Tate Gallery) 1992, pp. 40–56.

2 *Ibid.*, p. 109, cat. nos. 65, 66.

J.M.W. TURNER

8 *The walls of Rome with the tomb of Caius Sestius*, 1833

Watercolour
Vignette 5³/₄ × 7⁵/₈ ins (13.5 × 19.5 cm); sheet
9¹/₈ × 11¹/₄ ins (23.2 × 28.5 cm)
The Trustees of the Tate Gallery, London

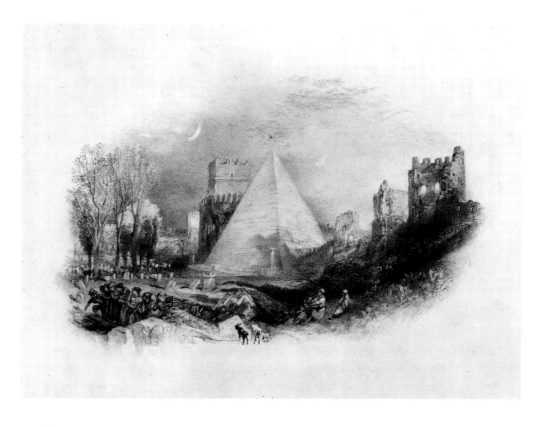

The Pyramid of Caius Sestius with the adjacent gate in the Aurelian Wall composed a naturally picturesque view popular with artists from the eighteenth century. The imposing tomb set among the crumbling but still monumental perimeter erected to defend Rome from its enemies at a time when her power was in decline served as a melancholy symbol of decay, not only of the individual commemorated (long forgotten, but for his memorial – a reminder of mortality and the transitoriness of fame) but also of the greatest empire in history. From the 1820s the place held an additional fascination for British visitors since the English Romantic poets Keats and Shelley were both buried in the Protestant Cemetery there.[1] The association is suggested in Turner's vignette, originally used for the title-page of the thirteenth volume of the *Life and Works of Lord Byron* published by John Murray between 1832 and 1833, by the inclusion of mourning figures around an open grave. Above all it was a place calculated to induce reflection, and Turner deepens the sentiment by adding a sunset and rising moon. The passage the vignette relates to is taken from a drama by Byron set in front of Rome's walls, but rather than illustrate the specific narrative Turner uses the scene to unite with Byron's verse to create by word and image a range of associational sensations:[2]

… but those walls have guided in great
 ages
And sent forth mighty spirits. The past
 earth
And present phantom of Imperial Rome
Is peopled with those warriors; and
 methinks
They flit along the eternal city's rampart,

And stretch their glorious, gory, shadowy hands,

And beckon me away.

Read together, verse and vignette encapsulate the spell that Rome's remains exerted on the Romantic imagination.

1 See also fig. 4 and cats. 38, 39.

2 From Byron's drama, *The Deformed Transformed*.

J.M.W. TURNER

9 *The Arch of Constantine, Rome, ca.* 1835

Oil on canvas
36 × 48 ins (91 × 122 cm)
The Trustees of the Tate Gallery, London
(Clore Gallery for the Turner Collection)

In the pictures he made of Italy and of Roman subjects in the 1830s, as Cecilia Powell has noted, Turner "grew less and less interested in amassing topographical detail and translating it into paintings; his imagination soared higher and higher".[1] *The Arch of Constantine* in its unfinished state shows Turner in the process of transforming his earlier experiences, conjuring with light and atmosphere to transfigure reality: what had once been a view is now becoming a vision. Compositionally, the picture pays an explicit tribute to Claude Lorrain. Its tones and colour correspond to the qualities that Turner defined as characteristically Claude's in a lecture he gave while he was Professor of Perspective at the Royal Academy: "Pure as Italian air, calm, beautiful and serene spring forward the works and with them the name of Claude Lorrain. The golden orient or the amber coloured ether, the midday ethereal vault and fleecy skies, resplendent valleys, campagnas rich with all the cheerful blush of fertilization, trees possessing every hue and tone of summer's evident heat, rich, harmonious, true and clear, replete with all the aerial qualities of distance, aerial lights, aerial colour...".[2] Turner would also

have known the passage in the *Discourses* of Sir Joshua Reynolds in which he described the effect of Claude's idyllic scenes on the mind – by referring to them in his own paintings he was deliberately making visual connections which he knew his viewers would recognize and react to imaginatively: "... he conducts us to the tranquillity of Arcadian scenes and fairy land. Like the history painter, a painter of landscapes in this style and with this conduct, sends the imagination back into antiquity...".[3]

Cecilia Powell has shown that *The Arch of Constantine* was originally conceived as the companion to another unfinished painting, *Tivoli with Tobias and the Angel* (Tate Gallery, London).[4] The presence of a biblical subject in the second picture raises the possibility that the Roman scene may also have been intended to have a religious content. The shadowy figures, no more than suggestions in *The Arch of Constantine*, might have added some kind of Christian meaning to the picture. Since the arch itself commemorated Constantine's victory at the Milvian Bridge after his conversion, there is already implicit a reference to Christianity's appropriation of Rome, and the association of the Colosseum with the early martyrs provides another possible clue. If Cecilia Powell's proposal of a theme connected with Resurrection is right, Turner could have had in mind perhaps the story of Christ's appearance to St Peter on the road leading from Rome which gave rise to the *Domine quo vadis?* subject in painting

(for example, the picture by Annibale Carracci in the National Gallery, London). Although the topography would be wrong, it is just the sort of imaginative transference between subject and setting that Turner sometimes indulged in, and it would be perfectly consistent with nineteenth-century ideas about ancient Rome and early Christianity. For the two pictures to be paired, an Old Testament subject contrasted with a New Testament theme, is entirely characteristic of Turner's ideas at the time as represented by, for example, *Ancient Rome* and *Modern Rome* [cats. 10, 11].

1 Cecilia Powell, *Turner in the South*, New Haven and London 1987, p. 191.

2 Quoted from J. Ziff, '"Backgrounds, Introduction of Architecture, and Landscape": A Lecture by J.M.W. Turner', *Journal of the Warburg and Courtauld Institutes* XXVI, 1963, pp. 124–47.

3 Sir Joshua Reynolds, *Discourse XIII*, 1786 (ed. Pat Rogers, *Sir Joshua Reynolds. Discourses*, London (Penguin Classics) 1992, pp. 291–92).

4 C. Powell, *op. cit.* note 1, p. 197.

9

J.M.W. TURNER

10 *Ancient Rome; Agrippina landing with the ashes of Germanicus. The Triumphal Bridge and the Palace of the Caesars restored*, 1839

Oil on canvas
36 × 48 ins (91 × 122 cm)
The Trustees of the Tate Gallery, London
(Clore Gallery for the Turner Collection)

In 1839 Turner exhibited three paintings at the Royal Academy with Roman themes: *Ancient Rome; Agrippina landing with the ashes of Germanicus*, its pair *Modern Rome – Campo Vaccino* [cat. 11], and *Cicero at his villa* [fig. 3 on p. 11; private collection]. The three must be read together as a series in which the juxtaposition of ancient and modern, past and present, expresses profound sentiments about the meaning of history and particularly classical, Roman, history for the contemporary world. Turner had used contrasts from the ancient world before to convey a topical meaning in the modern world: *Dido building Carthage: or the Rise of the Carthaginian Empire* (1815; London, National Gallery) and *The Decline of the Carthaginian Empire* (1817; London, Tate Gallery) can be interpreted as referring to recent events – Napoleon's imperial ambitions and downfall, set against the context of (and, by implication, representing a moral lesson to) British imperial aspirations. Britain is equated with Rome, Carthage's conqueror, by virtue of her defeat of France. Painted either side of the Battle of Waterloo (1815), the moral is clear: the triumph of constitutional freedom over despotism. Significantly, it is Rome *before* the Empire that is celebrated in the Rise and Decline scenes alluding to Carthage. Turner is not making a politically radical point, but using history to contrast different circumstances to draw a moral. The same ideas inform the literary and artistic reactions to the remains of ancient Rome in the eighteenth and nineteenth centuries. Turner in this respect follows a well established tradition, using Imperial Rome as a metaphor for the corruption and decadence that destroy liberty and civilization.

The pair of pictures illustrating the theme he showed at the Royal Academy in 1838, *Ancient Italy – Ovid banished from Rome* [fig. 6; private collection] and *Modern Italy – the Pifferari* (Glasgow Art Gallery and Museum), make his interpretation of history and the present clear with regard to Italy's past and its contemporary significance. Ovid's exile from the Rome of Augustus was interpreted as an injustice due to arbitrarily exercised power – an incident that denoted the beginning of the end of the virtues on which Roman greatness rested. The setting sun in *Ancient Italy* makes its allegorical meaning clear. *Modern Italy – the Pifferari* (*pifferari* being the peasant pilgrims who toured the countryside around Advent and Christmas to play their pipes before shrines dedicated to the Virgin) by contrast depicts the sort of pious superstitions that afflicted contemporary Italy, equating the decline of ancient Rome with the present state of society. Turner uses ancient and modern contrasted to comment on current circumstances, but not in a narrow sense: Italy's history and present condition have a more general lesson to teach.

In the same vein, *Ancient Rome; Agrippina landing* refers to an episode that had become an example for virtue confronting the moral decline that eventually led to Rome's destruction. Agrippina returned with her husband's ashes after he was poisoned on orders from the Emperor Tiberius: another incident from the early Imperial period which defined the beginning of Rome's decline and fall. In fact, Turner altered history for effect in the painting, since Agrippina had landed not in Rome but in Brundisium, but his reconfiguration of the event for imaginative impact (and to make the meaning he intended clearer) is no different to his management of Rome's topography in *Ancient Italy – Ovid banished* in which, for example, the Arch of Constantine (erected centuries after the episode depicted) has been transplanted to the bank of the Tiber. Turner used familiar monuments to conduct his viewer imaginatively into the scene and thus transport his audience back in time historically. In *Ancient Rome* he signals the flight of fancy the scene requires in the subtitle by restoring the Bridge and Palace of the Caesars – reconstructing the ruined Palatine which, because of its imperial associations, nineteenth-century accounts of Rome frequently singled out for special attention.

10

11

J.M.W. TURNER

11 *Modern Rome – Campo Vaccino*, 1839

Oil on canvas
35.5 × 48 ins (90.2 × 122 cm)
The Earl of Rosebery (on loan to The National Gallery of Scotland, Edinburgh)

This is the pendant to *Ancient Rome; Agrippina landing* [cat. 10], for which Turner adapted a quotation from Byron's *Childe Harold's Pilgrimage* to accompany the Royal Academy exhibition catalogue entry:[1]

The moon is up and yet it is not night,
The sun as yet divides the day with her.

The combination of the sunset and the rising moon romantically suggests the idea of modern Rome existing in some sort of eternal twilight, magically evocative of past grandeur but at the same time expressing decline and present decay. Contrasted with its companion, it represents Rome as a moral emblem, as a contemporary critic made clear:[2] "The glory has departed. The eternal city, with its splendours – its stupendous temples, and its great men – all have become a mockery and a scorn. The plough has gone over its grandeurs, and weeds have grown in its high places." An attentive reader of the Academy catalogue in 1839 may have been drawn further into the meaning of the picture by connecting the poetic allusion with the lines immediately preceding it in Byron's verse:

– and now, fair Italy!
Thou art the garden of the world
Even in thy desert, what is like to thee?
Thy very weeds are beautiful, thy waste
More rich than other climes' fertility:
Thy wreck a glory, and thy ruin graced
With an immaculate charm which cannot be defaced.

Taken together, *Ancient Rome* and *Modern Rome* are the visual equivalents of innumerable passages in contemporary and earlier literature reflecting on the ruins of the Forum. Their resonance was reinforced by the third Roman subject shown in the same exhibition, *Cicero at his villa* [fig. 3 on p. 11]. The champion of liberty exiled from the city was a powerful reminder of the moral values the Empire had abandoned, as Charlotte Eaton recalled when she surveyed the Forum:[3]

"Amidst its silence and desertion, how forcibly did the memory of ages that were fled speak to the soul!... the remembrance flashed upon my mind, that it was here Cicero accused to the assembled Senate the guilty conspirators leagued with Cataline [*sic*] ... It was there, then ... that the thunder of Cicero's eloquence burst forth to a people yet undegenerated from their ancient fame, and capable of feeling the virtue they inspired; – it was there, in the latter days, he roused so often the languishing spark of patriotism... as I gazed on the ruins around me, the remembrance of the scenes their early pride had witnessed, the long lapse of ages and the fall of tyrants that have since intervened, the contrast of past greatness with present degradation, of ancient virtue and freedom, with existing moral debasement and slavery – forced on my mind, with deeper conviction, the eternal truth, confirmed by the voice of ages – that man is great and prosperous only when he is free; that true glory does not consist in the mere possession of unbounded power or extended empire, but in the diffusion of knowledge, justice and civilisation; that while it is denied to the wanton conqueror of the world and the despotic master of millions, whose laurels are reddened with the blood of his fellow creatures ... it is the need of the enlightened statesman, and disinterested patriot, whose counsels have crowned them with peace and honour, and whose exertions have confirmed their liberties; and finally, that the memory of long successions of imperial tyrants, from Caesar to Buonaparte, must fade before the fame of Cicero!"

1 Turner has changed the second line, which in Byron's original reads, "Sunset divides the sky with her – a sea" (*Childe Harold's Pilgrimage*, IV, XXVII). See David Blayney Brown, *Turner and Byron*, London (Tate Gallery) 1992, p. 94.

2 Quoted from Martin Butlin and Evelyn Joll, *The Paintings of J.M.W. Turner*, London, revised edn. 1984, pp. 210–11 (no. 379).

3 Charlotte Eaton, *Rome in the Nineteenth Century*, edn. 1823, I, pp. 123–25. For the group of three paintings, see Kathleen Nicholson, *Turner's Classical Landscapes*, Princeton 1990, pp. 115–27.

SAMUEL PROUT
1783–1852

12 *The Forum of Nerva, Rome ('The Temple of Pallas'), 1827?*

Watercolour and bodycolour with pen
26¹/₈ × 19 ins (66.2 × 48.2 cm)
Birmingham City Museums and Art Gallery

Samuel Prout was born in Plymouth where he received his initial training in watercolour painting and drawing picturesque scenery. An early patron was the antiquary John Britton for whom he drew archaeological and architectural subjects from 1807. As Britton was a prolific writer on British antiquities who commissioned numerous drawings to illustrate his books (mostly about medieval architecture), Prout quickly became thoroughly conversant with the conventions of picturesque topography and in accurately recording ancient monuments. In 1819 he travelled abroad for the first time to France, and thereafter toured extensively on the Continent during the 1820s and 1830s. From these visits he produced many lithographs of picturesque subjects abroad, and engravings reproducing his work appeared in popular publications such as *The Landscape Annual* and *The Continental Tourist*. He was also a prolific exhibitor at the watercolour societies and at the Royal Academy. Prout was in Rome on a tour of Italy in 1824; thereafter he frequently exhibited Roman scenes, and several occur among his

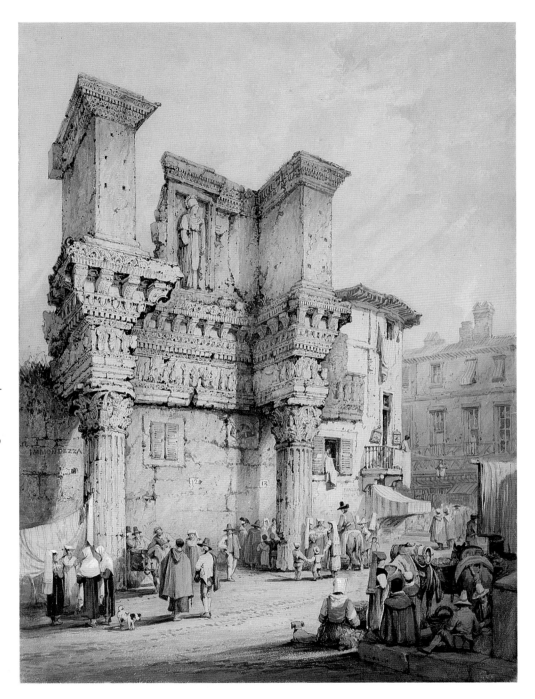

own prints (for example, his collection of lithographs of *Sketches in France, Switzerland and Italy* issued in 1839) or were reproduced in the landscape and travel anthologies published in the 1820s, 1830s and 1840s. Like Turner, Prout was one of the British artists whose Italian subjects reached a wide public through the print trade and helped to popularize the interest in travel.[1]

Prout's watercolour shows the remnants of the Temple of Minerva (also known by the Greek equivalent, Pallas) in the Forum of Nerva which lies between the Forum of Augustus and the Forum of Vespasian. The temple dates from the end of the first century and was admired as a particularly magnificent, though savagely mutilated, specimen of imperial ostentation. It appears as the American novelist Nathaniel Hawthorne described it in his enormously popular novel set in Rome, *The Marble Faun* (1860): "rich and beautiful in architecture, but woefully gnawed by time and shattered by violence, besides being buried midway in the accumulation of soil that rises over dead Rome like a flood-tide. Within this edifice of antique sanctity, a baker shop was now established, with an entrance on one side; for everywhere the remnants of old grandeur have been made available for the meanest of necessities of today." The site aroused strong religious associations since according to early historians the image of Pallas/Minerva had been greatly revered by the Romans who paraded Christians before it and tortured to

death those who would not venerate it.[2]

Samuel Prout exhibited more than one version of the subject either as *The Temple of Pallas* or as *The Temple of Nerva*:[3] an engraving after one of his views was published in Charles Heath's *Landscape Annual* for 1831, and Prout made a lithograph of the scene for his 1839 *Sketches in France, Switzerland and Italy*. He also painted variants in which he rearranged various features to create a more fanciful view of the monument. It has been suggested that the Birmingham drawing may be the 1827 Royal Academy exhibit.

1 Richard Lockett, *Samuel Prout 1783–1852*, London 1985.

2 Margaret Scherer, *The Marvels of Ancient Rome*, New York and London 1955, pp. 101–02.

3 1826 (Nerva), 1832 (Pallas), 1841 (Nerva), 1844 (Pallas), 1849 (Pallas): Society of Painters in Watercolours; 1827 (Pallas): Royal Academy. See Richard Lockett, *op. cit.* note 1, p. 139, for a smaller version, Victoria and Albert Museum, London.

SAMUEL PROUT

13 *The Arch of Constantine, Rome, from the south-east*, 1850(?)

Watercolour and bodycolour with pen
14¼ × 10¼ ins (36 × 26.2 cm)
The Trustees of the Victoria and Albert Museum, London

The Arch of Constantine standing near the Colosseum was dedicated in 315 to commemorate Constantine's victory over Maxentius at the Battle of the Milvian Bridge in 312. It had been

restored a number of times in the seventeenth and eighteenth centuries, and the area around its base was excavated in 1805 when the retaining wall seen in Prout's watercolour was constructed. The monument itself frequently appears in paintings, but usually as part of a general view with the Colosseum nearby or looking towards the Forum, or else showing one of its main elevations. Prout's view is unusually original, using the rearing mass of the end wall and the shadow cast over the lower part of the arch to create a dramatically illuminated and monumental effect that must owe its inspiration to G.B. Piranesi's etchings of the previous century. Although the arch was believed to predate Constantine's conversion to Christianity, it was sometimes viewed as an emblem of the religion that replaced Rome's pagan cults. It was also a symbol of decline, since when it was erected the capital of the empire had effectively moved to Constantinople, and the need to use earlier sculptures to supplement the artistically degenerate reliefs made for it showed how far Roman culture had deteriorated. The point was made abundantly clear by Edward Gibbon in *The Decline and Fall of the Roman Empire* (1776–88): "The triumphal arch of Constantine still remains a melancholy proof of the decline of the arts, and a singular testimony to the meanest vanity. As it was not possible to find in the capital of the empire a sculptor who was capable of adorning that public monument, the arch of Trajan … was stripped of its most elegant figures … The new

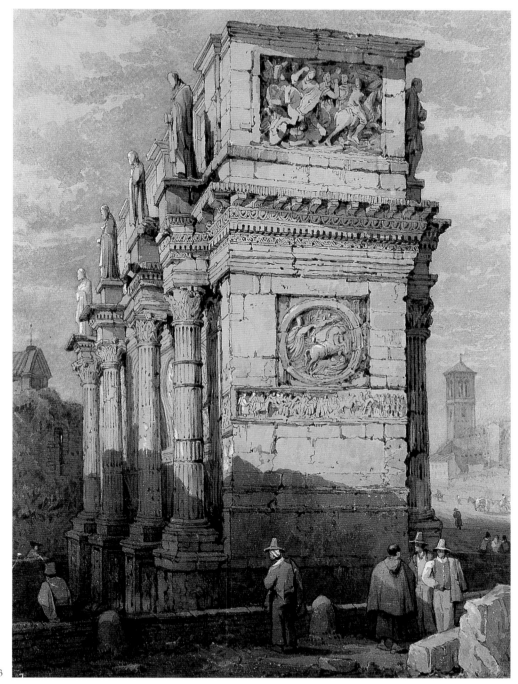

13

ornaments which it was necessary to introduce between the vacancies of ancient sculpture, are executed in the rudest and most unskilful manner."

Prout exhibited three versions of the subject between 1827 and 1850; another was engraved as a vignette for Charles Heath's 1830 *Landscape Annual*, and there are several others recorded. This drawing may be identified from its provenance as the watercolour exhibited in 1850 which was bought by the Reverend C.H. Townsend and bequeathed by him to the South Kensington Museum in 1869.[1]

1 The exhibited versions (1827, 1843, 1850) and other recorded examples are fully discussed in Richard Lockett, *Samuel Prout 1783–1852*, London 1985, p. 163.

SAMUEL PROUT

14 *Rome. The Forum*

Watercolour
$17\frac{1}{4} \times 11\frac{3}{4}$ ins (43.8 × 29.8 cm)
City Museum and Art Gallery, Bristol

In the foreground stands the Column of Phocas; beyond, from left to right are the Temple of Saturn, the two standing columns from the Temple of Vespasian, and the Arch of Septimius Severus, with the Palace of the Senator (built over the remains of the ancient Republican Tabularium) and the Renaissance *campanile* on the Capitol in the background. The confusion of fragments, partially excavated substructures and standing monuments,

enlivened by the addition of figures in colourful modern Roman costume, combine to create a particularly picturesque view of the Capitoline end of the Forum. It is, however, one in which the artist has played with the incidental details for purely ornamental effect. In fact the area surrounding the Column of Phocas had been substantially cleared by the French in 1813 during the Napoleonic occupation of Rome, when the pedestal was exposed revealing the inscription which recorded its erection in 608 to honour the Byzantine eastern emperor Phocas,[1] and further excavation had been carried out by the Duchess of Devonshire who was energetically archaeologizing in various places around the Forum from 1816. When Prout was in Rome in 1824 the area must have been a good deal tidier than it appears here, but nonetheless the drawing conveys very vividly the changing appearances that archaeology was effecting in the nineteenth century. As excavations led to new discoveries and improved the understanding and accuracy of the identity, history and topography of ancient Rome (previously the Phocas Column had been thought to have been part of a temple or of Caligula's Portico connecting the Palatine with the Capitol), so they captured the imagination of visiting tourists and artists, renewing the interest in and demand for views of this kind in the 1820s and 1830s. The discovery of the inscription to Phocas made the column a particularly poignant reminder of a civilization and empire that had

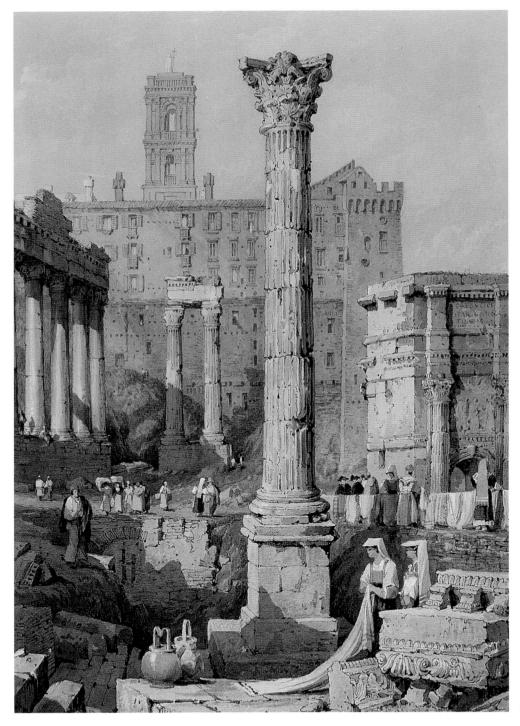

14

passed away: a fragment salvaged from some earlier monument and erected after the barbarian invasions, it could be seen in Margaret Scherer's words as "a sign of the fallen fortunes of Rome that the citizens set up no new column to honour this upstart Emperor of the East, but one carved long before and put to a new use".[2]

1 Ronald T. Ridley, *The Eagle and the Spade. Archaeology in Rome during the Napoleonic Era,* Cambridge 1992, pp. 123–26.

2 Margaret Scherer, *Marvels of Ancient Rome,* New York and London 1955, p. 66.

JOHN MARTIN
1789–1854

15 *The destruction of Pompeii and Herculaneum,* 1822–26

Oil on canvas
33 × 48 ins (83.8 × 121.9 cm)
The Trustees of the Tabley House Collection, Cheshire
(Not exhibited)

Martin rose to fame for his spectacularly dramatic, often fantastically visionary and intensely sublime historical landscapes and architectural epics, many of which he reproduced in brilliantly executed mezzotint engravings. He especially excelled as a printmaker in exploiting the rich contrasts available in mezzotint to create extraordinarily powerful images, in which his imaginative capacity to invent scenically theatrical architecture or landscape settings for great events was combined with a mastery of sensational effect. His subjects included biblical, historical and literary scenes in which he could allow his imagination free rein to conjure up the awe-inspiring, the epic and the fantastic with astonishing impact. His first critically acclaimed picture was the heroically sublime landscape with *Joshua commanding the sun to stand still upon Gideon* (Royal Academy, 1816; United Grand Lodge of England), followed by a succession of dramatic spectacles over a long career which included visions of Milton's Heaven and Hell and themes from Shakespeare, Byron, the Bible, ancient history and classical literature. Influenced by Turner's historical compositions and imaginative uses of landscape, architecture and atmosphere, Martin reconstructed extraordinary events in settings for which he drew on archaeological sources transformed by his own intensely romantic vision of the past. Their impact has continued into the twentieth century, with works like *Belshazzar's Feast* (1820; engraved 1832) and *The fall of Babylon* (1819; engraved 1831) influencing Hollywood biblical epics.

For *The destruction of Pompeii and Herculaneum* Martin consulted classical sources as well as the more recent literature on the site: in the description of the picture he published to accompany the exhibition of its first version in London (at the Egyptian Hall on Piccadilly) in 1822 he cites Pliny the Younger, Strabo, Diodorus Siculus and William Gell's *Pompeiana: The Topography, Edifices, and Ornaments of Pompeii* (1817–19). The original painting, twice the size of the Tabley House version, was ordered by the Duke of Buckingham in 1821 after he had failed to buy *Belshazzar's Feast.*[1] This smaller version was commissioned by Sir John Leicester (later Lord de Tabley) for the collection of pictures by artists of the modern British School he was forming at Tabley: a final payment for it was made in 1826. Martin's picture was essentially intended as an accurate historical reconstruction of the event. His depiction of Pompeii is archaeologically meticulous, and the Roman ships in a sea made rough by earth tremors and in danger of running aground as the waves retreat from the shore illustrate Pliny the Younger's account of the situation his uncle, Pliny the Elder, who was in charge of the fleet and died during the eruption, found when he sailed to Stabiae to rescue victims. The figures on the shore in the foreground include Pliny the Elder, and the whole scene is treated historically in an eighteenth-century tradition deploying the story of Pliny's heroic valour as an example of Roman virtue. At the same time, Pompeii's destruction might also arouse other thoughts, of the kind suggested by John Burford in the text that accompanied his panorama of Pompeii in 1824: "The destruction of cities, kingdoms, and empires, the exploits of heroes, and the conquest of nations, are so much the result of human combination, that the mind dwells with interest, perhaps, on the descriptions of these events, but contemplates them with few emotions of overpowering awe and surprise. In

15

the terrors of an earthquake and eruption ... or the horrors of a deluge, the interposition of Divine Power is so immediately apparent, as to arrest and occupy the attention with the sublimity of the event."[2] Soon, Pompeii's reputation for decadence was to make its

destruction into a moral symbol of retribution.

1 William Feaver, *The Art of John Martin*, Oxford 1975, pp. 55–59. The first version of the painting was sold from Stowe in 1848, bought by the National Gallery in 1869, and transferred in 1918 to the Tate Gallery where it was irrecoverably damaged by flood in 1928.

2 [John Burford and T. Leverton Donaldson] *Description of a second view of Pompeii, and surrounding country ... now exhibiting in the Panorama, Leicester Square*, London (C.& J. Adlard) 1824 (published anonymously).

JOHN MARTIN

16 *Marcus Curtius*, 1827

Sepia wash, signed and dated *J.Martin 1827*.
4³/₄ × 7 ¹/₈ ins (12.1 × 18.1 cm)
Laing Art Gallery, Newcastle upon Tyne
(Tyne and Wear Museums)

In a letter of 27 January 1849 (Laing Art Gallery) Martin describes the subject of the drawing, of which he made a mezzotint engraving in 1837: "Marcus Curtius was a Roman youth who devoted himself to the Manes for the safety of his country. About 360 BC a wide gap, called afterwards 'Curtius Lacus', had suddenly opened up in the forum, and the oracle said that it would never close before Rome threw into it whatever it held most precious. Curtius immediately perceived that no less than a human sacrifice was required. He armed himself, mounted his horse, and solemnly threw himself into the gulf which instantly closed over him." The sources of the legend are Livy (VII, VI) and Valerius Maximus (V, VI). Unusually, Martin's composition does not represent imperial Rome but the city at a much earlier, heroic period. As the setting for the story Martin has invented a Republican Rome, using a deliberately austere architectural style (Roman Doric, rather than the more embellished orders and ornamentally enriched buildings that signified post-Augustan Imperial luxury and decadence) to convey the spirit and virtue of nobler times. It provides a suitable context for the heroic sacrifice of Marcus Curtius, a

legend which epitomized the ideal of the *exemplum virtutis*. The composition is typical of Martin's historically romantic creations in which great events take place with huge crowds amid architectural grandeurs, but what makes his 'reconstructions' so interesting is the care he took over researching the details in order to make an historically convincing context for the subject depicted. In this instance, too, the topography is correctly configured, notwithstanding the artistic imagination in full flight. Beyond the Forum is the Republican Capitol. Nineteenth-century visitors to Rome would have been able to relate the scene to the sites they knew since they were familiar with the Lacus Curtius, a marshy spot in the Forum where there was a natural spring and

small pool. It was in this part of the Forum that one celebrated English visitor engaged in some amateur archaeology, as Henry Matthews recorded in 1817: "The Duchess of Devonshire is excavating round Phocas's Pillar; remaking the gulf which Curtius closed. Criminals in chains are employed in this work, under the superintendence of a military guard; – but, if patriotism and virtue be again necessary to fill up the chasm, where shall we find the materials here?" Part of the area the Duchess excavated is visible in Samuel Prout's watercolour of *The Forum* [cat. 14].

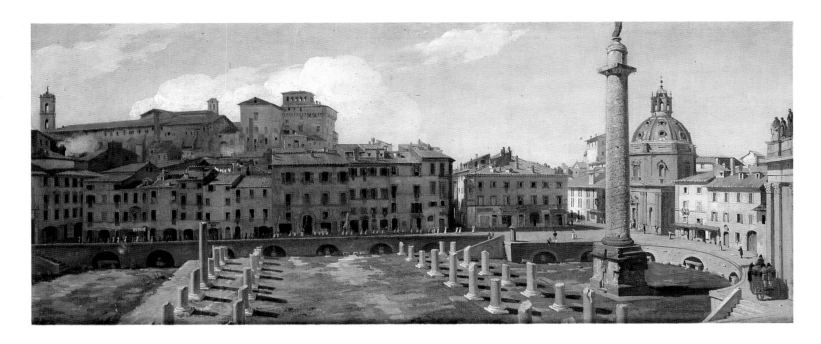

CHARLES LOCK EASTLAKE
1793–1865

17 *View of the Forum of Trajan, Rome,* 1821

Oil on canvas
15 × 35 ½ ins (38.1 × 90.2 cm)
The Trustees of the Victoria and Albert
Museum, London

Few Roman views painted in the early nineteenth century reveal so clearly the radical changes of appearance that parts of the city underwent as a consequence of the extensive clearances undertaken by the French during the Napoleonic occupation of 1809–14. Before their work Trajan's Column had stood in a small piazza without any of the remains of the colonnades of the Basilica Ulpia visible in Eastlake's picture appearing above ground level; close by were houses and the convents of Santo Spirito and Sant' Eufemia all of which were demolished to create the spacious area in front of the column which was excavated to reveal part of what had once been the grandest and most magnificent of the imperial fora. The transformation was astonishing, involving the clearance of an area one hundred yards long by sixty yards wide and excavated to a depth of some thirteen feet below the level that had existed before work began.[1] By their interventions the French made major changes to the topography of Rome as it had been known to eighteenth-century visitors, boldly recovering from amongst the often chaotic accumulations of medieval and modern buildings a clearer sense of the layout of the ancient imperial city – all, of course, for the glorification of the new empire and its ruler, Napoleon. A start had been made under Pope Pius VII between 1800 and 1809, and further works were carried out after 1814 by successive papal and civic administrations when Rome's remains became increasingly identified with Italian politics and nationalism.[2] One result of all this activity was inevitably to excite a renewed fascination with the past which invigorated both the antiquarian and the imaginative response to Rome, stimulating popular interest in archaeology at the same time as arousing the sensations and associations that find expression in romantic historicism in art and literature. Thus, although Eastlake's painting is a topographical view following the

eighteenth-century tradition of painters such as Canaletto, Pannini and the English Grand Tour souvenir painters, the novelty of what it presents relates it to the changing experience of Rome that gathered momentum after 1815.

Charles Eastlake began his artistic training as a pupil of the history painter Benjamin Robert Haydon in 1809 and continued his studies at the Royal Academy Schools where he absorbed the Neoclassical principles of painting. His ambition was "to throw my mind back as far as possible to the bright eras of Greece and Rome", and his first exhibited picture, of *Brutus exhorting the Romans to revenge the death of Lucretia* (Williamson Art Gallery, Birkenhead, 1814; British Institution, 1815) is a conventional exercise in the rhetoric of academic history painting – most interesting for its subject, a virtuous theme involving Roman ideals of freedom against tyranny with strong contemporary resonances for England once again confronting Napoleon in 1814–15. From 1816 until 1820 he travelled in Italy and Greece, and after briefly returning to England he settled in Rome in 1821 where he lived until 1830. There he painted views, and also sent back to London exhibitions history pictures, but he made his reputation with romantically popularizing scenes of contemporary Italian life involving peasants, brigands, and the like [see fig. 13 on p. 48]. Later he became a notable artist-administrator as President of the Royal Academy and Director of the National Gallery; he was knighted in 1850.

1 Ronald T. Ridley, *The Eagle and the Spade. Archaeology in Rome during the Napoleonic Era*, Cambridge 1992, pp. 152–69. The French scheme was finally completed in 1815 under Pius VII's restored administration.

2 Carolyn Springer, *The Marble Wilderness. Ruins and Representation in Italian Romanticism 1775–1850*, Cambridge 1987.

CHARLES LOCK EASTLAKE

18 *The Colosseum from the Maronite Convent, Rome*, 1822

Oil on canvas
20¾ × 25¾ ins (52.7 × 65.4 cm)
The Trustees of the Tate Gallery, London

Of all Rome's antiquities, the Colosseum was the most imposing, and, because of its history of imperial excesses, cruelty to Christians and its role as the place where the Roman populace and its rulers indulged their most extreme depravities, the ultimate symbol of the empire's inevitable ruin. Lady Sydney Morgan's *Italy* (1824) typically encapsulates the reaction of nineteenth-century visitors:

"… the last and noblest monument of Roman grandeur, and Roman crime – erected by the sweat and labour of millions of captives, for the purpose of giving the last touch of degradation to a people whose flagging spirit policy sought to replace by brutal ferocity. The first day's games given in this sumptuous butchery cost the nation eleven million in gold. The blood of five thousand animals bathed its arena. Man and his natural enemy the beast of the desert, the conqueror and the conquered writhed in agony together on its ensanguined floor: and eighty-seven thousand spectators raised their horrid plaudits, while captive warriors were slain 'to make a Roman Holiday'. Here was waged the double war against human life and human sensibility… All the recollections of this unrivalled edifice are terrible; and its beauty and its purport recall some richly wrought urn of precious ore, destined to enshrine the putrid remnants of mortality."

Eastlake's painting emphasizes the picturesque aspect of the Colosseum by framing it in a landscape and contrasting its architecture with the foreground occupied by a resting goatherd and his flock. The surrounding ruins, overgrown and reclaimed by nature, as well as the juxtaposition of decaying Roman grandeur with the pastoral simplicity of rural life, are conventional pictorial devices, but as is evident from contemporary descriptions of scenes like this they were features in the Roman landscape that served to remind visitors of human frailty and modern Italy's degraded condition.

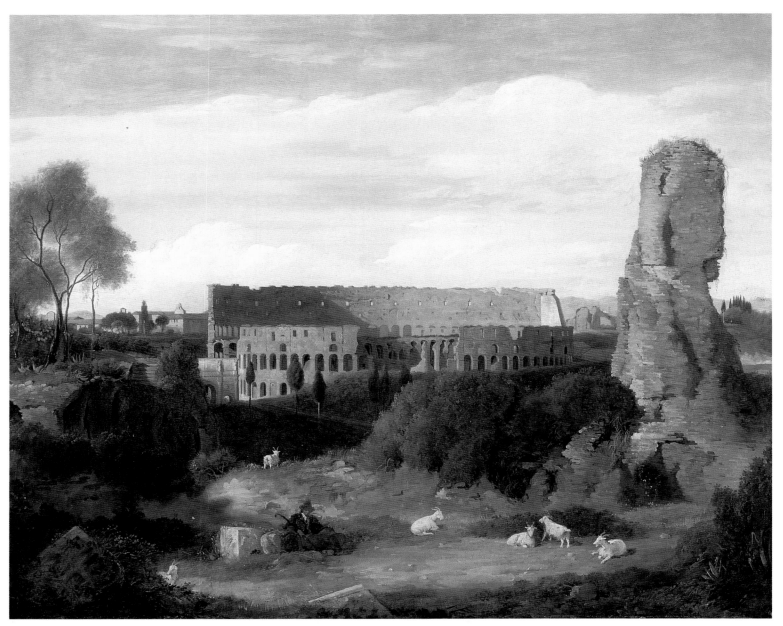

18

JOHN GOLDICUTT
1793–1842

19 *Ruins of the Basilica of Constantine, Rome*

Watercolour
19 3/4 × 15 1/4 ins (50.2 × 38.7 cm)
The Trustees of the Victoria and Albert
Museum, London

John Goldicutt was an architect who
trained at the Royal Academy Schools
(1812–15) and then briefly in Paris
under the Neoclassicist A. Leclère
before spending four years in Italy
(1815–19). From 1819 to 1830 he
worked for Henry Hakewill whose
pupil he had been before going to the
Royal Academy. He visited Italy again in
the 1830s. During his earlier tour he
collected materials for two books on
ancient remains, *Antiquities of Sicily*
(1819) and *Specimens of Ancient
Decorations from Pompeii* (1825). His
drawings are meticulously detailed and
finely coloured, and in the studies he
made of ancient buildings he shows a
distinctive feeling for form and scale
that reveals a powerful sense of the
architecturally dramatic. The massive
arches and coffered vaults of the aisles of
the Basilica of Constantine in this
watercolour present Roman architecture
in a powerfully evocative way, the qual-
ity of light playing on the textures of
stone and brick and casting shadows
that emphasize its relief, so giving the
drawing an especially vivid impact.

Begun by Maxentius (306–12) and

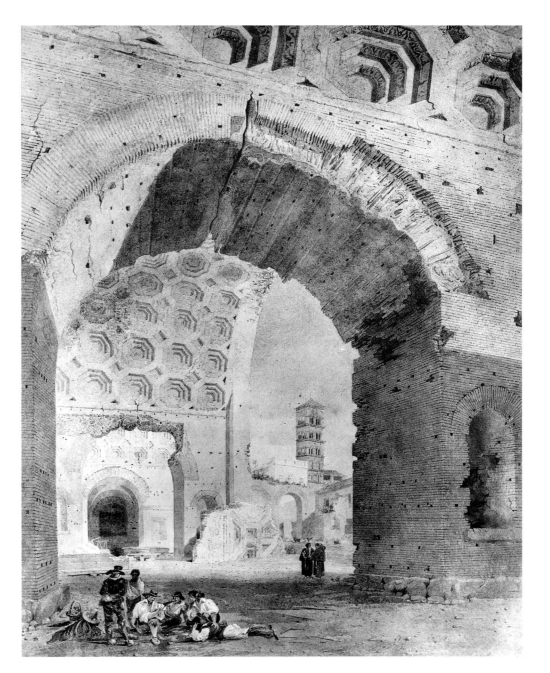

completed by Constantine, the Basilica was one of the most remarkable achievements of late Imperial Roman architecture, the largest structure overlooking the Via Sacra at one end of the Forum. For centuries when the Forum was used as a place for herding, grazing, selling and slaughtering cattle (hence its familiar name of Campo Vaccino, or cow pasture, used until well into the nineteenth century) parts of the Basilica were used to house hay-lofts and to shelter livestock. The French cleared the site during their occupation, and also made some repairs to the structure (particularly necessary after a major earthquake in 1812), but after they left the cattle returned to the Forum. The massive remains were generally considered to represent the end of Rome's architectural achievement: "The building of Constantine is remarkable as the last which bears the impress of the grandeur of ancient Roman genius" (Augustus Hare, *Walks in Rome*, 1893). In Goldicutt's drawing the medieval *campanile* seen through the arch beyond the Basilica ruins belongs to the church of Santi Cosma e Damiano, one of Rome's oldest churches, founded by Pope Felix IV in 527. The church was built attached to a small circular Roman building serving as an entrance atrium which became known as the 'Temple of Romulus', a case of mistaken identity which gave rise to the idea that it marked a site associated with Rome's original foundation (in fact it is much later, dating from after 307). To an informed visitor like Goldicutt, however,

the conjunction of Constantine's Basilica, the church of Santi Cosma e Damiano and the implied presence of the Temple of Romulus all within a single frame encompassed the whole history of ancient Rome. In reconstructing the meaning that a view such as this might carry for a nineteenth-century viewer, therefore, the historiography of Roman topography handed down across the centuries before modern scholarship and archaeology corrected earlier traditions is a factor that needs to be taken into account.

DAVID ROBERTS
1796–1864

20 *The Forum, Rome*, 1859

Oil on panel, signed and dated *David Roberts R.A. 1859*
15 $^{1}/_{8}$ × 24 $^{5}/_{8}$ ins (38.4 × 62.5 cm)
Corporation of London, Guildhall Art Gallery, London

Born in Edinburgh the son of a cobbler, David Roberts began his career apprenticed to a housepainter, then became a scene-painter for a travelling circus from which he moved on to painting stage-sets in various theatres, eventually reaching London in 1822 where he worked for the Drury Lane Theatre. He acquired his skills as a landscape and topographical artist in watercolours and oils by using manuals, copying, and through contacts with other painters whom he met through scene-painting. From the early 1830s to the end of his life he was one of the artists who exploited most

successfully the fashion for travel and the popularity of printed collections of picturesque Continental scenery and views of exotic places. He produced the drawings for four *Landscape Annuals* (1835–38) devoted to Spain and Morocco, illustrated Bulwer-Lytton's *Pilgrims of the Rhine* (1834) and was generally much in demand as a painter of travel pictures, which he exhibited prolifically. His most celebrated publications were *Picturesque Sketches in Spain, during the years 1832 and 1833* (1837) and *Views in the Holy Land, Syria, Idumea, Arabia, Egypt and Nubia* (1842–49). He twice visited Italy, travelling to Venice in 1851 and to Rome and Naples in 1853–54.[1]

Roberts was in Rome just after another phase of clearance in the Forum had been completed. The original French intention to clear the whole area had not been realised by the end of the occupation in 1814, although many of the later buildings among the Roman remains had been purchased and demolished. Pius VII had done some further work after 1814, but it was not until 1827 under Leo XII that a new scheme for a systematic campaign to clear the Forum and excavate the area down to its original level (involving the removal of a layer of later deposits over twelve feet deep) was approved. Various works were carried out into the 1830s, and there was another period of activity lasting from the brief rule of the Roman Republic in 1848–49 until 1853. Roberts painted seven views of different parts of the Forum following his visit in

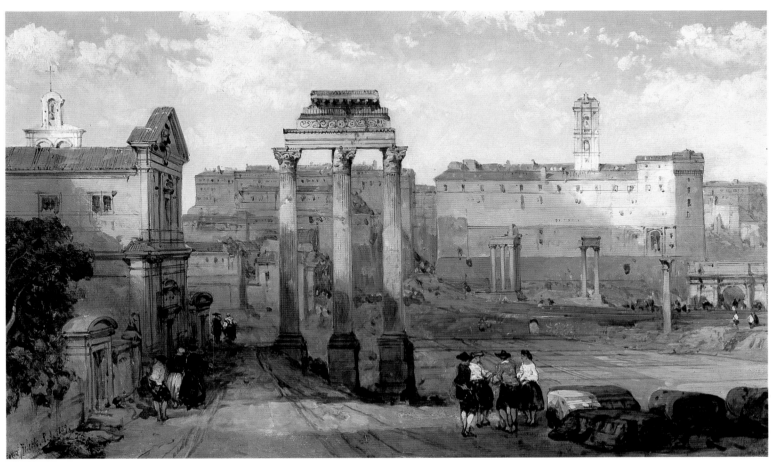

20

the winter of 1853–54. Here, the foreground is occupied by the three surviving columns of the Temple of Castor (known until later in the nineteenth century as the Temple of Jupiter Stator), one of the picturesque landmarks most often depicted in Forum views; on the left is the church of Santa Maria Liberatrice demolished in 1900–01. Beyond, across the paved area, are the columns of the Temple of Saturn and the Temple of Vespasian in front of the Palace of the Senator, while in the

middle ground on the extreme right of the painting is the Column of Phocas. Comparison with the views of the Temple of Saturn by H. W. Williams [cat. 1] and the Column of Phocas by Samuel Prout [cat. 14] painted in the 1820s reveal the extent to which the appearance of this area of the Forum had changed over the preceding thirty to forty years.

1 Helen Guiterman and Briony Llewellyn, *David Roberts*, London (Barbican Art Gallery) 1986.

DAVID ROBERTS

21 *At Rome*, 1859

Oil on panel, signed and dated *David Roberts R.A. 1859*
15 1/8 × 24 5/8 ins (38.4 × 62.5 cm)
Wolverhampton Art Gallery

A companion to the Guildhall Art Gallery painting [cat. 20], *At Rome* is another of the seven Forum views Roberts painted resulting from his time in Rome in 1853–54. The elevated view

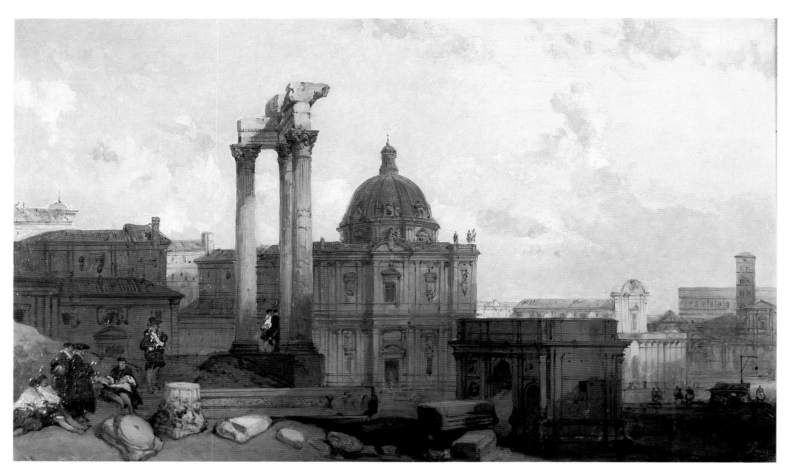

21

is taken from the edge of the Capitoline hill below the Palace of the Senator and beside the Temple of Saturn. The three columns are from the portico of the Temple of Vespasian built in the late first century; to the right is the Arch of Septimius Severus, and behind is the Baroque façade and dome of Santi Martina e Luca built in the 1630s by Pietro da Cortona, the church with which the Roman artists' Accademia di San Luca was associated. Further on in the distance and reflecting the sun from its distinctive light-coloured cipollino columns is the portico of the Temple of Antoninus and Faustina erected in 141 and converted in the seventh or eighth century into the church of San Lorenzo in Miranda, then rebuilt at the end of the sixteenth century and given its segmental pedimented façade in 1602. To the far right of the painting the church and *campanile* of Santa Francesca Romana rise immediately in front of the Colosseum. In this view, therefore, Roberts has given an extensive sweep across the Forum and route of the Via Sacra from the Colosseum to the Capitol, a prospect which to visitors in the eighteenth and nineteenth centuries summarized in its picturesque variety the changing continuities of Rome's history. The Reverend Hobart Seymour saw the same scene much as Roberts must have beheld it, and in his description of 1848 gives a vivid account of how it affected his imagination:[1] descending from the Capitol, the visitor "finds himself on that spot, which,

whether viewed in connection with the varied associations of the wondrous past, or with those exquisite groups of columns, the ruins of ancient temples that adorn it, must ever hold a very prominent place of interest in the mind... here is the arch of Severus, and the Via Sacra winding its way among the temples, and passing through this arch, and traversing the whole length of the Forum... It is altogether a scene so full of interest, so replete with objects, each in itself enough to supply the imagination with ample material for a noble epic... All is bewilderment, excess of beauties, repletion of wonders, crowding of memories, that fill and absorb the mind, and render it absolutely necessary to recur, again and again, and yet again, devoting the mind, day after day, to the thoughts that are suggested by each separate object... Imagination may wing its way through the remotest past, and command the range of thousands of years; but no imagination can grasp the multitude of objects of high and thrilling interest, that crowd the vicinity of the Roman Forum, unless they are taken in... slow and gradual succession...." Since the Wolverhampton and Guildhall Art Gallery paintings were made as a pair for the same patron they were evidently intended to convey the same sense of historical exhilaration when seen together.

1 The Rev. M. Seymour Hobart, *A Pilgrimage to Rome*, 4th edn. London 1851, pp. 140–41.

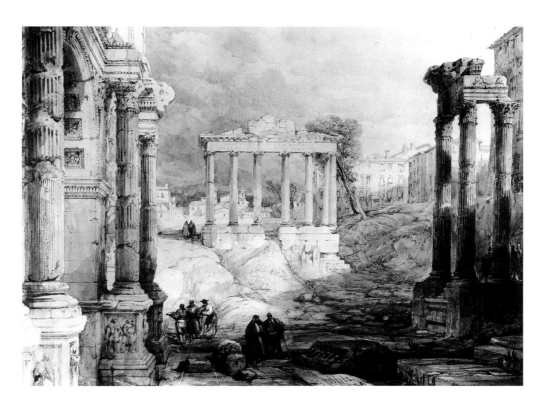

DAVID ROBERTS

22 *The Forum, Rome*, 1835

Watercolour, signed and dated
$11^1/_2 \times 15^1/_2$ ins (29.2×39.4 cm)
Manchester City Art Gallery

Drawn eighteen years before Roberts visited Rome, the watercolour is based on a sketch by another artist, W. Page. It was made as an illustration for a popular collection of views of places associated with biblical history which were first issued in 1836 in parts and then published by John Murray in two volumes: William Finden's *The Biblical Keepsake, or Landscape illustrations of the most remarkable places mentioned in Holy Scriptures.*

Another edition was produced later, also by John Murray, entitled *Landscape illustrations of the Bible, consisting of Views of the most remarkable places mentioned in the Old and New Testament, from original sketches taken on the spot.* Altogether one hundred views were engraved for the series, all of them reproducing watercolours done by leading landscape artists from sketches made by other professional as well as amateur draughtsmen: twenty-six were prepared by J.M.W. Turner, with the rest by artists who were major contributors to the popular illustrated travel literature and annuals of the time such as James Duffield Harding, Clarkson Stanfield and Augustus Wall Callcott. Roberts was assigned sixteen of

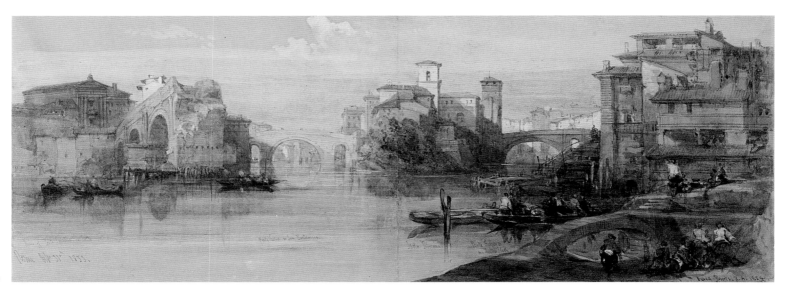

23

the series.[1] The publishers, the engravers William Finden and Edward Francis Finden together with John Murray, collaborated on several similar ventures involving 'literary' landscapes including *Landscape Illustrations to the Life and Works of Lord Byron* (1831–34) for which Turner made some Roman and Italian watercolours [cats. 7 and 8]. The great majority of plates in *Landscape Illustrations of the Bible* are of Holy Land subjects, with some Greek scenes and Roman views. The latter are, of course, relevant as sites of incidents from the New Testament, but they also aroused deeper religious sentiments as the introduction explained: "If Athens and Rome are visited with classic enthusiasm, how much more worthy of awakening the strongest emotions in the mind of a Christian must be the country whose history as far transcends in interest that of every other as its literature (if we may

apply that term to the divine volume) excels in sublimity all the ethics, and philosophy, and poetry and eloquence of the heathen world."

1 Mordechai Omer, *Turner and the Bible*, Jerusalem (Israel Museum) 1979.

DAVID ROBERTS

23 *Ruins of the Ponte Rotto, Rome,* 1853

Watercolour heightened with white, inscribed, signed and dated *Ruins of Ponte Palatine or Rotto Rome Octr 31st 1853* and *David Roberts R.A. 1854*
9 $^{1}/_{2}$ × 25 ins (24.1 × 65.9 cm)
The Trustees of the Cecil Higgins Art Gallery, Bedford

To the left of the picture are the three arches then surviving of the ancient Pons Aemilius project from the right bank of the Tiber. Begun in 179 BC and

completed 142 BC, it was the first of Rome's bridges to be built of stone and was one of the great engineering achievements in the city's history. The frequency with which the Tiber turned into a torrent and broke its banks meant that the bridge was often damaged and partially rebuilt over the centuries, but it was not until 1598 that it was finally rendered beyond repair by spectacularly severe floods: three arches collapsed and two of its supporting piers were swept away. Thereafter it remained a ruin and acquired its name of 'Ponte Rotto'. Much later, in 1885, most of what remained was dismantled to make space for the new Ponte Palatino and only one arch now survives stranded in midstream. It became a popular subject for artists, affording a fine picturesque feature in river views showing it together with the varied buildings on either side of the Tiber. The watercolour by

Roberts is more scenically panoramic than many, showing the full extent of the river where it is divided by the Isola Tiberina with the two bridges that join it to either bank. The massive scale of the remaining fragment of the Ponte Rotto contrasts with the buildings around it, giving a sense of its awe-inspiring monumentality even in its derelict state. Presumably it was so as not to detract from the bridge's grandeur and antiquity that Roberts omitted the iron suspension bridge which had been built on to it in 1853 to make a pedestrian crossing.[1]

1 Raymond Keaveney, *Views of Rome*, London and Washington 1988, p. 90.

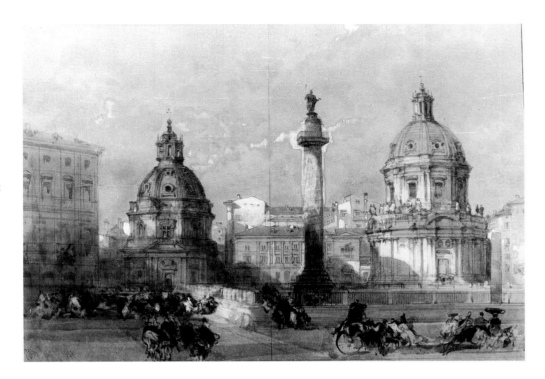

DAVID ROBERTS

24 *Trajan's Column, Rome*, 1854

Watercolour and bodycolour, signed and dated
14 1/3 × 20 ins (36.4 × 50.8 cm)
The Provost and Fellows of Eton College

This is a view from the end of the piazza in front of Trajan's Column and the two churches of Santa Maria di Loreto on the left and Santo Nome di Maria on the right. The French had opened up the area in 1809–14 when they cleared and excavated the site of the Basilica Ulpia in Trajan's Forum (see the *View of the Forum of Trajan* by Charles Eastlake, cat. 17). Trajan's marble column, along with the rest of the Forum, had been dedicated in 113; its celebrated continuous spiral relief depicts Trajan's campaigns in Dacia of 101–06 and attracted particular interest because of its very detailed representation of Roman military prowess at the height of the empire in the second century. The column had survived perfectly preserved since Roman times with the one exception that in 1588 the statue of Trajan at its top was replaced with one of St Peter by Pope Sixtus V in a fit of Counter-Reformation zeal. Its hollow interior with a staircase leading to a viewing platform at the top made it a favourite place from which to view the city. In the nineteenth century the site had become one of the places in Rome where visitors could experience an especially picturesque combination of archaeological remains and architectural splendour; this particular view was one of the most popular with the topographical artists and early photographers supplying the demand for tourist souvenirs.

PENRY WILLIAMS
1798–1885

25 *The Tiber with the Temple of Vesta and the Ponte Rotto from the Convent of San Bartolomeo, Rome*, 1828

Oil on canvas, signed and dated *Penry Williams, Rome, 1828.*
16 × 21¼ ins (40.64 × 54 cm)
The National Museum and Gallery of Wales, Cardiff

Penry Williams settled in Rome in 1827 and remained there for the rest of his life, returning to London for occasional short visits. He was a regular exhibitor at the Royal Academy, sending a steady stream of pictures from Italy which mainly consisted of landscapes and topographical views enlivened with picturesque figures to add local colour, but also included the kind of Italian peasant genre subjects which became popular with British collectors in the 1820s and 1830s. He became an established figure in the British artistic community in Rome, and was its longest resident member. He was an especially prolific painter of Roman and Campagna scenes, of which this is one of the earliest examples. He frequently returned to the same subjects, varying them slightly in their figurative content: several versions of the Temple of Vesta and Ponte Rotto view exist, one of the latest dating from 1870.[1] His pictures were popular for their bright colour and clear light, as well as the incidental narrative details which he introduced, adding a touch of authentic contemporary detail which appealed to the nineteenth-century taste for anecdotal or picturesque incident.

The circular temple in the Forum Boarium, the ancient cattle market, is of unknown dedication, but was for long identified as the 'Temple of Vesta' because of its proximity to the Tiber and the legend of the Vestal Virgin Tuccia who proved her purity by carrying water in a sieve from the river to the temple. Just visible in the bank below the temple and directly underneath the *campanile* of Santa Maria in Cosmedin is the top of the arch of one of the ancient Roman sewers which emptied into the Tiber, another of the remains which particularly aroused interest among visitors. It was part of the famous Cloaca Maxima, described by Henry Matthews in his *Diary of an Invalid* (1820) as "one of the most curious and interesting remains of Roman magnificence... They were, in the midst of the Roman greatness, and still are, reckoned among the wonders of the world." Matthews quotes another writer who noted that the Romans' sewers, superbly engineered on a huge scale such that a waggon loaded with hay might be driven through them, exceeded "what many well-accommodated cities of modern Europe have undertaken for their own conveniency". Later in the century, when expanded public sewage systems were proposed for great cities like

London, the Roman precedent was frequently cited – an instance of ancient history serving as a model for modern improvement, and an example of how Roman engineering was admired in the changing urban environment of the nineteenth century.

1 Christie's, London, *British Paintings*, 5 October 1984, lot 69.

PENRY WILLIAMS

26 *The Temple of Vesta, the Piazza di Bocca di Verità, and Santa Maria in Cosmedin*

Oil on canvas, signed *Penry Williams, Rome.*
8 ¼ × 12 ¼ ins (21 × 31.2 cm)
The National Museum and Gallery of Wales, Cardiff

26

Santa Maria in Cosmedin symbolized the interpenetration of the ancient, pagan past and Rome's early Christian history. Dating from the sixth century, the church incorporates parts of an older building which had been a granary, and in part it rises on the foundations of a classical temple. Inside the church the Roman columns of the grain hall are built into the walls, a reminder of how the early Church had assumed some of the functions of the imperial administration when it became the distributor of free grain to the population in place of the official agency and adapted what had been government buildings to ecclesiastical purposes. Thus the continuity from Roman to Christian eras in the city's history was represented by buildings like Santa Maria in

Cosmedin, seen in Williams's painting in picturesque conjunction with the ancient circular temple beside the Tiber. The piazza between them took its name from a Roman mask known as the 'mouth of truth', which survives beneath the church portico. The details of the inn and the ox cart (with the white long-horned oxen that were a familiar sight on Rome's streets) and the figures of peasants, pilgrims and priests are typical of the accessories Williams introduced in his paintings to add local colour and picturesque interest.

JOHN FREDERICK LEWIS
1805–1876

27 *Easter Day at Rome – Pilgrims and peasants of the Neapolitan States awaiting the benediction of the Pope at St Peter's*, 1840

Watercolour and bodycolour, signed and dated *J.F. Lewis 1840*
20 × 26 ½ ins (50.8 × 67.3 cm)
Northampton Art Gallery

A larger composition of the same subject (now in Sunderland Museum and Art Gallery; fig. 27), of which this watercolour shows only the central part, is signed and dated 1840. Lewis was one of the most successful travel artists of the nineteenth century. He was especially admired for his colourful observation of

27

local character and life in the places he visited. His first tour abroad was to Spain from 1832 to 1834 which resulted in a series of brilliantly radiant water-colours of picturesque and romantic scenes. He left England again in 1837, spending some time in France before going to Italy where he stayed two years until 1840. From there he travelled through Greece to Constantinople, Turkey and Egypt. He stayed abroad until 1851, living for ten years in Cairo from where he made excursions into Sinai and along the Nile. For the rest of his career he mainly painted exotic oriental subjects drawn from the streets, bazaars, mosques and domestic life of the Middle East. The two versions of *Easter Day at Rome* are the most impor-tant works he did in Rome. Typically it is the colourful and picturesque crowd

Fig. 27 John Frederick Lewis, *Easter Day at Rome*, signed and dated 1840
Watercolour and bodycolour, 30 × 53 ins (76.2 × 134.6 cm). Sunderland Art Gallery, Tyne and Wear Museums and Galleries

in front of St Peter's that interested him most. In this Lewis was responding to the growing taste encouraged by middle-class tourism for genre pictures showing the manners and customs of foreign countries. Lewis has filled his picture with anecdotal detail in much the same way that popular travel accounts of the time describe the incidentals of life in different parts of Italy. Sometimes, though, it is done to make a point: however picturesque or charming they may seem, peasants and pilgrims can signify a negative view of Italian society, as they did to Charles Dickens in *Pictures from Italy*. Others drew a moral from the magnificence displayed by the Church, epitomized by St Peter's and the Vatican Palace, contrasting its wealth and costly splendour to the condition of the "simple and credulous" who were its subjects.[1]

1 The Rev. M. Hobart Seymour, *A Pilgrimage to Rome* (1st edn. 1848), London 1850, pp. 91–92. Seymour also had a thoroughly derogatory view of the pilgrims who were a common sight in Italy, especially the vocational kind recognizable by their habits, distinctive 'clerical' hats and scallop-shell badges (*ibid.*, pp. 15–16).

SAMUEL PALMER
1805–1881

28 *Rome from above Santo Spirito*, 1838

Watercolour and bodycolour
$10^{3}/_{4} \times 14^{9}/_{10}$ ins (27.3 × 37.8 cm)
National Gallery of Scotland, Edinburgh

This is a general prospect of Rome taken from the Janiculum, a ridge overlooking the Tiber to the east of the Vatican (St Peter's is just out of sight to the left from this viewpoint) which was

28

one of the places recommended by the guidebooks as offering an especially fine view across the city and beyond to the Campagna and mountains in the distance. The situation was a favourite one with artists since it afforded such a comprehensive panorama of Rome's architectural splendours picturesquely com-

posed around the broad sweep of the River Tiber in the centre. The view from here embraces, framed between the medieval bell-tower of Santo Spirito and the cypress trees, the great mass of the Castel Sant'Angelo dominating the approaches to the Vatican immediately across the Tiber. Originally the

Mausoleum of Hadrian, it became the impregnable fortress of papal power in the Middle Ages and later, a symbol of the often corrupt and arbitrary authority the Church exercised for centuries over the city. Its notoriety as a prison, as well as its use as a refuge for unpopular papal courts in the more turbulent episodes in

Rome's history, made it a particularly potent but ambivalent symbol of the ancient past and of later times. To the other side of the river Palmer's view effectively conveys the densely crowded concentration of medieval and Renaissance Rome as it was before the clearances and replanning that followed the Risorgimento and the city's new status as capital of a united Italy. The most prominent features visible here are the churches and, in the middle distance, the portico and dome of the Pantheon; beyond, in the distance, the gardens of princely villas and the grand palaces on the Quirinal close the view. Palmer's watercolour evokes the scale of Rome before its late nineteenth-century expansion particularly well: the ancient city had been much more extensive and far more populous, and the contrast in extent and condition between it and the modern city exemplified for many English visitors the moral lessons to be learned from the end of the empire, the Church's baleful influence, and contemporary Italian circumstances.

SAMUEL PALMER

29 *A View of modern Rome during carnival*, 1838

Watercolour and bodycolour
15 $\frac{1}{4}$ × 22 $\frac{1}{4}$ ins (40.9 × 57.8 cm)
City Museum and Art Gallery, Birmingham

Samuel Palmer was in Italy for two years, from the end of 1837 until the late autumn of 1839. He went there immediately following his marriage intending to earn his living by painting topographical watercolours which he would sell to British visitors. In the event only one painting was purchased from him during the entire two years, a copy of *Modern Rome during carnival* bought by John Baring, a member of the famous banking family.[1] Adjusting to the requirements and conventions of descriptive view-painting did not prove easy for Palmer: his Italian scenes seem prosaic by contrast with the mystically religious and visionary landscapes he had done in the 1820s and 1830s around Shoreham in Kent, and they lack the concentrated intensity and romantic poetry that his work still retained in the mid-1830s after he abandoned Shoreham and became a more 'conventional' painter. Nonetheless, his Italian pictures have a distinctive quality of vivid colour and bright light, due to the individual technique he used, combining watercolour with opaque bodycolour. As he was not much practised in the traditions or discipline of topography, his views can be refreshingly different to those of his contemporaries – one reason, pre-sumably, why he sold so little.

Modern Rome and its companion *Ancient Rome* [cat. 30] were the first two large finished pictures Palmer painted in Italy and were exhibited at the Rome Academy in 1838 to draw attention to his work. In both of them he captures the quality of light which particularly attracted him: "Italy – especially Rome, is quite a new world – the magnitude of the buildings; the decorations of the churches – the processions of monks, the teams of bas-relief-like oxen – the statues in the open air; the antique ruins – and above all, the glorious sunshine which is worth coming the distance to see – leave only to be wished the English friends and fireside with a register stove, which last we should be much more likely to worship than relics and images …".[2] *Modern Rome* shows the seventeenth-century Piazza del Popolo with the twin churches of Santa Maria dei Miracoli and Santa Maria in Montesanto flanking the entrance to the Corso leading into the city. At carnival it became a temporary racecourse a mile long where riderless horses were raced each evening. The Roman carnival, preceding Lent, was a lengthy affair with much revelry, festive processions and popular entertainments: commentators sometimes observed that it was a legacy of earlier Roman festivals and customs, and some like the Rev. Seymour Hobart in his *Pilgrimage to Rome* expounded at length upon the iniquities of ancient pagan traditions carrying on within the Christian calendar and with the Church's approval.

29

30

1 For an account of Palmer's time in Italy, see Edward Malins, *Samuel Palmer's Italian Honeymoon*, Oxford 1968.

2 Raymond Lister (ed.), *The Letters of Samuel Palmer*, 2 vols., Oxford 1974, 22 December 1837, Samuel Palmer to his father-in-law, the painter John Linnell.

SAMUEL PALMER

30 *A View of ancient Rome*, 1838

Watercolour and bodycolour
$16^1/_5 \times 22^3/_4$ ins (41.1 × 57.8 cm)
City Museum and Art Gallery, Birmingham

Ancient Rome was exhibited together with its companion *Modern Rome* [cat.

29] at the Rome Academy in 1838. By painting an ancient and modern pair, Palmer was following an established precedent; however, unlike Turner's *Ancient Italy* and *Modern Italy* shown at the Royal Academy in 1838 and his *Ancient Rome* and *Modern Rome* exhibited in 1839, these watercolours are both contemporary views of Rome as it

appeared at the time they were painted. The associations aroused by the contrast, and the presence in the companion picture of carnival revellers, would probably have suggested a meaningful content to contemporary viewers. *Ancient Rome* shows the Forum towards the Colosseum as seen from the top of the tower of the Palace of the Senator on the Capitol; in the distance, stretching away across the Campagna, are the Roman aqueducts which so impressed travellers as they approached the city. Above all the view conveys how desolate and empty the Campo Vaccino must have seemed before it was cleared – the excavations around the base of the Column of Phocas in the centre of the scene give an indication of how deeply covered the original level of the Forum pavement had become. Within relatively few years the scene Palmer records had been transformed: excavations exposed the remains of many more features, the trees along the path from the Arch of Septimius Severus were cleared, and the area had ceased to serve as a cattle pasture. The view from the Capitol *campanile* was another of the vantage points especially recommended in the travel books, but relatively few pictures of it exist as the perspective was difficult to handle from such an elevated viewpoint, as Palmer noted in a letter:[1] "I have had a hard grapple with ancient Rome – for I was determined to get the whole of the grand ruins, which I believe has not yet been done. I got a little pencil sketch of it from a window ... then composed from it at home as I imagined it ought

31

to come if all of it could be seen, and then worked the details from the tower of the capitol where I saw everything – but 150 feet beneath me"

1 Raymond Lister (ed.), *The Letters of Samuel Palmer*, Oxford 1974, I, p.146 (7 June 1838).

SAMUEL PALMER

31 *The Street of the Tombs, Pompeii,* 1838

Watercolour and bodycolour
11³/₄ × 16⁵/₈ ins (28.9 × 42.3 cm)
The Trustees of the Victoria and Albert Museum, London

In the early summer of 1838 Palmer and his wife travelled south to Naples where they stayed for a few weeks before going to Pompeii where they remained for a month. In a letter of 14 July Samuel Palmer described their cottage and how "Going a few steps out ... we look down upon the dead city, not remarkable for grand or very spacious buildings, but having some elegant and classic temples, and shewing the detail of

ancient domestic architecture. Above the mutilated victim towers the dark Vesuvius; which has been rather uneasy of late, but refuses to give us the longed for spectacle of an eruption… Much as I love England – I think every landscape painter should see Italy. It enlarges his IDEA of creation and he sees at least the sun and air fresh from the hand of the maker." In another letter (16 September) he reported that he had made five finished watercolours at Pompeii, of the theatre, amphitheatre and Street of the Tombs. In this example the view is towards Vesuvius with part of the Bay of Naples visible. Like other visitors to Pompeii, Palmer was struck by the immediacy with which antiquity came alive in the "city of the dead" (a phrase he constantly quotes in his letters), but it was primarily the landscape around the Bay of Naples which excited his sensibilities:"… when we got upon the hills, and I saw it glittering through the gardens and vineyards, my heart opened, and I felt goodwill even for the Devil. It seems to me that all the choicest effects of shade and colours, all the happiest accidents – all the blooms and blushes of Nature hover about this enchanted region" (9 October, to his artist friend and associate from his Shoreham years, Edward Calvert).[1]

1 Quotations from Raymond Lister (ed.), *The Letters of Samuel Palmer*, Oxford 1974, I, pp. 155, 216.

SAMUEL PALMER

32 *The Ruins of the Amphitheatre at Pompeii*, 1838–39

Watercolour with bodycolour and gum arabic
13 × 19 ¹/₂ ins (33 × 49.5 cm)
Private collection (courtesy of Agnew's, London)

One of the most imposing and highly finished of Palmer's Italian subjects with Roman remains, the composition with its foreground figures adding local interest and a suggestion of narrative or anecdotal incident may, as has been suggested, reflect the influence of Turner's work.[1] The watercolour evokes both the grandeur that Roman monuments represented and the poetry of the landscape in southern Italy which Turner's exhibited oils and watercolours especially impressed on his contemporaries. Palmer himself was also deeply read in classical authors, particularly Virgil whose pastoral verse he illustrated, and the inclusion of the goatherd in the context of Roman associations and a romantically evocative landscape may be intended to add a literary inflection to the picture. Eighteenth- and nineteenth-century travellers habitually brought Virgil's poetry to mind when they admired the scenery of the region around Naples, and Palmer's own landscape vision owed much to his assimilation of ideas, sentiments and imagery acquired by reading the *Eclogues* and *Georgics*.

1 Raymond Lister, *Samuel Palmer, his Life and Art*, Cambridge 1987, p. 106.

SAMUEL PALMER

33 *The Colosseum, the Arch of
Constantine, and the Alban Mount from
the Palatine, Rome, ca.* 1843

Watercolour and bodycolour over black chalk
8 × 15 7/10 ins (20.3 × 39.9 cm)
The Visitors of the Ashmolean Museum, Oxford

Following his return to England in 1839
Palmer continued to paint Italian sub-
jects in which he recollected with poet-
ic sensibility the landscapes and classical
remains he had experienced abroad. In
these later compositions there is some-
times a more contrived and consciously
pictorial quality intended to appeal to

the taste of the English market, as in this
example which evidently reflects the
kind of ideal landscape deriving from
Claude Lorrain's seventeenth-century
formulations that still fundamentally
conditioned English perceptions of
Italian scenery. Although it lacks the
directness and immediacy of the pictures
he had painted in Rome, it typifies the
kind of popular picturesque view and
atmospherically suggestive effects that
were expected of such travel souvenirs.
Palmer's Italian subjects attracted the
attention of Charles Dickens, who com-
missioned him to design the illustrations
for his *Pictures from Italy*, for one of
which he adapted his *Street of the Tombs,*

Pompeii composition [cat. 31]. As Palmer
wrote in a letter of 1846, the illustra-
tions were to be decorative vignettes
"and like those in Rogers's Italy", a
reference which makes clear the debt his
own Italian vision owed to one of the
sources which most influenced the
English vision of Italy in the nineteenth
century.

114

ARTHUR ASHPITEL
1807–1869

34 *Rome as it was, restored after Existing Remains*, 1858

Watercolour
25 × 65 ins (63.5 × 165.1 cm)
The Trustees of the Victoria and Albert Museum, London

An architect by training and profession until 1854 when he ceased to practise because of his health and physical disability, Ashpitel was a friend of the painter David Roberts and joined him in Italy where he stayed in Rome for several years. He devoted the remainder of his life to antiquarian studies, becoming a Fellow of the Society of Antiquaries and regular contributor to the Archaeological Association, as well as a writer on architecture and archaeology

for the *Encyclopaedia Britannica*. The panoramic reconstruction of ancient Rome was exhibited at the Royal Academy in 1858, and together with its companion [cat. 35] was left by the artist to the nation in 1869. Its format may well have been suggested by the panoramic view Roberts painted of Rome at sunset in 1853.[1] For his drawing Ashpitel took a viewpoint from the imperial palace on the Palatine, looking out across the Forum and imperial fora in the middle ground towards the twin summits of the Capitoline crowned by temples to the left; in the centre the buildings of Trajan's Forum with his column appearing over the rooftop lead the eye to the right where the Quirinal hill with the Baths of Constantine rises over the city, and in the far distance on the horizon Diocletian's Baths are visible. Nearer to hand, at the extreme right is

the Colosseum and, just to the right of the foreground trees, the Colossus Neronis, the statue originally erected of himself by Nero but changed by Vespasian into an *Apollo*, moved by Hadrian and finally turned into a *Hercules* by Commodus. What Ashpitel has created in his drawing is a magnificent restoration of late Imperial Rome, using surviving remains and current archaeological understanding along with his architect's conception of Roman style to reconstruct a topographically convincing and reasonably accurately configured view. It conveys very vividly how the Rome of the emperors was visualized by the mid-nineteenth century.

1 David Roberts, *A panoramic view of Rome from Mount Onofrio*, 1853; Phillips Auctioneers, London, *Early British and Victorian Paintings*, 20 June 1995, lot 49 (reproduced in colour).

ARTHUR ASHPITEL

35 *Rome as it is, from the Palatine Hill,* 1859

Watercolour
24 × 65 ins (61 × 165.1 cm)
The Trustees of the Victoria and Albert Museum, London

Exhibited at the Royal Academy in 1859, the year after its companion [cat. 34], *Rome as it is* shows precisely the same view from the ruins on the Palatine. The two drawings together form an Ancient and Modern pair, but unlike Turner's treatment of the theme there is no romantically inspired sentiment to be read from them. Nonetheless, they afford a vivid insight into how the topography of Rome was experienced by visitors in the 1850s, and how difficult it must have been to imagine what the ancient city had looked like with its remains scattered amidst medieval, Renaissance, Baroque and modern buildings. The drawing also shows very clearly how the different levels of the Roman city had become obscured by the layers of accumulated debris the centuries had deposited. The view from the Palatine looking over the city is one that nineteenth-century writers frequently describe, and it was a sight that many of them recommended as an exemplification of transience and the decay that overcame the greatness of Rome. Ashpitel's drawing is the visual equivalent of what had become a commonplace literary convention, and viewers seeing it at the Royal Academy in 1859 no doubt would have invested it with the same associations that travel writers habitually brought to mind.

PAUL FALCONER POOLE
1807–1879

36 *The destruction of Pompeii, ca.* 1835

Oil on canvas
43⁷⁄₈ × 61³⁄₄ ins (111.4 × 156.8 cm)
City Museum and Art Gallery, Bristol

The appearance of Bulwer-Lytton's immensely popular novel *The Last Days of Pompeii* in 1834 was a powerful stimulus to the nineteenth-century British response to Roman life and history, and may well have inspired this spectacularly dramatic attempt to evoke the horror of the event. If so, it is one of the first pictures – possibly, indeed, the earliest – to have been painted in the immediate aftermath of Lytton's book capturing the imagination of the British public. At the same time it follows in a tradition of eruption scenes showing Pompeii's

destruction which extends back into the eighteenth century and begins with the Scottish painter Jacob More who exhibited *Mount Vesuvius in eruption: the last days of Pompeii* (National Gallery of Scotland, Edinburgh) at the Royal Academy in London in 1781.[1] More's painting, like John Martin's of forty years later [cat. 15] and Poole's version of the subject, is conventionally conceived within the theatrical idiom of the eighteenth-century sublime – a cataclysmic scene conveying the fearsome and terrifying power of nature to overwhelm and inspire awe in the beholder, and emphasizing the human horror of the event. Their representation of the subject owes much to the description of Pliny the Younger, who recorded the eruption that destroyed Pompeii. By the 1830s, however, the simple narrative had become imbued with moralising content: excavations had revealed plentiful evidence of the decadence of Pompeii's citizens, and Poole's painting could be viewed as a depiction of some kind of divine retribution, just as Lytton's novel uses the event to contrast Christian with pagan values. In his foreground Poole composes a scene reminiscent of biblical Deluge subjects, and it has been suggested that the picture may derive from Francis Danby's *Opening of the Sixth Seal* which was the most popular exhibit at the Royal Academy in 1828.[2] Equally, Poole's painting might be generically compared to John Martin's apocalyptic Old Testament subjects, or to some of Turner's histories such as his *Fifth Plague of Egypt* (1800, Indianapolis Museum of

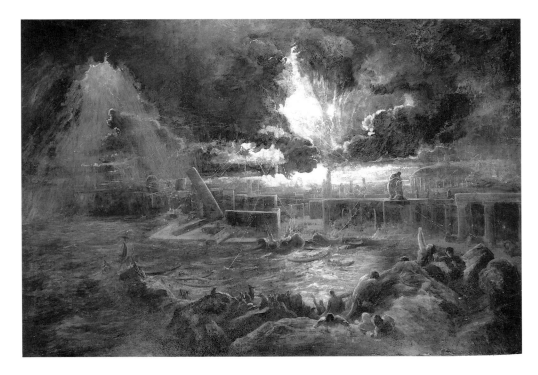

Art) or *Destruction of Sodom* (1805, Tate Gallery) – with all these it shares a romantically sublime character and vision, and like them it strikes the imagination forcefully while consciously referring compositionally to a type of picture that viewers in the 1830s would associate with moral overtones.

P.F. Poole was a Bristol-born artist whose interest in poetic and historical landscapes originated among the amateur and professional painters who formed a sketching society which met in the 1820s to make imaginative drawings inspired by literary sources. Until he left Bristol in 1824 Francis Danby was one of their circle, and Poole's early work owes much to the connection. *The destruction of Pompeii* is one of

Poole's pictures most obviously influenced by Danby; subsequently he went on to enjoy considerable success as a painter of historical subjects, becoming a Royal Academician in 1861. He exhibited two Roman subjects, *The Goths in Italy* (Royal Academy, 1851), illustrating a passage from Edward Gibbon's *Decline and Fall of the Roman Empire*, and a subject from Lytton's *Last Days of Pompeii: The escape of Glaucus and Ione, with the blind girl Nydia, from Pompeii* (Royal Academy, 1861).

1 For a short account of the subject generally, see Alexandra R. Murphy, *Visions of Vesuvius*, Boston, Museum of Fine Arts, 1978.

2 Francis Greenacre, *The Bristol School of Artists. Francis Danby and Painting in Bristol 1810–1840*, Bristol City Art Gallery, 1973, pp. 235–36.

THOMAS HARTLEY CROMEK
1809–1873

37 *The Temple of Saturn and the Temple of Vespasian, Rome*, 1842

Watercolour and bodycolour, inscribed and
dated *August 2 1842*
21¹/₂ × 15³/₄ ins (54.6 × 40.3 cm)
The Trustees of the Victoria and Albert
Museum, London

Thomas Cromek lived abroad between
1830 and 1849, mainly in Rome and
Florence. He travelled extensively in
Italy and Greece, specializing in making
very accurate watercolours and drawings
of classical remains. In 1837 in Rome
he gave lessons to Edward Lear, whose
early watercolours of similar subjects
follow Cromek's exacting observation of
light, colour and texture. His drawings
of architecture and archaeological
topography are very literally precise and
consequently are historically valuable as
accurate records of the appearance of
specific sites at the time they were
taken, whereas those of other artists
such as Samuel Prout or David Roberts
tend to rely more on picturesque or
atmospheric effect. Their highly finished
realism concentrates attention on the
antiquarian interest of the particular
scene, sometimes deliberately taking a
viewpoint which eliminates as far as
possible distracting details without,
however, sacrificing authenticity – in
this drawing, for instance, he has selec-
ted an angle which conceals the tower

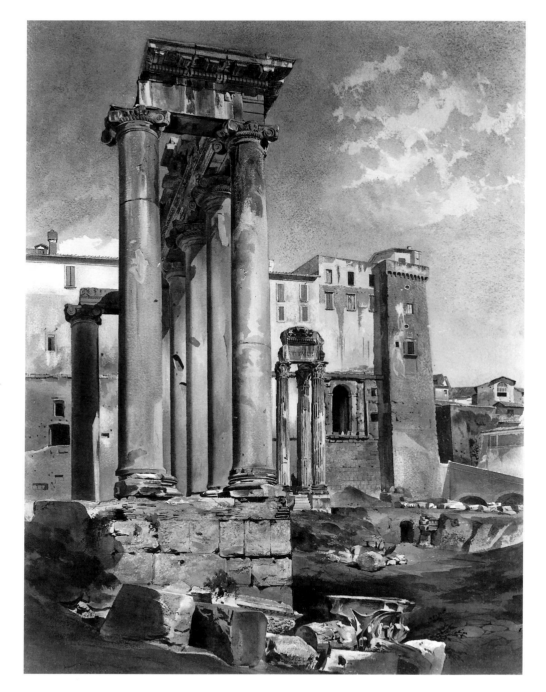

of the Capitoline Palace in the background and thereby emphatically accentuates the scale of the Temple of Saturn as it would impress itself on a visitor standing before it in the Forum.

WILLIAM BELL SCOTT
1811–1890

38 *Keats's grave in the Old Protestant Cemetery at Rome*, 1873

Oil on canvas, signed and dated *W.B.S. Rome. June 1873*
18⅞ × 13 ins (48 × 33 cm)
The Visitors of the Ashmolean Museum, Oxford

The Old and New Protestant Cemeteries, picturesquely situated where the Pyramid of Cestius is built into part of the Aurelian Wall, cast a very special kind of spell over English visitors in the nineteenth century. John Keats was buried there in 1821, and in 1823 the ashes of Percy Bysshe Shelley were interred in the New Cemetery on the other side of the pyramid. Romantic and literary associations mingled with ancient remains to arouse a variety of feeling that could be experienced nowhere else in Rome. In painting this picture and its companion William Bell Scott has captured the mood of a passage from Shelley's *Adonais: An Elegy on the Death of John Keats* (1821) describing the cemetery and expressing the sentiments it evoked for so many visitors:

Go thou to Rome, – at once the
 Paradise,
The grave, the city, and the wilderness;

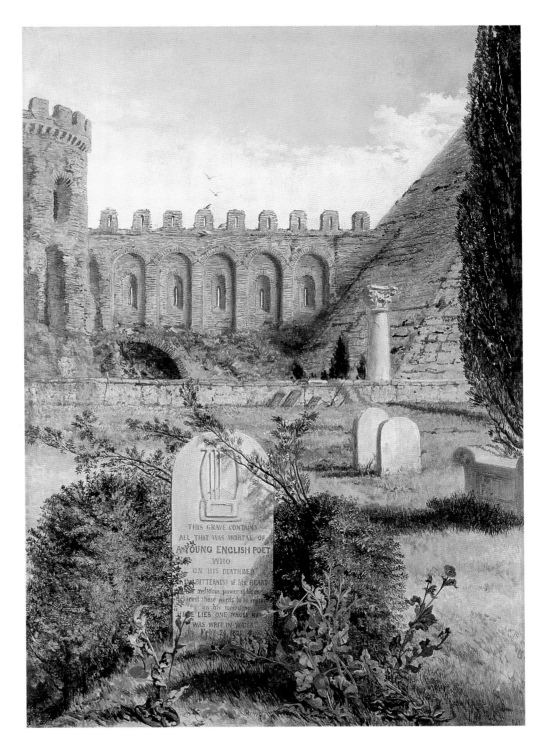

And where its wrecks like shattered
 mountains rise,
And flowering weeds, and fragrant
 copses dress
The bones of Desolation's nakedness
Pass, till the Spirit of the spot shall lead
Thy footsteps to a slope of green access
Where, like an infant's smile, over the
 dead
A light of laughing flowers along the
 grass is spread.

And gray walls moulder round, on
 which dull Time
Feeds, like slow fire upon a hoary brand;
And one keen pyramid with wedge sub-
 lime,
Pavilioning the dust of him who planned
This refuge for his memory, doth stand
Like flame transformed to marble; and
 beneath,
A field is spread, on which a newer band
Have pitched in Heaven's smile their
 camp of death,
Welcoming him we lose with scarce
 extinguished breath.

WILLIAM BELL SCOTT

39 *Shelley's grave in the New Protestant
Cemetery at Rome, 1873*

Oil on canvas, signed and dated *W.B. Scott.
Rome. June 1873.*
18 ⅞ × 13 ins (48 × 33 cm)
The Visitors of the Ashmolean Museum, Oxford

In his preface to *Adonais* Shelley had
written that "It might make one in love
with death to think that one should be
buried in so sweet a place". The

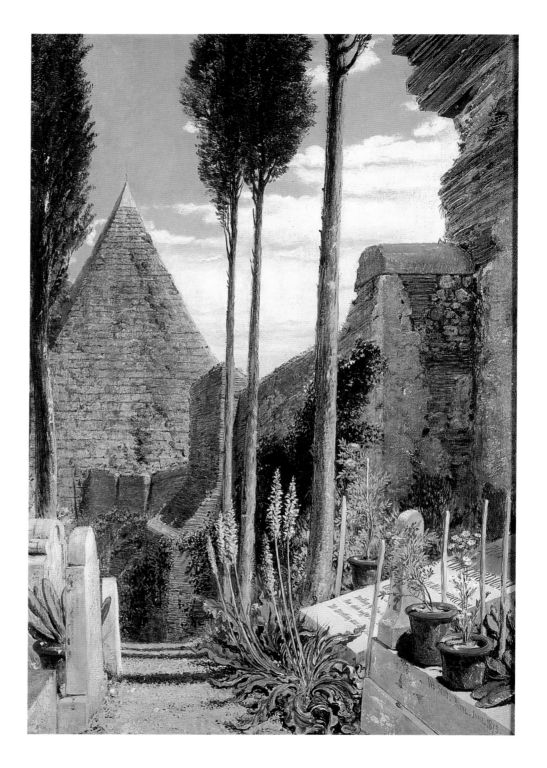

Protestant Cemetery generally inspired writers to reflect upon temporality and the subjectively experienced, emotionally felt sense of past and present which Rome excited in the imagination. For Henry James it was a place "where the ancient and the modern world are insidiously contrasted. They make between them one of the solemn places of Rome… Here is a mixture of tears and smiles, of stones and flowers, of mourning cypresses and radiant sky, which gives us the impression of looking back at death from the brighter side of the grave. The cemetery nestles in an angle of the city wall, and the older graves are sheltered by a mass of ancient brickwork, through whose narrow loopholes you peep at the wide purple of the Campagna. Shelley's grave is here, buried in roses – a happy grave in every way for the very type and figure of the Poet. Nothing could be more impenetrably tranquil than this little corner in the bend of the protecting rampart, where a cluster of modern ashes is held tenderly in the rugged hand of the Past. The past is tremendously embodied in the hoary pyramid of Caius Cestius, which rises hard by, half within the wall and half without, cutting solidly into the solid blue of the sky and casting its pagan shadow upon the grass of English graves – that of Keats, among them – with the effect of poetic justice. It is a wonderful confusion of mortality and a grim enough admonition of our helpless promiscuity in the crucible of time" (*Italian Hours*, 1909).

EDWARD LEAR
1812–1888

40 *The Baths of Trajan, Rome*

Watercolour
9¼ × 11⅞ ins (23.5 × 30.2 cm)
The Trustees of the Tate Gallery, London

When he was twenty-five Edward Lear decided to become a landscape painter, having earned his living over the previous nine years as a general draughtsman undertaking a variety of work, including ornithological illustration. In 1837 he went to Rome and remained in Italy, apart from two short visits home in 1841 and 1845–46, until 1848, leaving because of political unrest. The two occasions on which he returned to England were connected with publishing ventures: in 1841 he produced a collection of lithographs of *Views in Rome and its Environs* which was issued to subscribers, and in 1846 he completed a much more ambitious two-volume work, *Illustrated Excursions in Italy by Edward Lear*. When he was in Italy he taught drawing to English visitors and residents, and he also painted landscapes and topographical scenes which were bought or commissioned by patrons who were visiting or living in Italy. Like several British artists who were living there (among them Thomas Cromek,

41

Joseph Severn, Thomas Uwins, Penry Willliams), and others who stayed for shorter periods, Lear was able to make a good living selling paintings and watercolours to the travelling public, and there was also a growing British community for whom he could work. At the same time he was gathering material to use in illustrated travel and foreign landscape publications in which there was enormous interest at home, something he exploited successfully for the rest of his life, extending his travels throughout the Mediterranean and much further afield, into Egypt, the Near East and beyond to India.

While he was in Rome in the 1830s and 1840s Lear made many precise studies of its remains, as well as landscapes of the surrounding countryside. He also travelled extensively in Italy. His Roman sketches are exceptional for the brilliant quality of light and vivid immediacy they possess, and for the intensely direct observation of their subjects which give them an informal freshness and purely perceptual character which is distinctively original.

EDWARD LEAR

41 *The substructure of the Palace of Septimius Severus*

Watercolour
7 1/4 × 13 ins (18.4 × 33 cm)
The Trustees of the Tate Gallery, London

The remains of the emperors' palaces which covered the Palatine hill provided a magnificent spectacle for the nineteenth-century visitor. The Palatine was one of the sites where history and the romantic imagination engaged most productively, since it brought to mind so

many of the personalities who had created and destroyed Rome. Guidebooks tend to repeat the same litany of heroes and villains: Romulus who had founded the first settlement, Cicero who had lived on the hill, Augustus who was born there and for whom the first imperial palace was built there, Nero who had watched Rome burning from its terraces and whose Golden House had stretched across the Palatine to the Esquiline and Caelian hills, and so on to the final collapse. The romantic perception of the Palatine was definitively expressed by Byron in *Childe Harold's Pilgrimage* (IV, CVII):

Cypress and ivy, weed and wallflower
 grown
Matted and mass'd together, hillocks
 heap'd
On what were chambers, arch crush'd,
 column strown
In fragments, choked up vaults, and fres-
 cos steep'd
In subterranean damps...
Behold the Imperial Mount! 'Tis thus
 the mighty falls.

In the Renaissance the area was covered by the villas and palaces of princely families, their gardens incorporating ancient fragments and ruins as ornamental features. It was in one of them, the Villa Palatina, that Lady Blessington saw Napoleon's mother in 1828 and noted her sense of past and present coming together in the encounter: "Here was the mother of a modern Caesar, walking amidst the ruins of the palace of the ancient ones, lamenting a son whose

Fig. 28 After J.M.W. Turner, *The Campagna.* Engraving by F. Goodall for Samuel Rogers, *Italy*, 1830

fame had filled the four quarters of the globe".[1]

1 Marguerite, Countess of Blessington, *Idler in Italy: the Journal of a Tour*, 1839 (quoted by Margaret Scherer, *Marvels of Ancient Rome*, Princeton 1955, p. 56).

EDWARD LEAR

42 *Campagna di Roma: via Prenestina*, 1865

Oil on canvas, signed with monogram and dated
EL 1865
24½ × 53¼ ins (64.7 × 135 cm)
Private collection

The plains of the Campagna around Rome often seemed strangely desolate, "miles of barren common, much like Hounslow Heath".[1] The contrast with ancient times, when it had been a richly cultivated and prosperous area, was regularly remarked upon, and its remaining features of interest – the Roman roads, ruins of the great aqueducts, and scattered tombs – only served to emphasize

42

the air of decay, devastation and decline.
There must have been many travellers
whose response to the landscape coin-
cided with the opening lines of 'The
Campagna of Rome' in Samuel
Rogers's *Italy: A Poem* (1822):

Have none appeared as tillers of the
 ground,
None since They went – as though it
 still were theirs,
And they might come and claim their

own again?
Was the last plough a Roman's?

Lear's painting of the ruined Roman
sepulchre known since the sixteenth
century as the Torre de' Schiavi uses the
same imagery that Turner employed for
the vignette illustrating the lines by
Rogers [fig. 28]. Like other landscape
painters, Lear was attracted to the
Campagna by its solitude and the
changing effects of light and atmosphere

which added a distinctive poetry to the
picturesque potential of the scenery –
"There is a charm about this Campagna
when it becomes all purple & gold,
which it is difficult to tear oneself from.
Thus – climate & beauty of atmosphere
regain their hold on the mind – pen &
pencil."[2]

1 Henry Matthews, *Diary of an Invalid*, London
1820 (edn. Paris 1825, p. 52).

2 Letter, 27 March 1847, to Ann Lear.

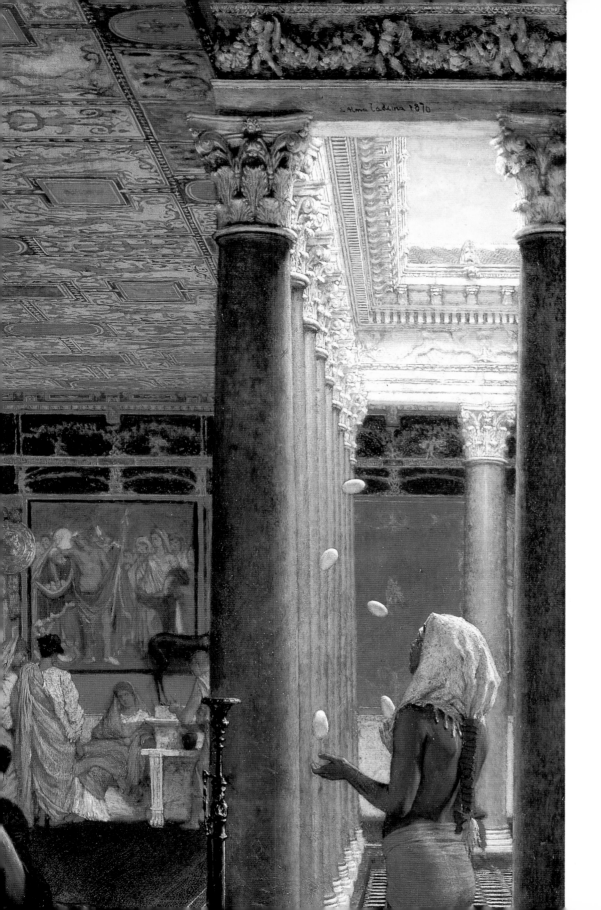

CATALOGUE II

Recreating Rome

ELIZABETH PRETTEJOHN

EDWARD JOHN POYNTER
1836–1919

43 *Faithful unto death*, 1865

Oil on canvas
45 ¼ × 29 ¾ ins (115 × 75.5 cm)
Exhibited Royal Academy, London, 1865
(no. 542)
The Board of Trustees of the National Museums
and Galleries on Merseyside (Walker Art Gallery,
Liverpool)

Faithful unto death became one of the
most famous images in Victorian paint-
ing, familiar to schoolchildren well into
the twentieth century through repro-
ductions in textbooks. Its popularity as a
didactic image depended on a simple
interpretation of its message about
obedience to duty; more recently, it has
been seen as a glorification of British
imperialism in Roman disguise.[1]
However, its meanings were more com-
plex for its original audience, to whom
Roman genre painting was a novel
category in 1865, when the picture
appeared in the same exhibition as
Solomon's *Habet!* [cat. 44]. Poynter
appended the following note to the pic-
ture's title: "In carrying on the excava-
tions near the Herculanean gate of
Pompeii, the skeleton of a soldier in full
armour was discovered. Forgotten in the
terror and confusion that reigned dur-
ing the destruction of the city, the sen-
tinel had received no order to quit his
post, and while all sought their safety in
flight, he remained faithful to his duty,
notwithstanding the certain doom
which awaited him."

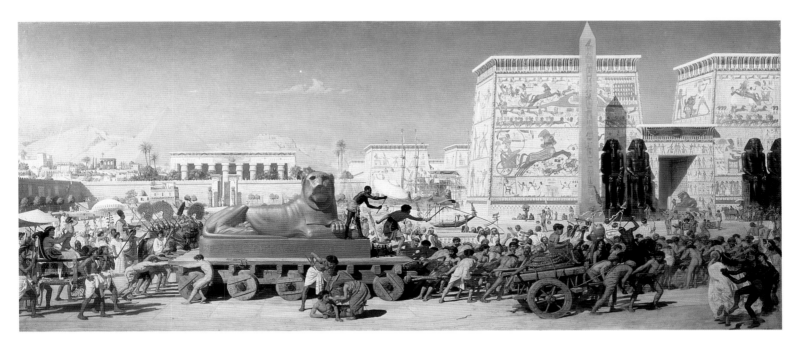

Fig. 29 Edward John Poynter, *Israel in Egypt*, signed and dated 1867. Oil on canvas, 54 × 125 ins (137.2 × 317.5 cm)
Corporation of London, Guildhall Art Gallery

The critics of 1865 emphasized the soldier's heroism. However, this is not a Roman history painting of the kind sanctioned by academic art theory; the 'hero' is not a general or statesman. He represents a class of ordinary people, unrecorded in the classical literary texts; instead, the evidence for his existence is archaeological. As Poynter took care to stress, the 'authenticity' of the picture derived from the physical remains of the sentry; all contemporary critics thought this fact noteworthy.

The figure's heroism is more poignant for having been lost to the written historical record. As F.G. Stephens put it in *The Athenaeum*, this is a "hero, – whose mere number in the century has perished"; nonetheless, he "sees the way of

his duty, and stands unknown but glorious".[2] Although the figure's humble social status is in abrupt contrast to the history painting tradition, this common soldier has the body of a Roman 'hero': his grip on the spear emphasizes the well developed musculature of his forearm, and his bare legs are well formed, by the standards of academic figure drawing.

However, the glorification of the soldier does not necessarily entail approval for the Roman social system that relegated this 'hero' to oblivion in the historical record. Although Poynter did not cite Bulwer-Lytton's *The Last Days of Pompeii* as his source, the subject is similar to an incident towards the end of the novel. Bulwer-Lytton presents the sen-

try's determination to stay at his post as deplorable submission to an autocratic régime: even the volcanic eruption "had not animated the machine of the ruthless Majesty of Rome into the reasoning and self-acting man! There he stood amidst the crashing elements: he had not received the permission to desert his station and escape."[3] The novelist's comment suggests that the picture should not necessarily be read as glamorizing obedience to imperial authority: it can also be read as critical of a system that deprives individuals of their capacity for independent action. The soldier's expression, staring up at the source of the glaring red light, suggests that he is well aware of his danger.

This does not rule out an 'imperialist'

interpretation: the soldier's submission to despotic imperial authority can be seen in antithesis to the 'free' British soldier of Victoria's enlightened empire. On the other hand, the picture can also be read as a criticism of authoritarianism, with relevance to the Victorian social system. Poynter's biblical picture of 1867, *Israel in Egypt* [fig. 29], was widely interpreted as a critique of forced labour with direct relevance to contemporary industrial labour; *The catapult* of 1868 [cat. 45] presents Roman soldiers compelled to serve as manual labourers.

Whatever Poynter's intentions were, the picture makes a fascinating example of the complexity of narrative modes in painting. Victorian narrative pictures are often treated as if their messages were cut and dried, but pictures such as *Faithful unto death* show that this was far from the case. Even for contemporary audiences, immersed in the cultural conditions of the time, different readings could be advanced for the same narrative image.

1 George P. Landow, 'Victorianized Romans: Images of Rome in Victorian Painting', *Browning Institute Studies* XII, 1984, p. 34.

2 'Royal Academy', *Athenaeum*, 13 May 1865, p. 658.

3 Edward Bulwer-Lytton, *The Last Days of Pompeii,* London 1834, Book V, Chapter VI.

SIMEON SOLOMON
1840–1905

44 *Habet!*, 1865

Oil on canvas
48 × 39 7/8 ins (122 × 101.5 cm)
Exhibited Royal Academy, London, 1865
(no. 431)
Private collection (on loan to Bradford Art Galleries and Museums, West Yorkshire)

Solomon's contemporaries identified *Habet!* as his most important painting, but by the end of the nineteenth century it had disappeared without trace. Its recent reappearance is therefore of vital importance to the study of Solomon's work and of progressive English painting of the 1860s, with which Solomon was closely associated until his arrest on a charge of homosexuality in 1873. *Habet!* was exhibited at the Royal Academy in 1865 together with Poynter's *Faithful unto death* [cat. 43]; the two pictures were pioneers of the new category of Roman genre painting. However, both were closely related to the earlier practice of literary illustration [see p. 65]. It has even been proposed that Solomon's picture was an 'illustration' to G.J. Whyte-Melville's popular novel of 1863, *The Gladiators*.1 Although the picture does not correspond to any scene in that novel, it dramatizes a stock scene, found in many historical novels about Rome, that reports the reactions of the spectators of a gladiatorial combat; these scenes often concentrate on the female spectators. A notable example occurs towards the end of *The Last Days of Pompeii*, describing the women's excitement as they see the nearly naked, highly trained bodies of the gladiators.

This helps to explain Solomon's characterization of the Roman women in *Habet!* The concern of the woman on the right, and the horror of the woman who has fainted on the left, suggest that they may have romantic attachments with the men fighting in the arena; romances between patrician women and gladiators were a common motif in historical novels. The central woman was identified as an empress by most contemporary critics: heavy lidded, full lipped, and draped in a blood-red robe, she displays a more mature and disturbing sensuality than the younger women. Her *décolletage* reveals the swelling of her heavy breasts; the ornate gold necklace draws attention to the bosom, where there hangs a winged male figure, perhaps an Eros, and probably based on a particular artefact. Similar jewellery had been found at Pompeii.

The sensuality of the figures appears more sensational in the context of the picture's subject: these women are watching a scene of violent combat and death. The expression "*Habet!*" (he has it) indicates that the crowd is denying mercy to the fallen gladiator. The blond figure to the right of the Empress was repeatedly described as "bloodthirsty" in contemporary critical notices. Solomon's friend, the poet Algernon Charles Swinburne, drew particular attention to this figure:2 "All the heads are full of personal force and character, especially the woman's with heavy brilliant hair and

glittering white skin, like hard smooth snow against the sunlight, the delicious thirst and subtle ravin of sensual hunger for blood visibly enkindled in every line of the sweet fierce features."

Swinburne suggests that the figure captures what he describes as "the ferocity of blondes". Her blondness probably refers to the fashion in the Imperial period for dyeing hair; it is an indication of the woman's vanity, to add to her other vices.

With hindsight, *Habet!* is easy to interpret as evidence of Solomon's fascination with illicit sexuality and sado-masochism; the picture's spectator notionally occupies the position of the fallen gladiator, under the gaze of the women who show him no mercy. However, contemporary critics did not react to the picture with horror: the presentation of Roman women as sensual and bloodthirsty accorded with contemporary notions about the decadence of Roman society in the Imperial period. Whatever private meanings the picture had for Solomon and Swinburne, its public meaning was not necessarily transgressive; it could be read as a censorious depiction of Roman depravity, rather than as a picture revelling in immorality for its own sake. Indeed, the picture's depiction of Roman cruelty, as well as the archaeological specificity of accessories such as the women's jewellery, helped to set a precedent for later Roman genre pictures, including many amphitheatre scenes presented as explorations of ancient Roman customs.

1 Percy H. Bate, *The English Pre-Raphaelite Painters: Their Associates and Successors*, London 1899, p. 65.

2 A.C. Swinburne, 'Simeon Solomon: Notes on his "Vision of Love" and other Studies', *Dark Blue* I, July 1871, pp. 571–72.

EDWARD JOHN POYNTER

45 *The catapult*, 1868

Oil on canvas
61¼ × 73⅓ ins (155.5 × 183.8 cm)
Exhibited Royal Academy, London, 1868 (no. 402)
Laing Art Gallery, Newcastle upon Tyne (Tyne and Wear Museums)

Three years after *Faithful unto death* [cat. 43], Poynter returned to the theme of the Roman soldier, this time with a setting during the Roman Republic: the inscription, *Delenda Est Carthago: SPQR*, indicates a Punic War subject. However, the picture does not represent a documented battle or a confrontation between the 'heroes', Hannibal and Scipio Africanus; instead it shows a group of common soldiers arming a catapult, under the direction of an anonymous commander. Although it was conventional to interpret the Republic as a less authoritarian period than the Empire, *The catapult* presents the Carthaginian siege as strictly disciplined: even the archers in the lower left corner are members of a workforce, rather than glorious warriors performing individual acts of heroism. Indeed, the depiction of Roman soldiers as manual labourers seemed strange to some critics. *The*

Daily Telegraph thought that the subject "presents no greater interest than if he had drawn a fatigue party of legionaries throwing up earthworks… or the Praetorian guards drawing their pay, and clamouring, like Oliver Twist in the story, 'for more'".[1] However, it was precisely the intention to present the routine business of Roman warfare.

Poynter uses the activity of arming the catapult to place a figure in the centre foreground, in the position traditionally reserved for the 'hero'; the figure's nudity must be a deliberate reference to the history painting tradition, ridiculed by Thackeray in his account of the Luxembourg Museum in 1839 [see p. 58]. However, Poynter adopts the convention of heroic nudity for a new purpose: the commanding officer is displaced to the right, behind a group of anonymous soldiers, to make way at the centre for a common soldier represented as a nude 'hero'. His pose displays his muscular chest, as well as both arms and legs; it is a variant of the pose of the celebrated antique statue the *Discobolus*. The paradox of presenting an ordinary working man as a nude Roman 'hero' would have been immediately apparent to its contemporary audience; most critics commented on Poynter's skill in the 'academic' drawing of the nude figure.

The prominence of the central nude figure can be seen as glorifying the working man; as in *Faithful unto death*, that is not necessarily incompatible with an interpretation of the picture as a critique of forced labour under an authoritarian system. However, it is also possible

to read the picture as celebrating the Romans' achievements in engineering, with the catapult itself as the 'hero', at huge scale and centrally placed. The victory over Carthage could then be attributed to the Romans' use of intelligence rather than brute force; in this case a positive parallel to contemporary British military achievements might be implied. Whatever Poynter's own intentions, this was an available reading for the contemporary audience: a number of critics delighted in describing the technological subtleties of the catapult in considerable detail. As in the case of *Faithful unto death*, the picture cannot be confined to a single, unambiguous reading.

The catapult set a crucial precedent for critical response: it was the first Roman picture accorded high status principally because of the 'authenticity' of its archaeological detail. Some critics introduced a motif that would later become common in the criticism of Alma-Tadema, finding the archaeological precision so vivid as to create a sense of experiential 'reality'. As P.G. Hamerton put it, in the *The Saturday Review*, the details of Roman siegecraft were "set forth visibly by Mr. Poynter with infinite spirit and skill, so that after seeing his picture we have the feeling of having been actually present at a Roman siege".[2]

The critical response suggests that archaeological erudition could already serve as a substitute for a specific historical subject, in elevating a Roman picture to high status. Even though *The catapult* was not a history painting in the

traditional sense, critics treated it as a picture of unusually high ambition. This opinion was evidently shared by the members of the Royal Academy, who elected Poynter to the rank of Associate immediately after the picture's exhibition.

1 'Exhibition of the Royal Academy', *The Daily Telegraph*, 24 June 1868, p. 7.

2 'Pictures of the Year', *The Saturday Review*, 30 May 1868, p. 719.

LAWRENCE ALMA-TADEMA 1836–1912

46 *The flower market*, 1868 (*'A Roman flower market'*)
OPUS LXII

Oil on panel
16½ × 22¾ ins (41.9 × 57.9 cm)
Manchester City Art Gallery
(Not exhibited)

This early picture by Alma-Tadema represents a marketplace, a common theme in Dutch genre painting, transferred to an ancient setting, the Roman provincial town of Pompeii. Within its small dimensions, the picture presents a variety of commercial transactions, all of which involve the pleasures of the senses: men drink in the wine-shop in the right background, while in the left foreground a young man strikes a bargain with a seated woman who may be selling her sexual favours as well as the fragrant flowers. Vern Swanson's recent catalogue raisonné of Alma-Tadema's work notes the comment by the earliest

cataloguer of the artist's works, Carel Vosmaer, linking the picture with a classical epigram: "You with the roses, rosey is your charm; but what do you sell, yourself or the roses, or both?" Swanson casts doubt on the implication, citing the artist's assertion that the young man is buying flowers for his beloved, presumably a respectable woman of his own social class.[1]

However, the association of the flower-girl with prostitution was clearly a possible reading for contemporaries. The exchange of glances between the standing man and the seated flower girl leaves the narrative tantalizingly open, but the pair is counterpointed against the well-to-do couple at the extreme left, who have just purchased a bouquet. The juxtaposition suggests a contrast between the respectable partnership of social equals, and the unequal transaction between the patrician man and the plebeian flower-girl. The differences in social status are emphasized by the figures' poses and costumes. The patrician figures stand upright and wear carefully draped togas, while the flower-girl sits on the ground amid her wares, wearing a practical headband that contrasts with the elegant sweep of drapery over the patrician woman's elaborate coiffure.

The principal incident occurs in one corner of a decentralized composition, creating the sense of a casual glimpse of bustling everyday life. In the narrow side street, women draw water from the well while working men lift heavy amphorae for the wine-shop. Victorian historical novels presented the ancient Roman

wine-shop as a place for class mixing, gambling and dissolute behaviour; the picture shows figures drinking and socializing in the middle of the day. Despite the hint of disreputability, the elegant statuette and metalwork drinking bowls suggest the prosperity of Roman life, even in this obscure corner of a provincial town.

The inscriptions on the walls help to characterize the commercial environment: the figures are surrounded by the ancient Roman equivalent of advertising. The most legible inscription appears on the corner of the wine-shop, a favourite location for such inscriptions; it appears to be an election poster similar to numerous examples found at Pompeii. The names of the candidate, Marcus Epidius Sabinus, and his supporter Suedius Clemens are familiar from extant Pompeian inscriptions.[2] Less decipherable are the writings on the receding wall at the left, but the general configuration, with numerous notices on panels separated by pilasters, is of a type well known from Pompeian examples. The form of the lettering, in slender, elongated capitals, appears 'authentic'. Moreover, there may be a reference to the ancient practice of whitewashing over older notices to make space for new ones: the election poster shows faint traces of an earlier inscription, imperfectly covered by the whitewash, between the top and bottom lines of lettering. The picture therefore offers a detailed survey of the ancient Roman practice of inscribing notices and advertisements on walls.

Since this picture was not exhibited in England until after the artist's death, contemporary critics had no opportunity to record their opinions of it. However, the picture's recreation of ancient Roman commercial life evidently appealed strongly to art collectors. When the picture appeared at auction in 1873, it sold for £640 10s., a remarkably high price for so small a picture; when resold in 1898 it was more expensive still, at £924.[3]

1 Vern G. Swanson, *The Biography and Catalogue Raisonné of the Paintings of Sir Lawrence Alma-Tadema*, London 1990, p. 150.

2 Catharine Edwards has identified the two names on the election poster; for an example of one of Clemens's surviving posters, see *Corpus Inscriptionum Latinarum*, IV, 768. For further information on Pompeian election posters, see James L. Franklin Jr., *Pompeii: the electoral programmata, campaigns and politics, A.D. 71–79*, Rome 1980.

3 Swanson, *op. cit.*, p. 150.

LAWRENCE ALMA-TADEMA

47 *Un amateur Romain*, 1868 ('*A lover of art*') OPUS LXV

Oil on panel
31 × 22 ins (78.7 × 55.9 cm)
Exhibited Royal Academy, London, 1869
(no. 154)
Glasgow Museums: Art Gallery and Museum, Kelvingrove

This was one of two pictures contributed by Alma-Tadema to the first Royal Academy exhibition in which he participated; its companion was a Greek subject, *Une danse Pyrrhique* (Guildhall Art Gallery, London). As critics noted, the two pictures juxtaposed contrasting phases in ancient civilization: the vigour of pre-Classical Greece and Imperial Roman decadence.[1] At his first major public exhibition in England, Alma-Tadema presented himself as a historian of ancient progress and decline; this also allowed him to display the wide range of his archaeological erudition.

Un amateur Romain presents a group of Romans admiring a Hellenistic statue, reproduced from an original in Rome, as critics informed their readers.[2] The theme of Roman connoisseurship, frequent in Alma-Tadema's early work, has been interpreted by some recent scholars as flattering to the artist's Victorian patrons. However, contemporary critics interpreted the picture as a satire on the vulgarity of Roman taste. The statue the figures admire is in silver; this refers to the complaint, in the history of ancient art by Pliny the Elder, that the Romans of the Imperial period valued works of art more for the precious materials of which they were made than for their aesthetic excellence.[3]

The statue's owner pays no attention to the work of art: his concern is with impressing his guests, whose reactions he scrutinizes. This corresponds to a stock scene in Victorian historical novels about Rome, in which a wealthy Roman host invites his guests to admire his collections of art and precious objects. Such scenes reflect a contemporary stereotype about the Romans as a collecting rather

than an originating nation; frequently the emphasis is on the Imperial Roman practice of plundering Greek cities for their works of art. In the picture, as in the novels, Roman connoisseurship is presented as a matter of acquisitiveness and social status. It is possible that Alma-Tadema was offering a disguised critique of Victorian middle-class patronage, often attacked in similar terms; he was also inviting his audience to share the pleasure of ridiculing ancient Roman Philistinism.

The figural characterizations are overtly unflattering. The foreground woman wears the elaborate 'false front' of curls, dyed blonde, of Roman Imperial fashion; this is a sign of her vanity, as her pose, intent in the contemplation of the vulgar statue, ridicules her pretensions to expertise as a connoisseur. The owner of the statue is overweight and complacent, reclining indolently on the couch; his hair and beard may also be dyed. The setting emphasizes the 'decadent' luxury of the Imperial period, presenting the heavy porphyry columns of an elaborately decorated peristyle from an oblique angle. As one critic observed, the columns appear to have been "erected regardless of expense".[4]

Although Alma-Tadema's work had appeared in London before, at small exhibitions organized by his dealer, Ernest Gambart, his contributions to the Royal Academy of 1869 provided critics with the first significant opportunity to respond to his approach to antiquity. Some critics found the figural charac-

terizations in *Un amateur Romain* unpleasantly cynical, but the general response was one of admiration for the artist's ability to create a compellingly 'realistic' ancient Roman world, through the accumulation of archaeologically precise detail. The critic for the major specialist art periodical, *The Art-Journal*, expressed the consensus:[5] "The picture restores to life what has been dead in antiquarian detail; the old Roman citizen now walks before us, treading on ancient mosaics and surrounded by antique bronzes and classic columns." The emphasis on the immediacy of the recreated Roman material environment would dominate the English critical response to Alma-Tadema's work for the rest of his career.

1 'The Royal Academy', *The Athenaeum*, 1 May 1869, p. 609.

2 'The Exhibition of the Royal Academy', *Illustrated London News*, 12 June 1869, p. 602.

3 *The Elder Pliny's Chapters on the History of Art*, trans. K. Jex-Blake, London 1896, p. 7.

4 'The Royal Academy', *The Athenaeum*, 1 May 1869, p. 609.

5 'The Royal Academy', *The Art-Journal*, N.S. VIII, 1 June 1869, p. 168.

LAWRENCE ALMA-TADEMA

48 *Un jongleur*, 1870 ('*A juggler*')
OPUS LXXVII

Oil on canvas, mounted on panel
31 × 19 1/2 ins (78.7 × 49.5 cm)
Exhibited Royal Academy, London, 1870 (no. 153)
Stanley J. Allen

Un jongleur is perhaps the most complex example of Alma-Tadema's characterization of the private life of a patrician family. Wealthy and materialistic, this Roman family inhabits an interior well stocked with luxury objects, including a fresco on the rear wall that appears to be a Bacchanalian scene similar to examples found at Pompeii; this suggests that these Romans are not averse to the pleasures of the flesh. The women are frivolous and fashion-conscious: the woman on the couch in the left background wears a 'false front'; she and one of her companions have dyed red hair. Moreover, the men of the household have no business more important than to watch a juggler's tricks. These are idle, privileged Romans, served and entertained by slaves who come from the empire's subject nations; contemporary critics identified the juggler as an Egyptian.

The Roman artefacts form a complete inventory of the kinds of archaeological data that Victorian painters could introduce into their reconstructions of ancient life. Some elements are exact reproductions of well known objects,

easily recognizable to contemporary critics: the bronze statue of the infant Hercules wrestling with the snakes reproduces an original in the Museum at Naples, and the statue of a stag came from Herculaneum. Other elements, such as the frescos, are creative interpretations of the kinds of objects found at Pompeii. The foreground bench was based on a studio prop Alma-Tadema had commissioned, in imitation of a common kind of ancient bench. Even the figures are 'imitated' from ancient sources, according to the critic F.G. Stephens, who linked the women in the background group to epigrams by Martial, satirizing the 'false front' and the practice of hair-dyeing.[1]

The picture therefore brings together a collection of identifiable artefacts, each of which has a claim to some kind of 'authenticity'; but their claims to authenticity are disparate. Alma-Tadema's technical skill created the illusion that this collection of archaeological fragments represented a complete world. However, the overall composition reasserts the notion of the fragment. Only a corner of the peristyle is shown, seen in a sidelong glance down one of its colonnades. The figural groups are dispersed in an unorthodox manner, for the painting of this period: the monumental colonnade interrupts the narrative space between the juggler and his audience, and the other groups are pushed to the edges. Two of the figures are cut off at the left edge; Alma-Tadema was an early user of the device of edge-cropping, usually associated with

French Impressionism in later decades. Even the famous statue of the stag is rendered a fragment, its head cut off by the colonnade. Such compositional devices are ubiquitous in Alma-Tadema's pictures. At one level they help to create a sense of 'life-like' immediacy, but at another they call attention to the partial or fragmentary nature of attempts to restore the completeness of the Roman material world.

Alma-Tadema's technique does not differentiate 'real' ancient objects from invented props, or important works of art from the other accessories of Roman luxury. Indeed, the famous statues are relegated to the background, while trivial accessories occupy centre stage: a bronze candelabrum usurps the centre foreground. The position that, in a traditional history painting, would be accorded to the highest-ranking human figure is here occupied by a material object.

The 'materialism' of this Roman world has multiple functions. Not only does it display the precision of the painter's technique; it draws on an important motif in the history of ancient art by the Elder Pliny, who repeatedly complained that the Romans valued works of art only as so many luxury objects. The candelabrum may even refer to a particular passage where Pliny comments that "we are not ashamed to give as much for [a bronze candelabrum] as the year's pay of a military tribune".[2] The candelabrum may, then, be the family's most expensive material possession: its position at centre

stage reflects its importance in the family's 'luxurious' life.

The 'materialism' of the picture is also central to its claim to 'authenticity'. Not only are the individual objects verifiable as 'real' survivals from the Roman past; the technique of accumulating material objects corresponds to the archaeologist's method of gathering evidence about the past. Alma-Tadema's treatment imposes no hierarchy of values: a candelabrum is of equivalent value, as 'evidence' about the Roman past, as a celebrated work of fine art.

1 'The Royal Academy', *The Athenaeum*, 7 May 1870, p. 619.

2 *The Elder Pliny's Chapters on the History of Art*, trans. K. Jex-Blake, London 1896, p. 11.

LAWRENCE ALMA-TADEMA

49 *Pottery painting*, 1871
('*Etruscan vase painters*')
OPUS XCIV

Oil on panel
15½ × 10¾ ins (39.4 × 27.3 cm)
Exhibited French Gallery Winter Exhibition, London, 1871–72 (no. 67)
Manchester City Art Gallery

The female painter is the creative spirit in this ancient workshop, standing back to judge the effect of her work. Her theatrical attitude contrasts with the workmanlike poses of her male colleagues, clearly subordinate to her: one is seen from the back, and cropped at the left edge; the head of the other is obscured, indeed cut in two, by the

woman's dramatic gesture.

Critics offered contrasting interpretations of the female painter's role when the picture was first exhibited in 1871. *The Art-Journal* noted, with evident approval, that "A woman is the principal in this antique studio".[1] However, F.G. Stephens of *The Athenaeum* thought that the woman was being ridiculed for her pretentious absorption in a vase whose design he described as "old-fashioned".[2] The different responses indicate the complexity of male attitudes towards the woman artist, a major issue in the Victorian art world, particularly after the debates of the 1860s over the admission of women to the Royal Academy Schools, the traditional educational institution for the élite among art students.[3]

Alma-Tadema's picture makes an intriguing comparison with James McNeill Whistler's representations of female art-workers in another setting that came into vogue in the 1860s, the Far East; Alma-Tadema and Whistler shared an interest in Japanese prints. Whistler had exhibited an oil painting of a female vase-painter in a Chinese setting in 1864, and he would certainly have seen *Pottery painting* at the French Gallery in 1871. Early the next year Whistler was working on a figure of a female Japanese art-worker, intended to join a series of portraits of artists commissioned for the new South Kensington Museum; two drawings show the female artisan painting a fan and a parasol.[4] Whistler's Japanese artisan would have been the only female artist in the South Kensington series, had he

completed the commission.

Both Alma-Tadema and Whistler focus attention on the female artist, but both limit her creativity to the decorative arts. When Alma-Tadema painted a series of pictures representing the fine arts of painting, sculpture and architecture, in 1877, the depicted artists were male.[5] Indeed, the male artists in *Painters* (untraced) study the female figure in her traditional role as nude model. It is possible, then, that Alma-Tadema's (and Whistler's) pictures represent a conservative point of view that identified the humbler decorative arts as a more appropriate field for a woman than the fine arts.

There were further associations for the female vase-painter. Spectators familiar with the ancient literature on the history of art would have been reminded of the group of legends connecting the invention of figural decoration with a Greek maiden's desire to record the image of her beloved by tracing his profile on the wall. *Pottery painting* might, however, be described as bringing these romantic legends down to earth: the lover is not present, and the workshop is devoted to the commercial production of vases. Moreover, in the legends it is not the woman herself but her father who is the vase-painter.[6] If Alma-Tadema's female artist is relegated to the lower sphere of the decorative arts, she is at least permitted pre-eminence in her own sphere.

The artisans in *Pottery painting* are probably Greek, demonstrating the Victorian notion of the Greeks as a

creative nation, in contrast to the Romans as a nation of collectors [see cat. 47]. However, Ian Jenkins has identified the central vase, on which the woman is at work, as an Apulian red-figure *lekythos*; the picture may therefore represent the Greek pottery industry of southern Italy.[7] The theme of commercial production of vases, in a workshop employing both male and female artisans, corresponds to new historiographical interests in the social and economic history of the ancient world; another aspect of ancient commercial life is explored in *The flower market* [cat. 46].

1 'The French Gallery', *The Art-Journal*, N.S. x, 1 December 1871, p. 291.

2 'Winter Exhibition, French Gallery', *The Athenaeum*, 4 November 1871, p. 597.

3 Deborah Cherry, *Painting Women: Victorian Women Artists*, London 1993, pp. 55–57.

4 Margaret F. MacDonald, *James McNeill Whistler: Drawings, Pastels and Watercolours: A Catalogue Raisonné*, New Haven and London 1995, nos. 458, 460.

5 See Vern G. Swanson, *The Biography and Catalogue Raisonné of the Paintings of Sir Lawrence Alma-Tadema*, London 1990, nos. 216, 221, 222.

6 Swanson connects the picture with the legend of the daughter of Dibutades (Swanson, *op. cit.*, p. 164). Although the legend was probably among the associations suggested by the picture, *Pottery painting* does not precisely represent the story of Dibutades, which involved modelling on a more archaic type of vase; see *The Natural History of Pliny*, trans. John Bostock and H.T Riley, London 1898, VI, p. 283.

7 Ian Jenkins, 'Frederic Lord Leighton and Greek vases', *Burlington Magazine* CXXV, October 1983, pp. 602–05.

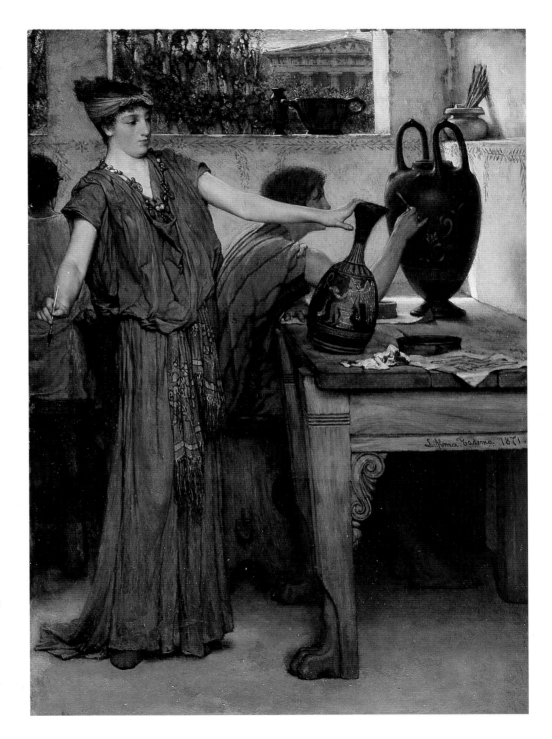

DANTE GABRIEL ROSSETTI
1828–1882

50 Study for *Dis Manibus* (*Roman widow*), ca. 1873

Pen and brown ink
7 1/16 × 6 1/2 ins (17.9 × 16.5 cm)
The Visitors of the Ashmolean Museum, Oxford

This drawing was probably a preparatory study for Rossetti's painting, *Dis Manibus* (Museo de Arte de Ponce, Puerto Rico). The drawing corresponds closely to the painting, one of the period's rare representations of a virtuous Roman woman [cf. cat. 54]. The widow sits beside the cinerary urn containing her husband's ashes, and inscribed *D.M.* for *Dis Manibus*, a dedication to the gods of the dead; she plays two musical instruments, in her husband's honour and in expression of her grief.

The loyal widow was a traditional subject for history painting, the quintessential *exemplum virtutis* involving a woman; the most compelling example of a Roman widow was Agrippina, who brought Germanicus's ashes back to Italy in a number of history paintings, including Benjamin West's famous picture in the Royal Collection [fig. 18 on p. 57]; see also cat. 10.[1] The theme of the loyal Roman woman had a particular attraction for Rossetti: each of the three Roman subjects he chose, over the course of his career, featured a woman of exceptional loyalty. In the earliest example [fig. 30], Rossetti even took a liberty with his source, to present the

poet Tibullus returning to a faithful Delia; the subject was designed as a watercolour in 1853, but two repetitions were made in the later 1860s, perhaps reflecting the beginning of the rise in market demand for Roman pictures.[2] In 1872, Rossetti sketched the design for a projected picture of *Paetus and Arria* (untraced), another subject featuring a woman's loyalty: Arria stabs herself to encourage her husband to follow suit, in preservation of his honour.

Rossetti is often treated as a solitary eccentric, working in isolation from his contemporary art world. *Dis Manibus* is of particular interest since it shows Rossetti, in the early 1870s, fully aware of contemporary developments: both by choosing a Roman subject and in the way he treats it, Rossetti participates in the recent fashion for Roman genre scenes. It is true that Rossetti's emphasis on Roman female virtue is unusual, and the physical type of the figure is less Roman than Rossettian, with its pouting mouth and exaggerated neck. Nonetheless, the picture is a Roman genre scene of the kind coming into vogue at the time it was executed.

Abandoning the stories with named historical figures, drawn from literary sources, of his earlier forays into Roman subject-matter, Rossetti presents an anonymous Roman woman whose claim to 'authenticity' is located in her adherence to Roman social customs and her archaeologically specific accessories. Rossetti did not subject his pictures to the ordeal of public exhibition, but he did allow carefully edited descriptions of

his works to appear in the press, through his friend F.G. Stephens, art critic of *The Athenaeum*. The account of *Dis Manibus* published in 1875 seems to have been written by Rossetti himself, and stresses the picture's claims to 'authenticity'. The inscription on the urn, the custom of playing on two harps, the woman's white mourning robes, and the "antique forms of the harps" are mentioned in turn as guarantees of the picture's 'accurate' Roman credentials.[3] The inscription was important enough that Rossetti indicated it, in abbreviated form, even in the small dimensions of the drawing.

The motif of the two instruments does indeed derive from a Pompeian fresco in the Museum at Naples. However, it was Rossetti himself who linked the motif to the theme of the loyal Roman woman; he first used it in *The return of Tibullus to Delia*, where the maid plays the two instruments to while away Delia's time as she awaits Tibullus's return. In his series of Roman pictures, Rossetti developed an idiosyncratic iconography associating the theme of the loyal woman with doubled musical instruments and a Roman setting.

The motif of the two instruments, one on either side of the woman, suggests the availability of a choice between loyalty and unfaithfulness. This implication is particularly appropriate to the subject of Delia, whose infidelity was eventually discovered. However, the iconographical similarity suggests that the potential for infidelity is integral to the fascination of the loyal woman in *Dis Manibus* as well. The sensuality of

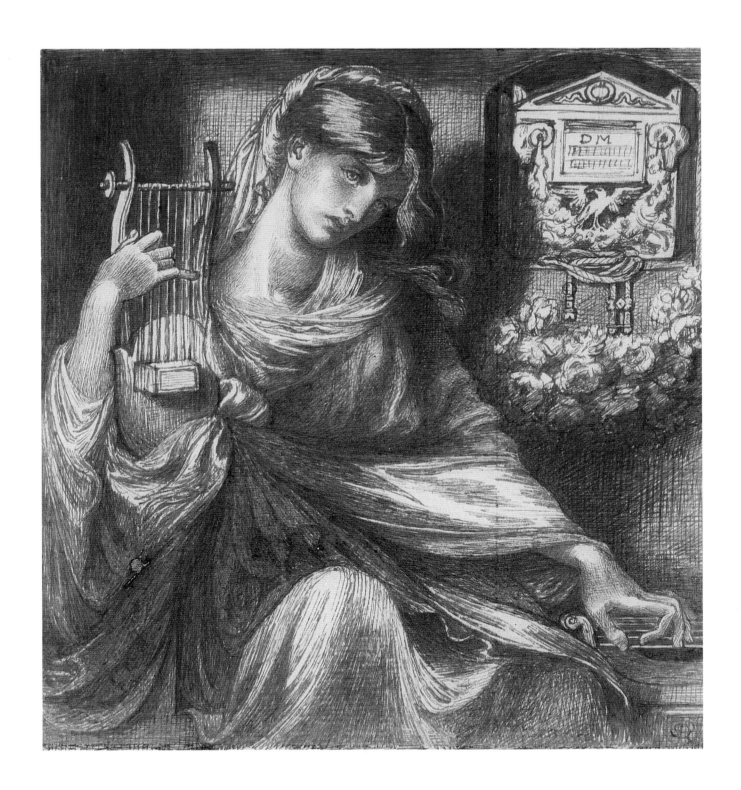

141

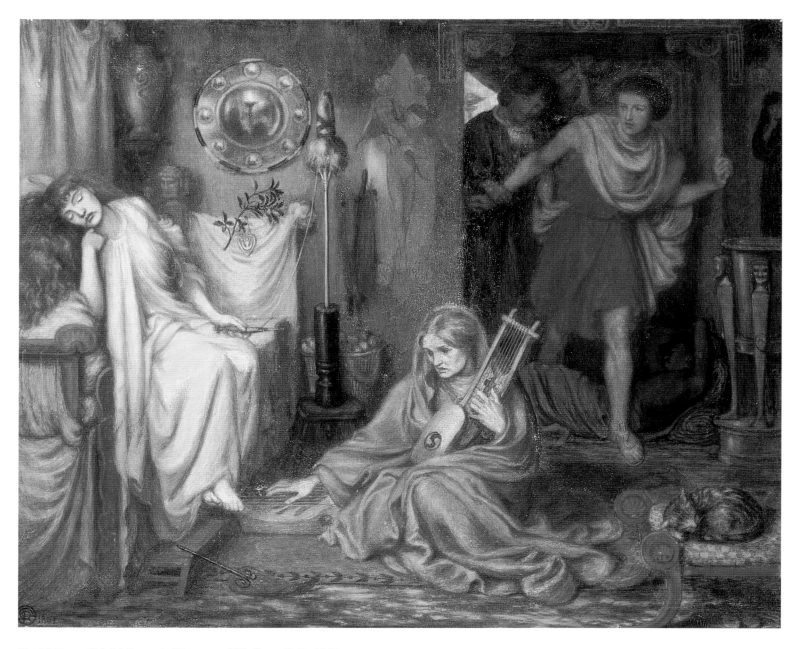

Fig. 30 Dante Gabriel Rossetti, *The return of Tibullus to Delia*, 1867
Watercolour, 19 × 23¼ ins (48.2 × 59 cm). Private collection (photograph courtesy of Christie's, London)

the Rossettian female type, in the later picture, intensifies the pathos of the figure's devotion to the memory of her dead husband. Although Rossetti departs from contemporary convention in depicting a virtuous Roman woman, the figure's implicit counterpart is the wicked Roman woman familiar from other Victorian paintings of Rome.

1 For the virtuous widow theme, see Robert Rosenblum, *Transformations in Late Eighteenth Century Art*, 3rd printing, Princeton, N.J. 1974, pp. 39–48.

2 For details about the various versions, see Virginia Surtees, *The Paintings and Drawings of Dante Gabriel Rossetti (1828–1882): A Catalogue Raisonné*, Oxford 1971, no. 62.

3 'Pictures by Mr. Rossetti', *The Athenaeum*, 14 August 1875, p. 220.

LAWRENCE ALMA-TADEMA

51 *An audience at Agrippa's*, 1875
OPUS CLXI

Oil on panel
35 3/4 × 24 3/4 ins (90.8 × 62.8 cm)
Exhibited Royal Academy, London, 1876
(no. 249)
East Ayrshire Council: The Dick Institute, Kilmarnock

The subject of *An audience at Agrippa's* is of a type that Victorian critics sometimes called 'semi-historical': although the particular event is not documented, it is of a kind that must often have occurred in the daily life of Marcus Vipsanius Agrippa, the son-in-law of the Emperor Augustus. Indeed, the sense that this is a routine rather than an

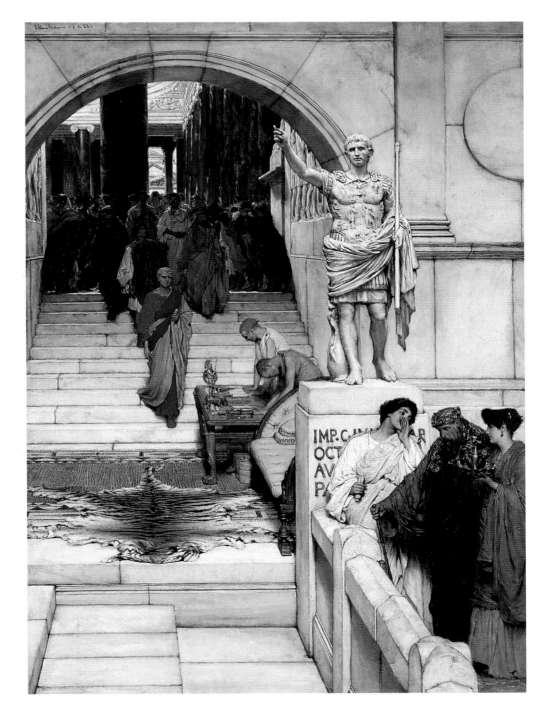

exceptional event is crucial: however important the audience may be to petitioners, hoping for favour from the imperial family, it is nothing out of the ordinary for Agrippa and his household, who seem to be well drilled in the protocol of the audience. The famous statue known as the 'Prima Porta' *Augustus* appears closer to the foreground and larger in scale than the ostensible 'hero' of the scene, suggesting that Agrippa's authority derives from his relationship to the emperor.

At the bottom right are an elderly man and a younger woman, presumably his daughter, carrying a costly gift; the male figure whispering to the old man is perhaps advising him how to address Agrippa. The picture presents the Imperial world as one where bribery and flattery are necessary; the spectator sympathizes with the petitioning man, bowed with age and leaning on a stick, and his pretty daughter. Agrippa's face is impassive, and he appears to be autocratic: the scribes at the table on the right bow submissively as he approaches, and his entourage remains at a respectful distance behind him. As the critic for *The Times* noted, some of Agrippa's clients, in the background, "have not yet lifted their heads from the obsequious obeisance which has followed the passage of the grim ruler".[1]

The picture suggests little hope that the petition of the foreground group will be successful. However, the narrative is left open-ended, nor did Alma-Tadema wish to resolve the mystery when he painted a sequel to the picture,

After the audience of 1879 [cat. 52]. In the sequel, there is no sign of the old man and his daughter, nor does their gift appear among the luxury objects left on the ground as Agrippa departs. By the 1870s, the earlier Victorian practice of providing neatly resolved narratives in genre pictures was being replaced by a fashion for 'enigma' pictures. In this case, the absence of narrative resolution contributes to the theme of arbitrary power in the Roman Imperial world. The spectator does not learn the fate of the petitioners, one way or the other; there is no clear distinction, in this world, between justice and injustice. The two pictures might be described as parodies of a traditional subject-type of history painting, the Clemency scene, where a ruler is shown in an act of mercy or benevolence towards his subjects.

As in the case of other Roman pictures of which the moral implications were potentially worrying, contemporary critics tended to focus their attention, instead, on the 'accurate' archaeological data, and particularly on the skilful painting of the marble, for which Alma-Tadema was becoming increasingly famous.

1 'Exhibition of the Royal Academy', *The Times*, 29 April 1876, p. 14.

LAWRENCE ALMA-TADEMA

52 *After the audience*, 1879
OPUS CXCVI

Oil on panel
36 × 26 ins (91.4 × 66 cm)
Exhibited Royal Scottish Academy, Edinburgh, 1879 (no. 332); Grosvenor Gallery, London, 1882–83 (no. 70)
Private collection (courtesy of Julian Hartnoll, London)

In the sequel to *An audience at Agrippa's* [cat. 51], the figures appear in the same opulent marble setting, but with their backs turned, processing away from the spectator. The humour has a tart edge: after the conclusion of the audience, there is no indication of any benefit to the petitioners, crowded behind the wall at the left and excluded from the palatial space of the imperial household. Their gifts are more welcome; indeed, the gifts occupy a conspicuous position in the foreground, emphasizing their role as signs of bribery and corruption. However, such gifts are apparently so commonplace to Agrippa that he leaves them in a heap on the ground, awaiting a slave to tidy them away. Among the gifts are a variety of objects in different materials, including the famous crater from the Hildesheim treasure, perhaps implying that the petitioners have come from all parts of the empire. This is confirmed by the faces in the huddled group of petitioners: the different skin colours and types of feature indicate a variety of ethnic origins. Despite their diversity, most of them are glancing up

at the statue of Augustus with expressions of awe or fear: imperial power appears even more tyrannical than in the previous *Audience*.

Vern Swanson's catalogue raisonné draws on contemporary sources to account for the genesis of the idea for the second picture. The Newcastle armaments manufacturer and art collector Sir William Armstrong had become eager to purchase an Alma-Tadema, immediately after the exhibition of *An audience at Agrippa's*. When the artist sent an interior scene of a young woman begging her father for permission to marry, Armstrong objected to the absence of white marble, the feature that had apparently attracted him, as it had many critics, in *An audience at Agrippa's*. Alma-Tadema is reported to have responded in annoyance:[1] "Well if he wants to have marble, and that is dearer to him than figures then I will reverse the Audience and make the same thing, *After the Audience*! If all the people go away then he'll see their backs and marble will remain the main subject!" This did not amuse Armstrong, who rejected *After the audience*. The anecdote illustrates the extent to which the commercial value of Alma-Tadema's work had become associated with the skilful representation of ancient Roman marble; in the later decades of the Victorian period, expanses of marble became an indispensable sign of Imperial 'luxury' in Roman genre pictures [see p. 66, and cat. 63].

However, the marble setting is not identical to that in the earlier picture:

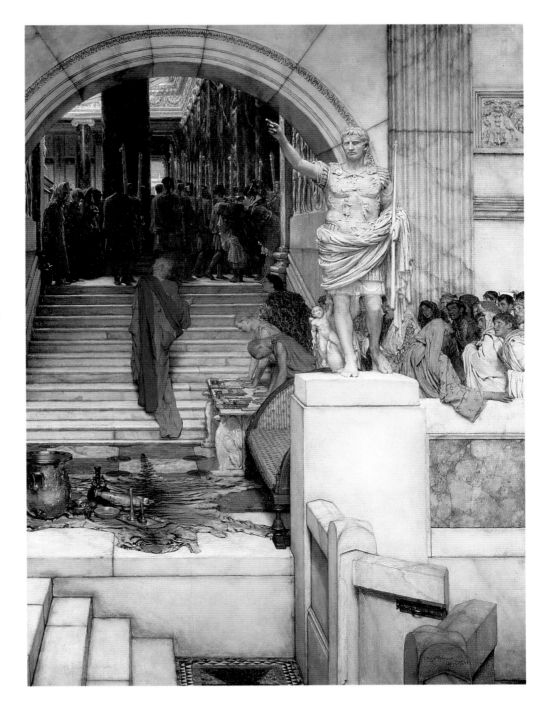

there are differences of detail in every part of the picture, such as the pilaster on the right, which has become fluted, and the foreground steps, which have multiplied and acquired a mosaic paving with a cut-off inscription, perhaps the final 'E' of a *Salve*. Even the famous statue of Augustus has changed slightly, re-acquiring the putto astride the dolphin, a feature of the original statue inexplicably absent from its representation in *An audience at Agrippa's*. These changes might be explained in practical terms: the earlier picture had left Alma-Tadema's possession immediately after its exhibition in 1876, and may not have been available for reference. However, the spatial relationships between the background columns and the round arch are identical; the carefully judged relation of the statue's extended arm to the curve of the arch exactly repeats the bravura display of the artist's skill in relieving one marble surface against another, again emphasizing the drama of the statue's authoritative gesture. Perhaps Alma-Tadema had retained a measured drawing of the architectural surroundings. On the other hand, he may have introduced the play between repetition and variation deliberately, as a witty comment on the commercial pressure for 'mass production' of Roman paintings. The changed form of the scribes' table is particularly telling: in the second picture, the table metamorphoses into marble, the element most associated with the commercialization of Roman genre painting. However, the scribes themselves appear in attitudes of submission identical to the earlier picture; they seem not to have dared to raise their heads.

The changes of detail also introduce a play on the very notion of the sequel: Alma-Tadema thwarts the viewer's expectation that the second picture will correspond exactly to the first. Moreover, *After the audience* fails to provide a neat resolution to the situation dramatized in *An audience at Agrippa's*. Victorian pictures conceived as sequels traditionally provided a strong narrative resolution to the drama of the earlier scene, as in the case of Abraham Solomon's pair, *Waiting for the verdict* of 1857 and its sequel "*Not Guilty*" of 1859 (Tate Gallery, London). The minute changes in the details of the setting emphasize the fact that *After the audience* departs from contemporary conventions for dramatizing a sequel. There is no logical explanation for the changes to Agrippa's physical surroundings, just as there may be no logical explanation for the decisions of an imperial despot.

1 Quoted in Vern G. Swanson, *The Biography and Catalogue Raisonné of the Paintings of Sir Lawrence Alma-Tadema*, London 1990, p. 50.

LAWRENCE ALMA-TADEMA

53 *Tepidarium*, 1881 ('*In the tepidarium*') OPUS CCXXIX

Oil on panel
9 1/2 × 13 ins (24 × 33 cm)
Exhibited Galerie Georges Petit, Paris, 1882 (no. 82); Grosvenor Gallery, London, 1882–83 (no. 118)
Board of Trustees of the National Museums and Galleries on Merseyside (Lady Lever Art Gallery, Port Sunlight)

This tiny picture is justly famous as the most sensual of Alma-Tadema's nudes. The glowing tonality of the flesh and marble suggests the warm atmosphere of the *tepidarium*, the room in a Roman bath intermediate in temperature between the hot *caldarium* and the cold *frigidarium*; the picture is also a painter's *tour de force* in relieving shades of white and flesh-tints, counterpointed with the single brilliant accent of the azalea. The woman appears in a trance-like state of sensual abandon, too languorous even to move the feather fan she holds in her left hand. Modern observers have commented on the phallic connotations of the strigil, the scraping implement in the figure's right hand, and this is likely to have been intentional: Alma-Tadema's pictures of Bacchanalian rites indicate that he was adept at deploying the sexual symbolism of accessories. The strigil is also virtually the only archaeologically precise accessory in a picture unusually sparing of detail; this dual function for the object, as sexual symbol and

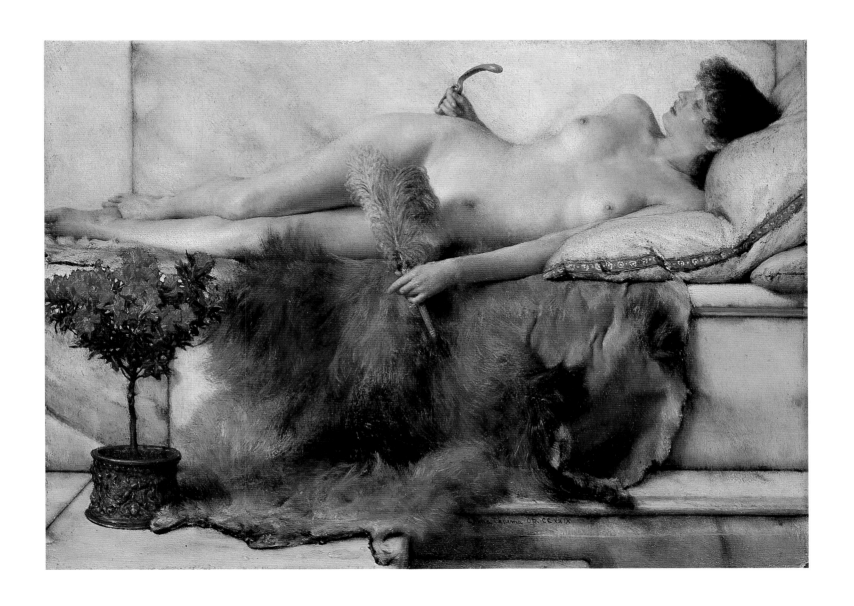

147

guarantee of archaeological 'authenticity', may well have appealed to the artist's sense of humour. Perhaps the archaeological credentials of the strigil were even a challenge to art critics who might have accused the nude figure of impropriety.

The nude had virtually disappeared from the English public exhibitions in the 1850s, when the vogue for 'moralising' contemporary genre painting was at its height, but there had been a dramatic revival in the painting of the nude beginning in the later 1860s. In this revival, led by painters such as Frederic Leighton, G.F. Watts and Albert Moore, the nudes were ordinarily linked to Greek antiquity, either by a mythological reference in the title or by visual references to Greek art, seen in contemporary works on art history as distinguished for purity and restraint. The exalted connotations of Greek antiquity justified the representation of the nude figure more easily than a Roman context, with its connotations of luxury and decadence. Although Alma-Tadema had exhibited a few pictures of the nude previously [see fig. 31], *Tepidarium* was the first of his nudes to make an overt reference to Rome in the title. It was exactly contemporary with Poynter's (untraced) picture of a Roman female nude, also set *In the tepidarium*, and shown at the Royal Academy exhibition of 1882.

A setting in the baths was an obvious pretext for the nude, since the bathing customs of the ancient Romans were a respectable area of research for social historians; after 1882, Alma-Tadema, Poynter and other painters exhibited further pictures of nudes in the Roman baths [cats. 56, 64]. Even so, Alma-Tadema appears to have taken great care about introducing *Tepidarium* in public, showing it in Paris at the gallery of the dealer Georges Petit, then in London at the Grosvenor Gallery; both settings were strongly associated with élitist connoisseurship. The Grosvenor Gallery showing occurred in the winter of 1882–83, in the context of a large exhibition of Alma-Tadema's work, an early example of a practice that would become increasingly common, the single-artist show.[1] In this context, though, the tiny *Tepidarium* failed to attract detailed attention from art critics. Most comments were admiring, but brief; it is impossible to say whether critics were uncomfortable with the sensuality of the nude figure, or simply found more to write about the larger and more complex pictures in the exhibition.

1 The Grosvenor exhibition included works by another artist, Cecil Lawson, but the 184 pictures by Alma-Tadema were presented as a retrospective of his entire career.

FREDERIC LEIGHTON
1830–1896

54 *Vestal, ca.* 1882–83

Oil on canvas
24 5/8 × 17 5/8 ins (62.5 × 44.8 cm)
Exhibited Royal Academy, London, 1883
(no. 220)
Leighton House, The Royal Borough of
Kensington and Chelsea, London

Vestal is one of only two pictures by Frederic Leighton that can definitely be associated with ancient Rome, rather than Greece; it might be described as a 'Greek' painter's approach to a Roman subject.[1] The picture is devoid of the archaeological detail that characterized the 'Roman-ness' of virtually all Victorian pictures set in ancient Rome. The patterned drapery is similar to the draperies in many of Leighton's Greek pictures, particularly the similarly patterned, gauzy draperies of the female figures in *The Daphnephoria* of 1876 (Lady Lever Gallery, Port Sunlight). The way it is draped over the head may suggest the Vestal's modesty; there is no elaborate coiffure or 'false front' underneath the smooth folds. However, the method of folding is not archaeologically specific in the fashion of many of Alma-Tadema's draperies [*e.g.* cats. 46, 48].

The subject of the virtuous Roman woman was unusual; most of the Roman women in Victorian painting were at least mildly wicked (although see cat. 50 for another notable exception). However, the subject of the Vestal Virgin had appeared occasionally, often

in an anecdotal context; Eyre Crowe's *The Vestal* of 1870 (untraced), for instance, illustrated a text from Plutarch: "If by accident she met a person going to execution, his life was granted him".[2] No such narrative is hinted at in Leighton's picture, nor is there any reference to the Vestal's role in Roman society, unless the purity of outline, in the figure's profile, can be read as a sign of her moral purity.

Leighton was the most eminent Victorian 'classical' painter, but his classicism was unequivocally and resolutely Greek; indeed, his eminence was inextricable from his status as the painter of ancient Greece. His fourth Address as President of the Royal Academy, delivered in 1885, expressed almost unmitigated contempt for Rome, repeating all of the most damning contemporary stereotypes about Roman authoritarianism and decadence. The previous lecture had been an extravagant eulogy of the Greeks and their art; Leighton characterized the Romans by antithesis, as an essentially inartistic nation, entirely dependent on the Etruscans and Greeks for their culture. Interestingly, one of the few points of comparison he introduced between the Greeks and Romans was "the worship of the Goddess of the hearth: Hestia – Vesta"; the lecture was delivered two years after the exhibition of *Vestal*.[3]

Leighton's characterization of Rome was determined by the pattern of rise and decline in ancient art that the scheme of his lecture series required;

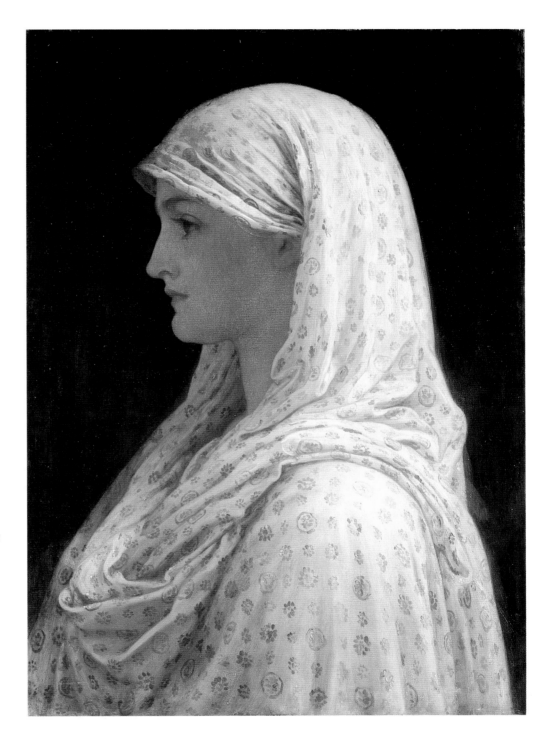

when he encountered real Roman art, he found himself more enthusiastic. In his Address of 1888 to the Art Congress at Liverpool, he spoke of Pompeii in glowing terms, stressing "the absence there of any ugly thing" even among the most mundane household utensils. Indeed, Leighton gave Pompeii the supreme accolade, by describing it repeatedly as "Greek".[4]

1 Leighton's other Roman subject was *The frigidarium* of 1893 (private collection).

2 Other examples included W.F. O'Connor, *A priestess of Vesta*, RA 1865; E.J. Poynter, *A Vestal*, Grosvenor Gallery 1880 (both untraced).

3 Lord Leighton, *Addresses Delivered to the Students of The Royal Academy*, London 1896, p. 113.

4 Reprinted in Mrs Russell Barrington, *The Life, Letters and Work of Frederic Leighton*, 2 vols., London 1906, II, pp. 346–47.

EDWARD JOHN POYNTER

55 *The Ides of March,* 1883

Oil on canvas
60¼ × 44¼ ins (153 × 112.4 cm)
Exhibited Royal Academy, London, 1883
(no. 260)
Manchester City Art Gallery

The Ides of March is a rare example of a Victorian picture of Roman history that makes a 'hero' of its protagonist. Poynter takes a literary text for his source, although not a classical one; the catalogue quotation was from Shakespeare (*Julius Caesar*, Act II, scene 2):

Caesar "Yet Caesar shall go forth: for these Predictions
 Are to the World in general as to Caesar."
Calpurnia "When Beggars die there are no Comets seen:
 The Heavens themselves blaze forth the Death of Princes."

The picture illustrates its text precisely: Calpurnia is caught at the moment of her utterance, stepping forward to gesture at the dramatic light of the comet in the sky, her drapery in movement. Her face and gesture are brilliantly lit, while Caesar himself remains largely in shadow. The lighting creates a dim aureole around his head, a tenuous reminiscence of a halo that both glorifies him and emphasizes his tragedy: his features are barely distinguishable in the gloom. However, a lamp lights the sculptured bust of Caesar on the left, casting a fantastic shadow on the wall above it; the plays on illuminating and shading the two images of Caesar create a mood of foreboding, suggesting the danger that threatens him.

The picture uses a traditional *tour de force* of the painter's art, juxtaposing two light sources, the interior lamp and the light effect of the comet in the sky outside. This produces a complex array of reflections on the polished marble floor, of which the receding perspective is another display of skill. Although all critics recognized the technical difficulties that Poynter had set himself, some were made uneasy by the strange light effects. This was perhaps appropriate:

Poynter uses the fitful lighting and ominous shadows to dramatize the uncertainty of the moment when Caesar and Calpurnia speculate on future events. It is also appropriate that Calpurnia is more brightly lit, for her interpretation of the comet is the correct one; Calpurnia's forebodings were recounted in many classical sources. Although the picture comes closer than most Victorian pictures to the traditional Roman history painting, the spectator is offered a glimpse of a private moment in the hero's life, and one that is presented as transitory: the flash of light and Calpurnia's movement are caught in one poignant instant before tragedy strikes.

The figures are small in relation to the monumental architecture of the Roman palace and the sublime light effect in the sky, with the lone statue of a soldier in silhouette, atop a pediment in the distance. Poynter's archaeology is meticulous: the heavy entablature is highly decorated and presented in dramatic chiaroscuro; the striations of the marble columns emphasize the opulence of the setting; and the polished floor gleams with a sumptuous display of inlaid decoration. The archaeological specificity that served, in Roman genre pictures, to indicate a 'life-like' setting assumes a further role in this scene: the figures of Caesar and Calpurnia are dwarfed by the grandeur of the Roman material environment, just as they are powerless to avert the disaster that will strike them.

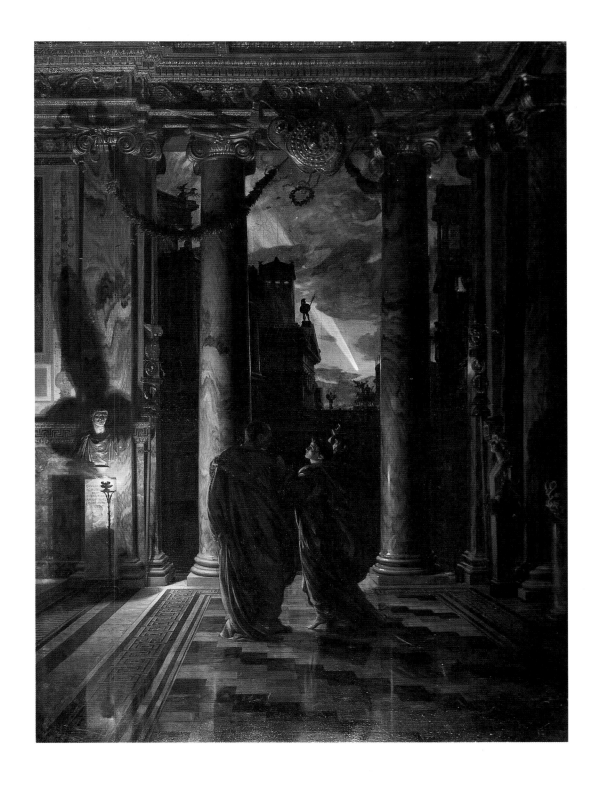

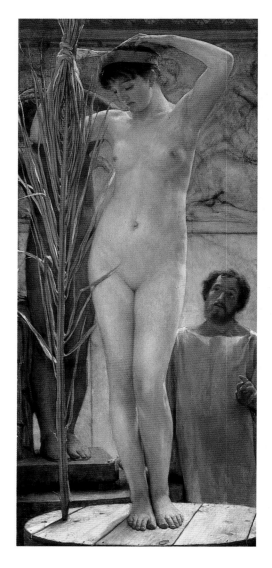

Fig. 31 Lawrence Alma-Tadema, *A sculptor's model (Venus Esquilina)*, 1878
Oil on canvas, 77 × 33 ins (195.6 × 83.8 cm)
Private collection (photograph courtesy of Christie's, London)

EDWARD JOHN POYNTER

56 *Diadumenè*, 1884

Oil on canvas
20 × 20 ins (51 × 50.9 cm)
Exhibited Royal Academy, London, 1884
(no. 368)
Royal Albert Memorial Museum, Exeter (Exeter City Museums and Art Gallery)

This is the first version of the nude bathing subject that Poynter would repeat, at larger scale but with the same title, for the next year's Royal Academy exhibition, when it would figure in a controversy about the nude in which Mitchell's *Hypatia* and Waterhouse's *St Eulalia* [cats. 57, 58] were also implicated [see next entry]. Poynter eventually decided to add draperies to the larger and more controversial version, but the present picture remains in its original form as a nude.

This was not Poynter's first excursion into the nude, with the Roman baths as a pretext; his *In the tepidarium* (untraced) had appeared in 1882, contemporary with Alma-Tadema's *Tepidarium* [cat. 53]. *Diadumenè* not only presents the figure in an elaborate, archaeologically specific interior; the figure itself is based on a classical statue, the 'Esquiline' *Venus*, that had been unearthed in the 1870s. As he had done in *Faithful unto death*, Poynter uses archaeology, rather than recorded history, as the 'authority' for his representation of an anonymous figure from ancient life. It is telling that the 'source' for the female nude is a work of art, rather than the skeletal remains invoked for the clothed male in *Faithful unto*

death: the presentation of the nude figure, at the Victorian public exhibition, required a delicate balance between 'nature' and art.

The reputation of the Esquiline *Venus* and the history of its importation into Victorian painting are complex. When the statue was unearthed, it was greeted as a major find; however, its status was immediately questioned, as some observers claimed that it was an inferior Roman copy of a Greek original. The controversy was covered in the British press, and would have been familiar to well informed members of the picture's audience.[1] Moreover, the figure had appeared in painting before Poynter's version: Alma-Tadema had used it in his picture of 1878, *A sculptor's model (Venus Esquilina)*, showing a model in the pose of the statue [fig. 31]. Some commentators had found Alma-Tadema's explicit representation of the practice of nude modelling offensive, despite the picture's scholarly use of a classical prototype.[2]

Therefore, the figure type of the Esquiline *Venus* already had a complicated and controversial history in contemporary debate, when Poynter chose to 'copy' it yet again, in *Diadumenè*. The title adds an additional layer of complexity, referring to Polyclitus's celebrated statue of a male figure in a similar pose, the *Diadumenos*; the Greek word designates the figure's action of tying a fillet around the head. The picture's invocation of classical prototypes explores the issue of the 'copy' versus the 'original', one of the most vexed problems in Roman archaeology:

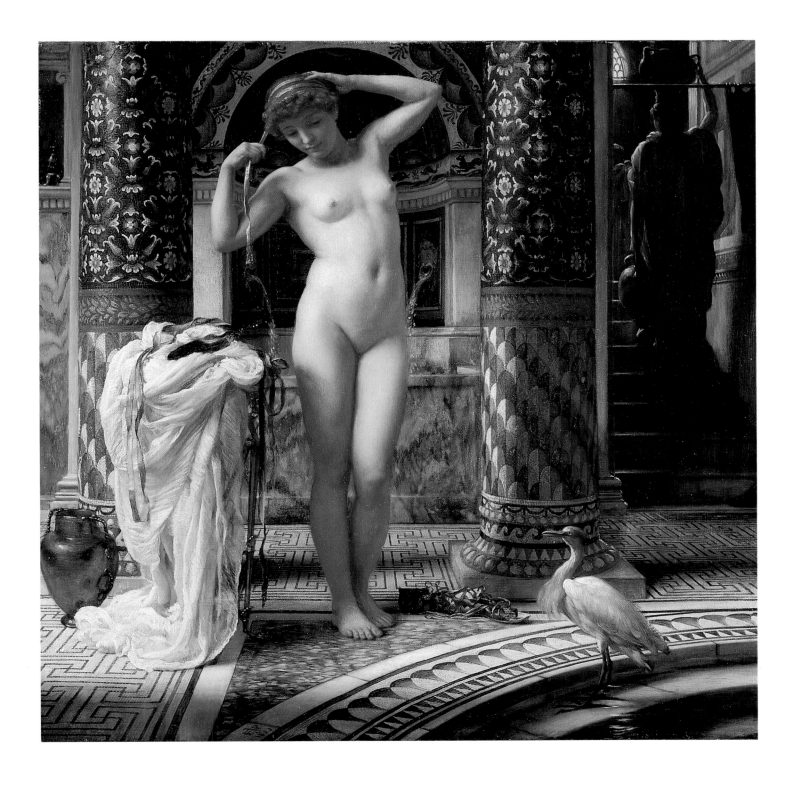

153

Poynter's picture is simultaneously a 'copy' of two different ancient statues and an 'original' Victorian genre picture, with a sidelong reference to Alma-Tadema's picture as well. Moreover, the reference to the *Diadumenos* of Polyclitus involves switching the figure's gender; the notion of interchangeability between the male and female nude is implied in the juxtaposition of the title with the visible female figure. There is a similar interchangeability between the references to Greece and Rome.

When Poynter found himself obliged to defend the *Diadumenè* of 1885 in the pages of *The Times*, he advanced a simple justification, claiming that he had wished to "give some idea of what the bath-room of a lovely Greek or Roman girl might be".[3] This draws on the respectability of social history, to present the picture as a form of research into Roman bathing customs, which the archaeological specificity of the sumptuous Roman interior was well calculated to support. However, the picture had additional layers of connotations for those observers knowledgeable enough to interpret its web of references to its 'sources'.

1 See, *e.g.*, 'Recent Discoveries in Art and Archaeology in Rome', *Quarterly Review* CXLIV, July 1877, p. 77.

2 I am grateful to Alison Smith for information on the sculpture and Alma-Tadema's picture, to be included in her forthcoming book, *The Victorian Nude*, Manchester 1996.

3 Edward J. Poynter, Letter to the Editor, *The Times, 28 May 1885, p. 4.

CHARLES WILLIAM MITCHELL
1854–1903

57 *Hypatia*, 1885

Oil on canvas
96 ¹/₄ × 60 ins (244.5 × 152.5 cm)
Exhibited Grosvenor Gallery, London, 1885 (no. 111)
Laing Art Gallery, Newcastle upon Tyne (Tyne and Wear Museums)

Hypatia created a sensation when it was exhibited at the Grosvenor Gallery, simultaneously with Waterhouse's *St Eulalia* at the Royal Academy [cat. 58]. The two dramatic pictures of the female nude, along with the second and larger version of Poynter's *Diadumenè* at the Royal Academy [see cat. 56], must have been a major reason for the outcry against the painting of the nude that erupted in the correspondence pages of *The Times* in May 1885. The Roman settings of these pictures perhaps made them more offensive to conservative taste; the associations of Rome with immorality and decadence, in contrast to the perceived purity of the Greek ideal, may have increased the shock of the female nude [see cat. 53].

The correspondence in *The Times* was polarized between opponents of the nude, as injurious to public morality, and those who supported the nude as the quintessence of High Art. Most art critics took the latter view, accepting *Hypatia* as a serious history painting, in which the representation of the nude figure was sanctioned by tradition [see

cat. 45]. Mitchell also had the sanction of history for Hypatia's nude martyrdom, although his text was not a classical source but the vivid description of the scene in Charles Kingsley's novel, *Hypatia*, of 1853. Kingsley had used the story of the pagan philosopher, Hypatia, as one strand in a complex morality tale about internecine struggles among Christian sects in fifth-century Alexandria, against a backdrop of the disintegration of Roman rule. Mitchell quoted an excerpt (from chapter XXIX) in the Grosvenor Gallery catalogue:

"On up the nave, fresh shreds of her dress strewing the holy pavement – up the chancel steps themselves – up to the altar – right underneath the great still Christ: …

"She shook herself free from her tormenters, and springing back, rose for one moment to her full height, naked, snow-white against the dusky mass around.

"… with one hand she clasped her golden locks around her; the other long white arm was stretched upward towards the great still Christ, appealing – and who dare say, in vain? – from man to God."

Mitchell illustrates the passage exactly, choosing the moment when Hypatia stretches her hand towards the figure of Christ, in the form of an archaeologically precise fragment of mosaic at the top right-hand corner. F.G. Stephens of *The Athenaeum* thought Hypatia's body excessively "lean".[1] However, the physical type is carefully chosen to give max-

imum expressiveness to the gesture, straining from the tiptoe of her right foot to the open palm of her left hand; details such as the musculature of the exposed armpit serve both to enhance the drama of the event and to display the nude figure. Hypatia's hair, abundant as it is, fails to cover her left breast, much as the miraculous fall of snow in Waterhouse's picture [see cat. 58] proves ineffective in hiding St Eulalia's nudity.

Critics admired the archaeological specificity of the altar and the surrounding architecture. Mitchell presents only a corner of the richly decorated Early Christian church, with its mosaics and pavement decorations. The oblique point of view and the fragmented mosaics are reminiscent of Alma-Tadema's techniques of spatial construction, but Mitchell uses these features to monumentalize Hypatia, in a strong mass of light. The treatment effectively combines the concentration on the central figure, appropriate to history painting, with the archaeological specificity expected of a Roman picture in the later Victorian period.

Mitchell's picture attracted additional attention because the artist was almost unknown in London; he was the son of a wealthy Newcastle art collector and shipbuilder, the partner of Sir William Armstrong [see cat. 52]. Although Mitchell continued to be active in the art world of the North East, *Hypatia* was his single startling success as a painter.

1 'The Grosvenor Exhibition', *The Athenaeum*, 25 April 1885, p. 541.

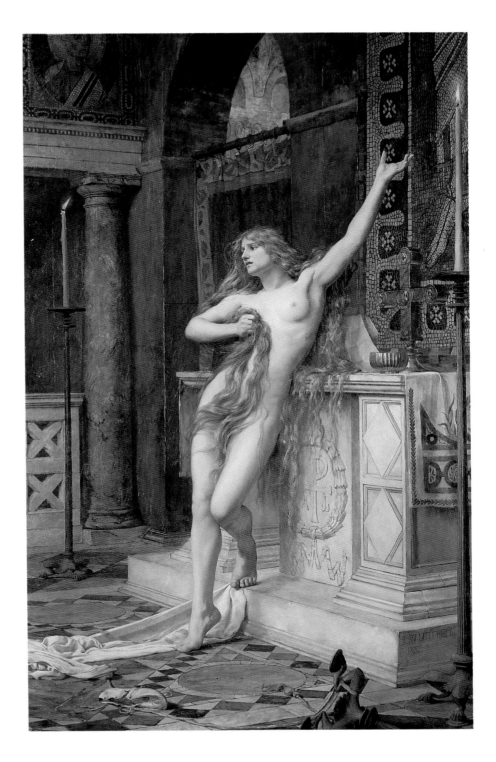

JOHN WILLIAM WATERHOUSE
1849–1917

58 *St Eulalia*, 1885

Oil on canvas
74¼ × 46¼ ins (188.6 × 117.5 cm)
Exhibited Royal Academy, London, 1885
(no. 503)
The Trustees of the Tate Gallery, London
(Not exhibited)

Waterhouse must have been reminded of the nude martyrdom of Hypatia, familiar through Kingsley's novel [see cat. 57], when he chose the similar subject of *St Eulalia*, but it seems to have been pure coincidence that the picture's exhibition, in 1885, coincided with that of Charles Mitchell's *Hypatia* [cat. 57]. Nonetheless, the pictures use similar means to dramatize the two martyrdoms. In both cases the body of the saint appears in the central position orthodox in the history painting tradition, surrounded by archaeologically specific details. Both artists use indirect means to mark the bodies with the horror of martyrdom: the extravagance and tension of Mitchell's pose serves the same function as the startling foreshortening of Waterhouse's figure, remarked upon by every critic who noticed the picture. Both nudes were excessively thin, by contemporary standards, creating a tension between the asceticism of the religious figure and the potential sensuality of the nude.

Waterhouse added an explanatory note to the title of his picture, in the

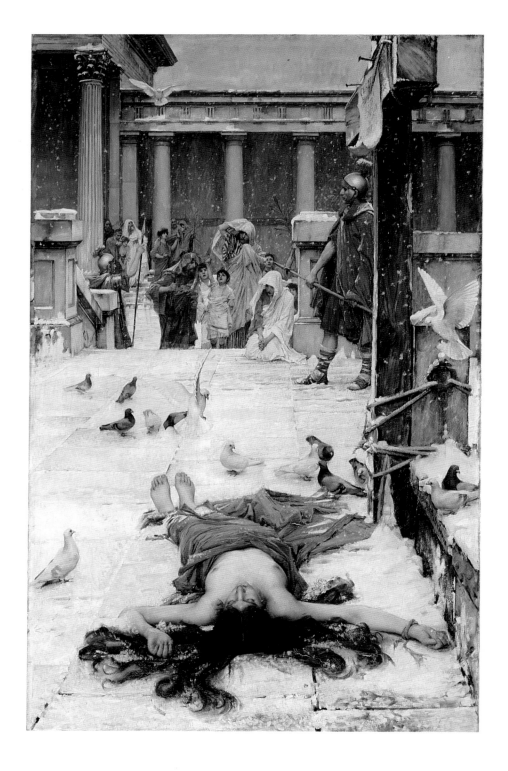

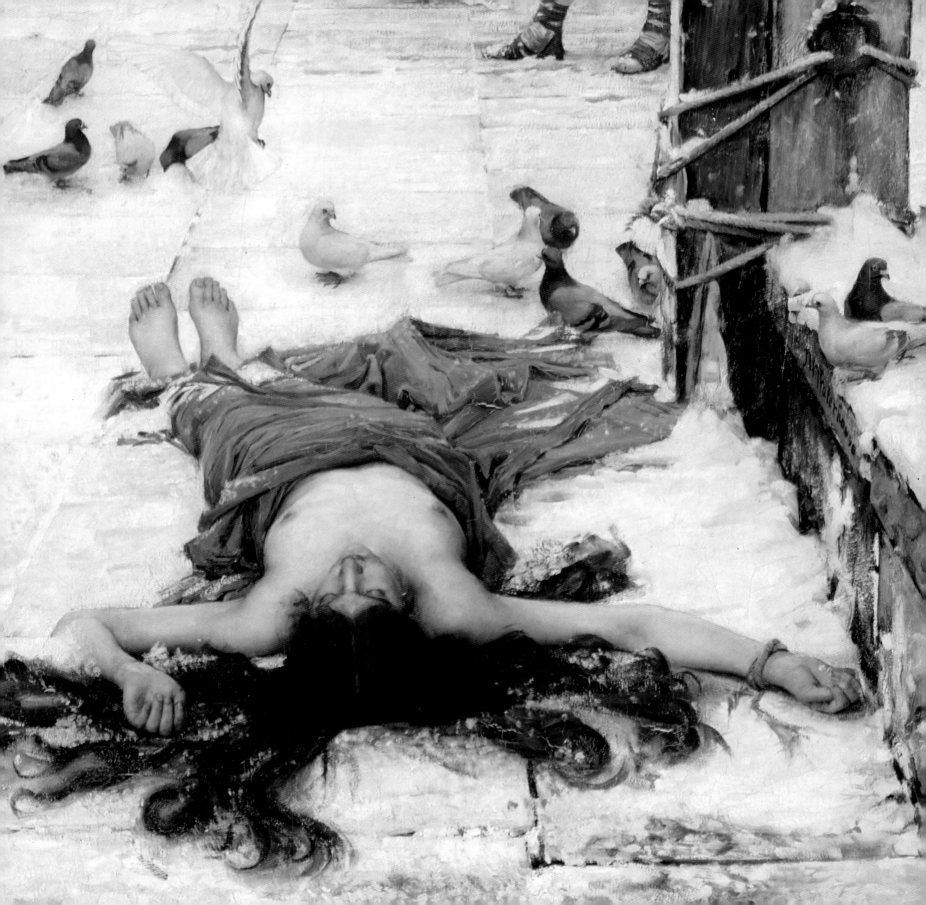

Royal Academy catalogue of 1885: "Prudentius says that the body of St. Eulalia was shrouded 'by a miraculous fall of snow when lying exposed in the forum after her martyrdom'". However, Waterhouse omitted the more unpleasant details of Prudentius's account of St Eulalia's martyrdom from both catalogue and picture, presenting the saint's body as unmarked by the tortures to which she had been subjected, just as Mitchell presents Hypatia's body still untouched by the violent mob. On the other hand, the "miraculous fall of snow", as depicted by Waterhouse, fails to fulfil its task of hiding the saint's nudity.

The artist might be accused of taking liberties with his text, to transform the gruesome cruelty of the historical martyrdom into a titillating display of female nudity, although, as one critic pointed out with impeccable logic, the picture would have been unintelligible if the body had been completely covered with snow.[1] Indeed, the depiction of the snow worried several critics. The suggestion of white, ice-cold snow next to the naked flesh may be another method of introducing the pain of the martyrdom. The nude flesh, the luxuriant hair and the cold snow give a sensuous immediacy to the figure that is disturbing in the context of the subject-matter; the potential for titillation intensifies the indirect references to physical agony. An explicit representation of St Eulalia's mutilations, as described by Prudentius, would certainly have been unacceptable at the Victorian Royal Academy. However, Waterhouse's abruptly fore-

shortened nude, in the immediate foreground of a dramatic recession into the distance, is not less powerful than a more explicit representation of the martyrdom would have been.

Although Roman history painting had long been in decline by this date, the painting of an event from Roman history could still indicate the painter's high ambition. Waterhouse was elected Associate of the Royal Academy immediately after the picture's exhibition; this echoes Poynter's election to the same honour after the exhibition of *The catapult* [cat. 45] in 1868.

1 Claude Phillips, 'The Royal Academy', *Academy*, 16 May 1885, p. 353.

LAWRENCE ALMA-TADEMA

59 *A silent greeting*, 1889, repainted 1891

OPUS CCXCIX

Oil on panel
12 × 9 ins (30.5 × 22.9 cm)
Exhibited New Gallery, London, 1892 (no. 15)
The Trustees of the Tate Gallery, London

The description of *A silent greeting*, printed in the New Gallery exhibition catalogue, presents a mixture of domestic sentiment and Roman archaeology: "Here is a small picture of colour. Roman officer in brown leather cuirass and *cothurni*, has just left a bouquet of deep pink roses in the lap of auburn-haired maiden, who is taking a siesta on a marble seat with pale green cushion near a doorway. She has dropped her shears and ball of yellow silk, but still holds her needle. On the shelf above her head are laid folds of shawls of many colours. An attendant holds back a curtain over the 'salve' on the threshold."

Such descriptions, routine in New Gallery catalogues, indicate how pictures were being 'sold' to their audience; and indeed the piquant juxtaposition of *cothurni* and bouquet is the basis of the picture's appeal. The picture is a miniature exposition of the doctrine of 'separate spheres': the alert male figure, about to stride, fully armed, to the outside world of masculine action, is contrasted with the sleeping female, left inside with her needlework. The motto on the

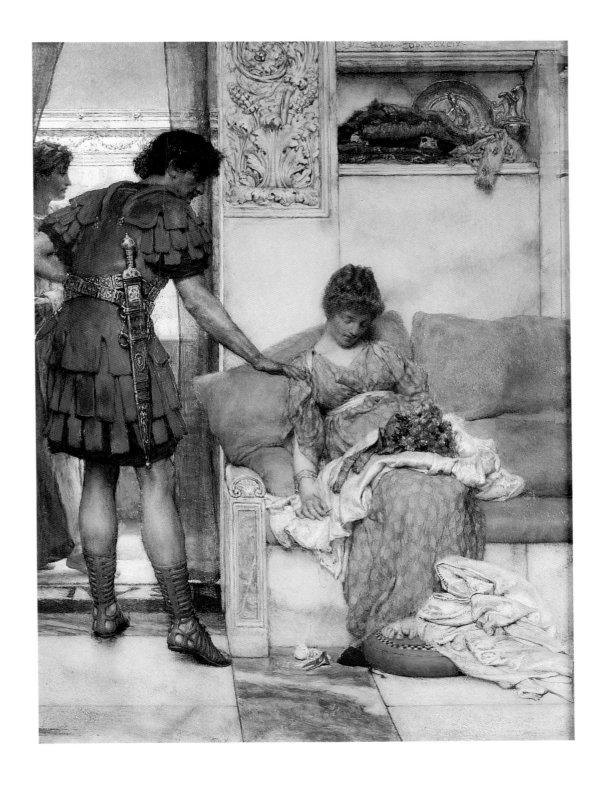

threshold, *salve*, is both a bravura demonstration of the painter's skill at foreshortening tesserae, and a marker of the boundary between the two spheres; the threshold is also guarded by a slave.

This picture is one of a number, from the 1880s onwards, that involve courtship, deploying Alma-Tadema's skill at spatial organization to dramatize separate male and female spheres. In many examples the woman occupies the foreground space, while the male suitor approaches or departs through a doorway or staircase on the left; compositions with a sharp recession on the left had always been favourites with Alma-Tadema [see cats. 46, 48]. In fact, Sir Henry Tate commissioned *A silent greeting* as a companion to another picture of the same type, *A foregone conclusion* of 1885 [fig. 32], where the man climbs a vertiginous staircase on the left, brandishing a shiny ring; the earlier picture had been Tate's wedding present to his wife.[1]

Alma-Tadema evidently found a lucrative market for small courtship pictures, using a clever combination of repetition and variation so that each picture was immediately recognizable both as an example of its type and a unique product. In the later decades of the Victorian period, mass production of Roman scenes was frequent, practised also by Poynter and painters such as John William Godward [see cats. 62, 63]. The repetition of a few popular formulae, in Roman painting, made the entire category a target for accusations of commercialization, such as Roger Fry's of

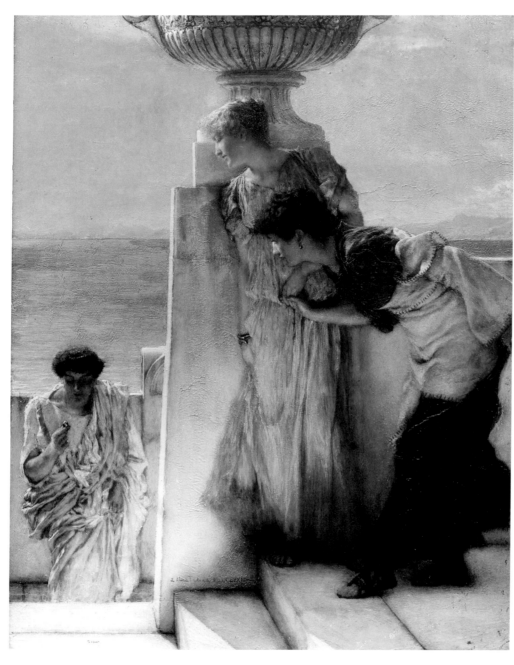

Fig. 32 Sir Lawrence Alma-Tadema, *A foregone conclusion*, 1885
Oil on panel, 12¹⁄₄ × 9 ins (31.1 × 28.9 cm)
Courtesy the Trustees of the Tate Gallery, London

1913 [see pp. 54, 66]. However, the 'mass-produced' categories were only one aspect of the Roman painters' work; although this aspect became more prevalent from the 1880s onward, it should be distinguished from other kinds of Roman painting that were not amenable to 'mass production'.

Nor were the pictures in 'mass-produced' categories mechanical in technique or composition; these may have been commercial products, but they were luxury products, usually of fine quality. As early as 1870, *The Art-Journal* was wondering how Alma-Tadema could be so prolific, "seeing that he paints in a deliberate, mature, solid style".[2] Moreover, the popularity of particular compositional types has interesting implications. The courtship pictures, with their clear demarcation of male and female spheres, may reveal more about Victorian than ancient Roman social customs. Among these Victorian customs, though, was a serious interest in the material culture of the ancient Roman world. As the New Gallery catalogue entry indicates, the audience remained fascinated in the archaeological details that continued to appear, even in tiny, unpretentious Roman pictures.

1 Vern G. Swanson, *The Biography and Catalogue Raisonné of the Paintings of Sir Lawrence Alma-Tadema*, London 1990, pp. 231, 240.

2 'The Royal Academy', *The Art-Journal*, N.S. IX, 1 June 1870, p. 165.

LAWRENCE ALMA-TADEMA

60 *Unconscious rivals*, 1893

OPUS CCCXXI

Oil on canvas
17 ³/₄ × 24 ³/₄ ins (45 × 62.8 cm)
Exhibited New Gallery, London, 1893 (no. 12)
Bristol City Museum and Art Gallery

Identifiable classical sculptures had always been conspicuous among the artefacts in Alma-Tadema's pictures [*e.g.* cat. 48]. However, in later works the sculptures take on new roles, appearing no longer as elements in inventories of Roman household objects, but as single artefacts of colossal proportions relative to the human figures. In *Unconscious rivals*, only the legs, feet and hands are visible of the statue of the *Gladiator*; this was partly a challenge to the informed spectator to recognize the statue from the fragment that Alma-Tadema shows. However, when the viewer's imagination supplies the rest of the statue, the colossal male figure is surveying the women from beyond the right edge of the picture. The masculine gaze presides over this scene of feminine intrigue, even though no human men are present.

The picture involves a series of plays on the notion of the gaze, and on the tension between awareness and 'unconsciousness'. The standing woman looks over the parapet, but there is no clue to what she sees; the seated woman looks toward the viewer, but there is no clue to her thoughts; the statue on the left is a colossal marble baby playing with a

mask that may hide or reveal the face; the *Gladiator* may be imagined as a voyeur, but cannot be seen except as a fragment. The spectator remains 'unconscious' of the precise implications of the women's rivalry, although permitted to scrutinize them in detail.

The plays on scale are startling; indeed, for D.S. MacColl of *The Spectator*, "the people introduced, like little chimney-piece ornaments, and the general confusion of scale" made the picture incoherent.[1] However, the picture makes its impact through the dramatic juxtaposition of the heroic masculinity of the fragmentary statue with the frivolous femininity of the women. The standing figure, leaning coquettishly over the parapet, may be another of the vain Roman women who dyed their hair red; this also allows Alma-Tadema the painter's *tour de force* of relieving the red hair against the red ceiling decoration.

Colour also plays a thematic role. The living things, the women and the flowering tree, are in warm or brilliant colours, as is the painted ceiling, the most ephemeral of the Roman artefacts. However, the monumental sculptural presences are pure white, cold and durable; it is the marble statues, not the human figures, that will survive as testimony to the lost 'reality' of the Roman past, as their gigantic size relative to the human figures suggests. The contrast is emphasized by the rhyme between the colossal arm of the *Gladiator* and the raised arm of the standing woman, more foreshortened, but similar in orientation.

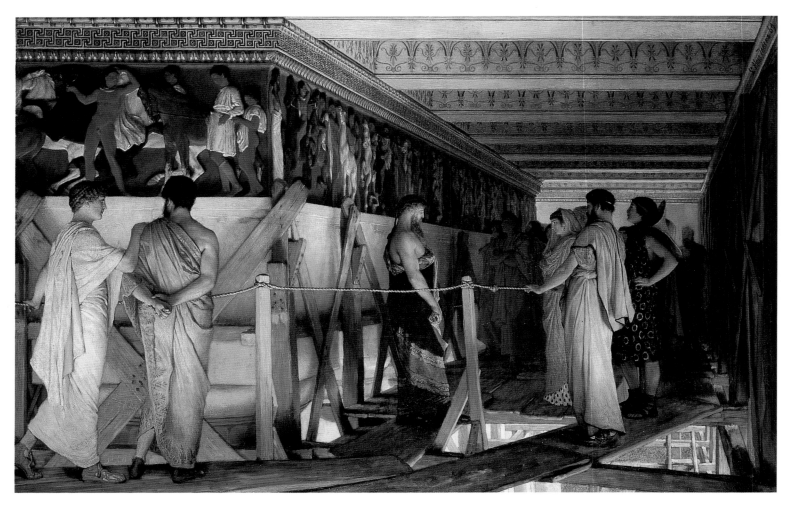

Fig. 33 Sir Lawrence Alma-Tadema, *Phidias and the frieze of the Parthenon*
Oil on panel, 28¹/₂ × 43¹/₂ ins (72.4 × 110.5 cm). Birmingham Museums and Art Gallery

The whiteness of the sculptures is a flagrant archaeological inaccuracy. As contemporary descriptions of the Pompeiian excavations stress, the statues as they were unearthed retained traces of the colouring that in general originally adorned classical sculptures.[2] Alma-Tadema was far too sophisticated an archaeologist not to know this; indeed, he had painted a picture in 1868 showing the Parthenon sculpture brilliantly coloured [fig. 33]. The whiteness of the sculptures in his late pictures must be a deliberate inaccuracy, placing the sculptures in a timeless realm: they are restored to pristine perfection of form, but deprived of their original colours.

1 D.S.M., 'The New Gallery', *The Spectator*, 6 May 1893, p. 607.

2 See the archaeologist A.H. Layard's article, 'Pompeii', *Quarterly Review* CXV, April 1864, p. 319.

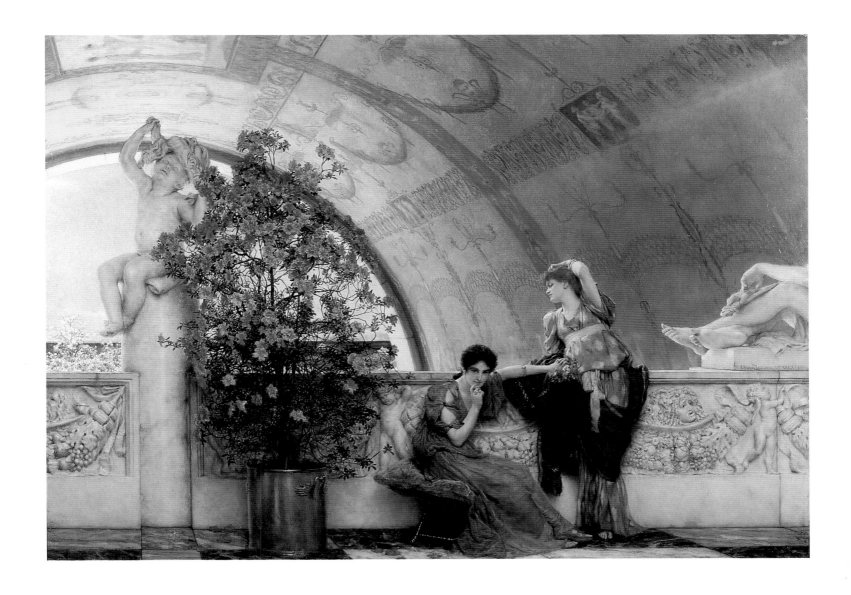

163

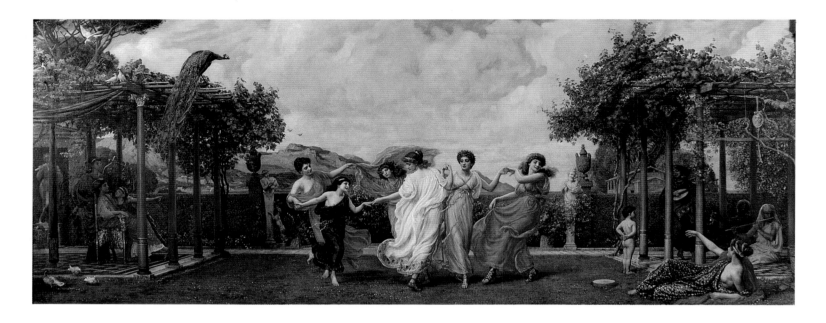

EDWARD JOHN POYNTER

61 *Horae serenae*, 1894

Oil on canvas
37 ½ × 93 ins (95.2 × 236.2 cm)
Exhibited Royal Academy, London, 1894
(no. 163)
Bristol City Museum and Art Gallery

Several critics described the setting of *Horae serenae* as "Arcadian", but the picture hovers between evoking an aestheticized dreamworld and offering a socially specific representation of female leisure in the Imperial period.[1] The themes of music and dancing were common in 'aesthetic' pictures, by painters such as Leighton, Rossetti and Edward Burne-Jones, whose classicizing settings were seen as Greek. However, the hierarchical social organization and archaeological specificity of Poynter's picture are characteristic of Roman genre painting.

The ambiguity is systematic, extending to every element of the picture.

Described by one critic as "a scene fit to illustrate Pliny's remarks on gardens",[2] the setting can be read either as an escapist fantasy world, enclosed by fanciful topiary, or as the garden of a villa on the Bay of Naples, the most fashionable country address for the wealthy in the Imperial period. The music-making theme is typical of 'aestheticism', but the participants demonstrate a Roman social hierarchy: the fair-skinned dancers and onlookers are members of the patrician family, contrasted with the darker musicians, slaves from the Roman provinces. Only the fair-skinned woman under the left pergola is permitted to play the classical lyre, the instrument of Apollo; the Egyptian musicians play humbler instruments, with the most tuneless, the cymbals, given to the darkest figure.

The two pergolas are architecturally identical, with their slender painted columns and patterned pavement, shown in the receding perspective that was virtually obligatory in Roman genre pictures by the later Victorian period. However, accessory details emphasize the difference in social status between the groups under the two pergolas. The principal woman on the left is enthroned on a luxurious and archaeologically specific chair; the gilded sphinx of the armrest is an identifiable artefact, also found in other Roman pictures. The peacock above her was a quintessential 'aesthetic' accessory, made famous by Whistler's Peacock Room; but it is also the traditional attribute of Juno, and may indicate the queen-like status of the woman below. The statue behind the left pergola reproduces a classical statue of

high status, a flute-playing faun; the reference to a particular antique statue is typical of the Roman genre scene, but the musical theme is again typical of 'aestheticism'. Next to the opposite pergola, though, is a ladder, the lone reference to the manual labour necessary to cultivate the elaborate garden.

Poynter had favoured long horizontal compositions with dispersed figure groups for important pictures since the 1870s; the frieze-like arrangement refers to classical precedents such as the famous Aldobrandini *Wedding* (Vatican Museums), simultaneously expressing the social difference as physical distance between the figure groups. The central group of dancing figures has the appearance of a quotation; it might be an expanded group of Graces, or a reference to Poussin's *Dance to the music of time* (Wallace Collection, London). The central figure with pale fluttering draperies, seen from behind, is reminiscent of the dancing figures that float in the centres of panels in Pompeian wall decorations. The practice of multiple quotation is typically 'aesthetic'. However, the references to works of art also help to elevate the central group of patrician women above the working women who play the instruments.

Horae serenae was an unusually ambitious picture for the later phase of Poynter's career [see cat. 62]. Most critics praised Poynter for the attempt, but treated the picture with respect rather than enthusiasm. Indeed, the remarks are rather contradictory, since critics praise the picture for its unusual importance,

then fail to offer the detailed comment usually accorded to important pictures. Perhaps critics were uneasy about the mixing of the socially specific Roman genre scene with the 'aesthetic' elements, ordinarily associated with a Greek context. Poynter had always been interested in testing the boundaries between pictorial types, from the time of the early pictures that hovered between Roman history and genre. *Horae serenae* may have been an attempt to create a new category, clearly Roman, but with the 'poetic' or 'aestheticizing' qualities more often associated with Greece.

1 The composition of *Horae serenae* had first appeared as a painted panel on the piano, designed in the mid-1880s by Alma-Tadema for Henry G. Marquand's music room, which also included ceiling paintings by Leighton; see Vern G. Swanson, *The Biography and Catalogue Raisonné of the Paintings of Sir Lawrence Alma-Tadema*, London 1990, p. 65.

2 'The Royal Academy', *The Athenaeum*, 5 May 1894, p. 584.

EDWARD JOHN POYNTER

62 *Water babies*, 1900

Oil on canvas
22 × 16⁷/₈ ins (56 × 43 cm)
Exhibited Royal Academy, London, 1900
(no. 224)
Private collection

Water babies belongs to a category of pictures with female figures, Roman settings, and fancy titles, conspicuous in Poynter's later work. Critics excused his neglect of more important subjects (see cat. 61 for a rare exception) by referring to his time-consuming administrative duties as Director of the National Gallery (1894–1906) and President of the Royal Academy from 1896. However, it is probable that Poynter also found a ready market for pictures of this kind, combining mild titillation with the archaeological interest of settings that were still carefully researched and meticuously executed. The architectural setting of *Water babies* is embellished with delicate painted decorations; the brick arch is made up of authentically elongated Roman bricks, each one individually delineated in perspective, with *opus reticulatum* on the rear wall.

Piquant titles were an essential element in the formula; earlier pictures of a similar kind had titles such as *Idle fears*, showing a nude child afraid to step into the bath (1894, private collection), or *When the world was young*, a group of antique maidens at leisure (1892, private collection). The title *Water babies* is borrowed from that of Charles Kingsley's novel for children of 1863, to which the

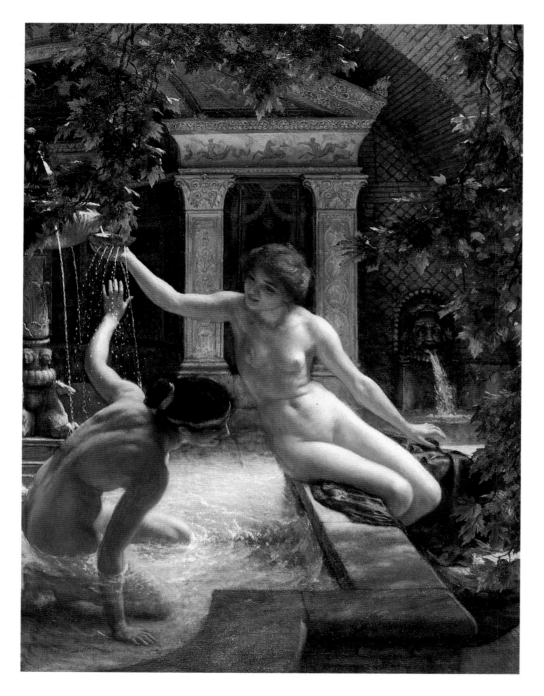

painting otherwise bears no obvious relation; as one critic observed, "the damsels who are splashing each other in the Roman bath appear to have reached a fair maturity".[1] It was stretching a point, though, to refer to "the Roman bath"; the figures' playfulness in the fountain is scarcely justifiable as a study of Roman bathing customs. Perhaps there is a distant relation, after all, to Kingsley's novel, a fantasy tale about encountering babies who live under water, but have no existence in the 'real' adult world. Poynter's picture offers a parallel fantasy specifically for adults. To refer to grown women as 'babies' was an element in this fantasy world; most of the male art critics of 1900 found the title appealing.

The painted frieze of mythological sea-creatures, behind the fountain, suggests a fairytale world populated by fantastic beings, analogous to Kingsley's, but 'authentically' classical. Moreover, it is given a 'realist' pretext, since it appears as an archaeologically specific 'imitation' of antique decorative painting, its naïveté in quaint contrast to the sophisticated 'realism' of Poynter's technique in the rest of the picture.

The tension between fantasy and 'reality' continues in the representation of the nudes. The poses are artfully arranged to complement each other; together, the two poses display the female nude from all sides. Except for the absence of pubic hair, though, the figures are treated with an extreme 'realism' quite foreign to the muted detail of the 'ideal' classical nude, and more spe-

cific than Poynter's earlier, more 'academic' treatment of the nude body [*e.g.* cat. 45]. The sharply focussed detail was in abrupt, and probably deliberate, contrast to the sketchier treatment of the nude in 'progressive' painting of the turn of the century, such as the nudes of Philip Wilson Steer and William Orpen at the New English Art Club. It differs also from the smoother, more Leightonesque treatment of flesh in Godward's pictures, but the juxtaposition of a 'realist' nude with the distancing effect of the Roman setting was similar to the formula of many of Godward's pictures of the same period [see cat. 63]. A 'realism' of sharp focus also characterizes the Roman setting, but in this kind of picture archaeological precision is detached from the recreation of Roman life.

1 'The Royal Academy', *The Times*, 5 May 1900, p. 14.

JOHN WILLIAM GODWARD
1861–1922

63 *A Roman woman*, 1909

Oil on canvas
29 ⅛ × 14 ¾ ins (74 × 37.5 cm)
Private collection

John William Godward was the most successful of a number of late Victorian painters who began to 'mass-produce' Roman genre pictures. Godward has usually been considered an imitator of Alma-Tadema, and *A Roman woman*

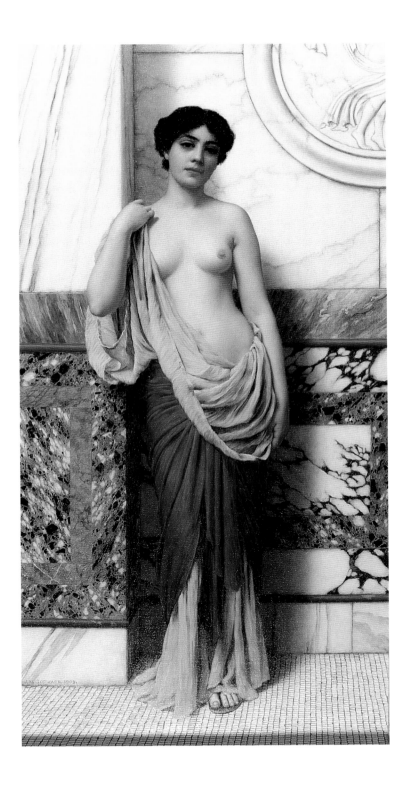

shows his skill in the depiction of marble, as well as other trademarks of the older painter, such as the receding perspective of the tiny tesserae of the floor and the sculptured roundel, cut off by the top right edges of the picture. However, the method of design in Godward's mature pictures is quite different from Alma-Tadema's, and much more 'neoclassical'. Instead of the Dutch painter's complex spatial dislocations and unexpected placement of figures and objects, Godward organizes his pictures on measured, rectilinear principles that produce a sense of classical order. In *A Roman woman*, the figure is placed exactly in the centre, before a balanced grid of horizontal and vertical lines. The sense of abstract design predominates; Godward's pictures rarely introduce even a hint of narrative content or psychological interest.

The seamless modelling of the flesh and the figure's sultry but unfathomable glance introduce a sensuality that the rational composition keeps under rigorous control. The ancient setting and accessories are an essential component of the picture's mood of distanced sensuality, although Godward makes such sparing use of archaeological detail that it is frequently difficult to determine whether his settings are intended as Greek or Roman. The tensions between antique remoteness and 'life-like' rendering of textures, between cold marble and soft flesh, between abstract design and sensual appeal are essential to the picture's impact.

Godward's facture appears impersonal;

there is no trace of the brush, and the surface is uniformly smooth, in a manner closer to Leighton or Poynter than Alma-Tadema. However, his pictures are instantly recognizable, not only for their characteristic combinations of marble, flesh and vividly coloured drapery, but for their ordered compositions and the seamless glossiness of the finish. The pictures are a series of variations on the same formula, differentiated just enough to make each one unique, but also repetitive enough to permit 'brand recognition'. The 'brand' is easily recognizable as belonging to the same general product-line as Alma-Tadema's and Poynter's pictures, but distinct enough to permit ready identification of 'the Godward'.

LAWRENCE ALMA-TADEMA

64 *A favourite custom,* 1909
OPUS CCCXCI

Oil on panel
26 × 17 ¾ ins (66 × 45 cm)
Exhibited Royal Academy, London, 1909 (no. 181)
The Trustees of the Tate Gallery, London
(Not exhibited)

This was one of Alma-Tadema's last contributions to the Royal Academy, appearing one year before Roger Fry's first 'Post-Impressionist' exhibition, and three years before the artist's death.[1] It was purchased under the terms of the Chantrey Bequest for £1,750, a substantial sum for a small picture, but the picture was an appropriate choice as a representative example for the national collection. The juxtaposition of the two playful nudes with an extensive, though miniature, survey of the customs of the Roman bath demonstrates the interplay between the scholarly and the irreverent that had characterized Alma-Tadema's work from the beginning.

Alma-Tadema had painted a series of bath scenes since the *Tepidarium* of 1882 [cat. 53]. The grandest was *Thermae Antoninianae (Baths of Caracalla)*, seen at the Royal Academy in 1899; at five feet by three feet, it was a relatively large picture, featuring a meticulous reconstruction of the magnificent swimming-bath in the Baths of Caracalla, based on the latest archaeological evidence [fig. 34]. *A favourite custom* is much less

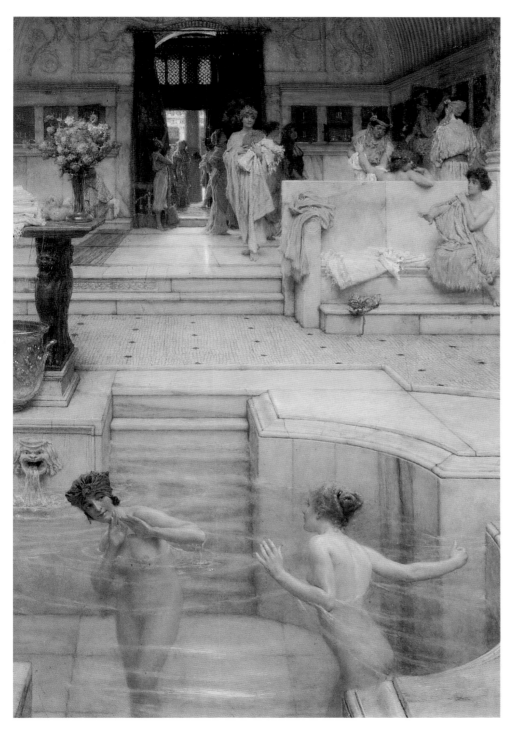

pretentious in scale, but scarcely less informative about the baths and their customs. Beyond the small swimming-bath in the foreground is an *apodyterium* or dressing-room, including the characteristic lockers for storing clothes, their doors wittily numbered with Roman numerals, and an array of accessories characteristic of the Roman bath, among which the rotund sponges are conspicuous. Farther still, through a doorway guarded by a *balneatrix* (the female slave in attendance at a Roman bath), a sunlit peristyle is visible, a place for exercise or socializing. The picture takes the spectator on a tour of Roman bathing customs, guided by the receding perspective lines. The diminution in scale, from the foreground nudes to the miniature figures beyond the doorway, creates the sense of a spacious interior, even within the small format.

It is almost unnecessary to add that the spatial recession is punctuated by individual artefacts, closely observed from ancient originals. Many are familiar from earlier pictures by Alma-Tadema: the marble table on the left, with its pedestal of beast's head and claw, is of a type that had been appearing in the painter's work since the 1860s. The silver crater, half cut off by the left edge, is based on the famous example in the Hildesheim treasure, and had appeared frequently, for instance in *After the audience* [cat. 52]. The artefacts in Alma-Tadema's late pictures appear as inventories, no longer simply of the Romans' collecting urge, but of the artist's own characteristic motifs. This

may have been partly for practical reasons, as the artist reused artefacts that he had previously researched. However, there is also, with frequently repeated artefacts such as the Hildesheim crater, the effect of a signature. Perhaps the artist wished to retain a kind of 'copyright' over certain artefacts, in the later period when he had many imitators. However, there is also a sense of experimenting with the 'authenticity' of the archaeological data. Each time an artefact is represented, it appears as a perfect imitation of a 'real' object, but the repetitions, in different contexts, remind the spectator that the assemblage is a fiction, an imaginative essay in historical reconstruction – one that is signed 'Alma-Tadema'.

1 Alma-Tadema continued to exhibit through 1912, the year of his death.

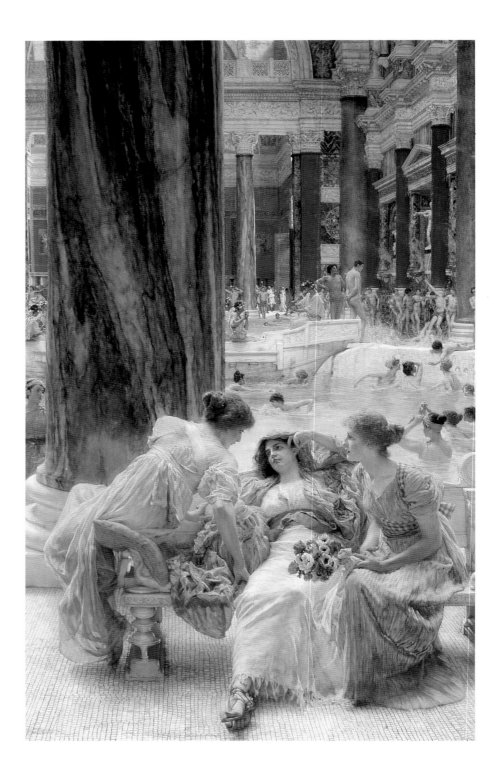

Fig. 34 Sir Lawrence Alma-Tadema,
The Baths of Caracalla, 1899
Oil on canvas, 60 × 37 ¹/₂ ins (152.4 × 95.3 cm)
Private collection (photograph courtesy of Sotheby's, New York)

SELECT BIBLIOGRAPHY

C.P. Brand
Italy and the English Romantics. The Italianate Fashion in Early Nineteenth Century England
Cambridge 1957

David Blayney Brown
Turner and Byron
London (Tate Gallery) 1992

Duncan Bull
Classic Ground. British Artists and the Landscape of Italy 1740–1830
New Haven (Yale Center for British Art) 1981

Bram Dijkstra
Idols of Perversity: Fantasies of Feminine Evil in Fin-de-Siècle Culture
New York and Oxford 1986

Laurence Goldstein
Ruins and Empire
Pittsburgh 1977

J.R. Hale (ed.)
The Italian Journal of Samuel Rogers
London 1956

Francis Haskell and Nicholas Penny
Taste and the Antique. The Lure of Classical Sculpture 1500–1900
New Haven and London 1981

Anthony Hobson
The Art and Life of J.W. Waterhouse R.A. 1849–1917
London 1980

Ian Jenkins
Archaeologists and Aesthetes in the Sculpture Galleries of the British Museum 1800–1939
London 1992

Richard Jenkyns
Dignity and Decadence. Victorian Art and the Classical Inheritance
London 1991

Raymond Keaveney
Views of Rome from the Thomas Ashby Collection in the Vatican Library
London 1988

Joseph A. Kestner
Mythology and Mysogyny. The Social Discourse of Nineteenth-Century British Classical Subject Painting
Madison, Wisconsin, 1989

Louise Lippincott
Lawrence Alma-Tadema: Spring
Malibu (Getty Museum) 1990

Claude Moatti
In Search of Ancient Rome
London 1993

Alexandra R. Murphy
Visions of Vesuvius
Boston (Museum of Fine Arts) 1978

Kathleen Nicholson
Turner's Classical Landscapes. Myth and Meaning
Princeton 1990

Ruth S. Pine-Coffin
Bibliography of British and American Travel in Italy to 1860
Florence 1974

Samuel Ball Platner
The Topography and Monuments of Ancient Rome
Boston 1904 (2nd edn., revised, 1911)

Samuel Ball Platner and Thomas Ashby
Topographical Dictionary of Ancient Rome
London 1929

Cecilia Powell
Turner in the South. Rome, Naples, Florence
New Haven and London 1987

Ronald T. Ridley
The Eagle and the Spade. Archaeology in Rome during the Napoleonic Era
Cambridge 1992

Margaret R. Scherer
Marvels of Ancient Rome
New York and London 1955

Sam Smiles
The Image of Antiquity: Ancient Britain and the Romantic Imagination
New Haven and London 1994

Carolyn Springer
The Marble Wilderness. Ruins and Representation in Italian Romanticism 1775–1850
Cambridge 1987

Vern G. Swanson
Sir Lawrence Alma-Tadema. The Painter of the Victorian Vision of the Ancient World
London 1977

Vern G. Swanson
The Biography and Catalogue Raisonné of the Paintings of Sir Lawrence Alma-Tadema
London 1990

Thorvaldsen Museum
Rome in Early Photographs. The Age of Pius IX. Photographs 1846–1878 in Roman and Danish Collections
Copenhagen 1977

William L. Vance
America's Rome (2 vols.: I *Classical Rome*, II *Catholic and Contemporary Rome*)
New Haven 1989

John Varriano
Sites and Sensibilities. Five Centuries of Roman Views
Mount Holyoke College Art Museum 1992

Andrew Wilton
Turner Abroad
London (British Museum) 1982

Christopher Wood
Olympian Dreamers: Victorian Classical Painters 1860–1914
London 1983

Christopher Wood
Victorian Parnassus. Images of Classical Mythology and Antiquity
Bradford Museums and Art Gallery 1987